The Forum of Trajan
in Rome

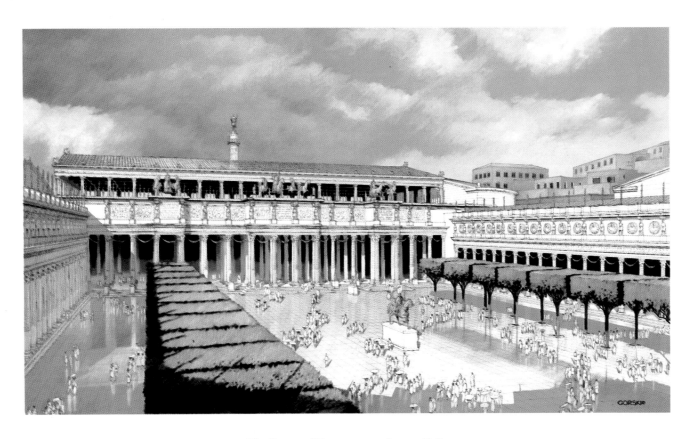

The Forum of Trajan: restored view. G.G.

The Forum of Trajan in Rome
A Study of the Monuments in Brief

by

James E. Packer

Architectural reconstructions by

John Burge, James E. Packer, and Kevin Sarring

University of California Press

Berkeley Los Angeles London

University of California Press
Berkeley and Los Angeles, California

University of California Press Ltd.
London, England

Published by arrangement with
Edizioni Quasar

© 2001 by the Regents
of the University of
California
ISBN 0-520-22673-9

Printed in Italy

9 8 7 6 5 4 3 2 1

In memory of
Barbara Bini
(1945-1990)

A dear friend in good
times and bad

Table of Contents

Abbreviations in the Captions and Figure Credits[1]

Amici (Carla Amici): *125 (Pl. 2), 126 (Pl. 3), 127 (Pl. 4), 128 (Fig. 148), 129 (Fig. 145).*

A.N.S. *(American Numismatic Society, New York): 48 (1967.153.138.).*

A.P.B. *(Archivio Fotografico Comunale, Palazzo Braschi, Rome): 8, 21, 25, 26, 27, 32, 33, 34, 37, 38, 40, 41, 42, 43, 44, 45, 46.*

B.A.V. *(Biblioteca Apostolica Vaticana, Archivio Fotografico, Vatican City): 51 (Vat. Lat. 3439, fol. 84ᵛ).*

B.B. *(Barbara Bini): 55.*

B.É B.A. *(Bibliothèque de l'École Nationale Supérieure des Beaux-Arts, Paris): 13 (Guadet, Pl. 1), 19 (Guadet, Pl. 2), 82 (Lesueur, Pl. 2), 83 (Lesueur, Pl. 3), 84 (Lesueur, Pl. 4), 85 (Lesueur, Pl. 5), 91 (Morey, Pl. 10), 92 (Morey, Pl. 12), 93 (Morey, Pl. 13), 94 (Morey, Pl. 14), 110 (Guadet, Pl. 30), 111 (Guadet, Pl. 31), 112 (Guadet, Pl. 32), 113 (Guadet, Pl. 33), 114 (Guadet, Pl. 34), 115 (Guadet, Pl. 35), 116 (Guadet, Pl. 36), 117 (Guadet, Pl. 37), 118 (Guadet, Pl. 38).*

B. L. *(Bank Leu, Coin Catalogue, Nov. 2, 1967) (Niggler Collection, vol. 3), No. 1224: 132.*

B.N. *(Bibliothèque Nationale, Paris, Cabinet des Médailles): 131 (No. 504).*

B./P. *(John Burge / James Packer): 156, 158, 159, 160, 161, 162, 163, 164, 165, 167, 168, 171.*

B.R. *([Alfonso] Bartoli, "Recinzione"): 49 (Pl. 37.1), 50 (Pl. 37.2).*

B.S. *(Biblioteca Sarti, Accademia di San Luca, Rome): 67 (De Romanis, Book 07026, No. 4).*

C.E. *([Luigi] Canina, Edifizj, vol. 2): 16 (Pl. 122), 17 (Pl. 124), 18 (Pl. 120A), 102 (Pl. 111), 103A, B (Pl. 112), 104 (Pl. 113), 105 (Pl. 114), 106 (Pl. 113), 106A (Pl. 116), 107 (Pl. 121), 108 (Pl.123), 109 (Pl. 124).*

C.I. *([Luigi] Canina, Indicazione): 100 (unnumbered plate facing p. 171), 101 (unnumbered Plate facing p. 174).*

D.A.I.R. *(Deutsches Archäologisches Institut, Rome): 3, 4, 5, 6, 20, 35, 36, 39, 140, 166.*

De Romanis *(Antonio De Romanis): see B.S.*

D.S. *(Dario Silenzi): 149A.*

F.U. *(Foteca Unione): 9 (G.A. Dosio, Urbis Romae aedificorum illustrium quae supersunt reliquiae [1569], fig. 35), 10 (Photo 4770; Nash, I: 283), 122, 123 (Gatteschi, Pl. 71).*

Gatteschi *(Giuseppe Gatteschi): 119 (Pl. 1), 120 (Pl. 69), 121 (Pl. 73).*

G.G. *(Gilbert Gorski): Frontispiece, 62, 78, 154.*

Gismondi *(Italo Gismondi): 124, 155, 170.*

Glyptothek *(Staatliche Antikensammlungen und Glyptothek, München): 145.*

G.M./U.C.L.A. *(J. Paul Getty Museum, Los Angeles/ Department of Art and Architecture, University of California at Los Angeles): 169.*

G.R.L. *(Getty Research Library): 1, 2, 14 (Studio Tau, 1987), 28, 52, 53, 56, 57, 58, 59, 60, 64, 65, 71, 72, 73, 74, 79, 80, 133, 134, 135, 136, 137, 138, 141, 142, 146, 147.*

Guadet: *see B. É B.A.*

J.P. *(James Packer): 47 (National Museum, Rome: Gnecchi Collection, Box 156.223), 81 (National Museum, Rome, Gnecchi Collection, Box 39. 89).*

Lesueur: *see B. É B.A.*

M.L. *(Musée du Louvre, Paris): 69 (MA 3129).*

M.N.R. *(Museo Nazionale, Rome).*

Morey: *see B. É B.A.*

N.G. *(National Gallery, Washington, D.C.): 157.*

P. /B. *(James Packer by Barbara Bini): 70, 139, 143, 144, 148.*

PM: *130 (vol. 2, Pl. 28).*

R.- G. *([Fjodor] Richter - [Antonio] Grifi): 95 (Pl. 3), 96 (Pl. 9), 97 (Pl. 7), 98 (Pl. 7), 99 (Pl. 9).*

R.E. *([Corrado] Ricci, "esplorazione"): 31 (Fig. 1).*

R.M. *(Corrado Ricci, Il Mercato di Traiano [Rome: arti Grafiche E. Calzoni, 1929]): 20 (p. 24 Pl. 7).*

Sakur *(Walter Sakur): 63 (Pl. 54.4).*

S.G. *(Studio Groma): 54, 61, 66, 75-77, 149B, 150, 151, 152, 153.*

Uggeri *(Angelo Uggeri): 7 (Pl. 6), 11 (Pl. 1), 12 (Pl. 2), 15 (Pl. 7), 68 (Pl. 23), 86 (Pl. 11), 87 (Pl. 13), 88 (Pl. 14), 89 (Pl. 24), 90 (Pl. 26).*

X rip. *(Comune di Roma, X Ripartizione, Archivio Comunale, Portico d'Ottavia): 22, 23,29, 30, 124, 170.*

[1] *All abbreviations herein are listed in the accompanying bibliography (pp. 219-25).*

List of figures

Introduction

Our roman sources agree that the Forum of Trajan and the Basilica Ulpia, the great lawcourt that was its most famous building, were among the most important monuments of imperial Rome (Figs. 1-6). Writing in the late fourth century A.D., the historian Ammianus Marcellinus summed up the opinion of antiquity when he called the Forum "a construction unique under the heavens, as we believe, and admirable even in the unanimous opinion of the gods... [a] gigantic complex..., beggaring description and never again to be imitated by mortal men" (Ammianus Marcellinus 16.10.15). Yet, despite its formidable ancient reputation, the Basilica and the Forum have only once in the present century been the subjects of a specialized monograph. And with good reason. By 1812, generations of looters had quarried the ruins. Later buildings had risen atop the rubble, and the remains of the Forum had been shattered into the thousands of pieces whose numbers daunt the most determined inquirer.

Even the first organized excavations did not significantly improve the fortunes of the site. Although the French uncovered the central section of the Basilica and a small part of the adjacent forum square (*Area Fori*) in 1811-14 (Figs. 7-16), they never published a systematic account of their finds (infra pp. 20-26). The handsome drawings of Antonio De Romanis, a contemporary Roman architect who documented the French discoveries in detail, remained unpublished, as, until very recently, did most of the work of his French successors. Thus, with only incidental reference to the work of their predecessors, nineteenth century students of the Forum of Trajan successively measured and drew the same exposed architectural fragments. In the present century, those who studied the Forum, while for the most part neglecting the published works of earlier scholars, produced incomplete or inaccurate general descriptions of the site.

Even the results of the large-scale excavations undertaken in the Forum of Trajan by the government of Mussolini in connection with the construction of the boulevard now known as the via dei Fori Imperiali (Figs. 1, 2, 22-27, 29-46) have not, until the last several years, been properly studied. In consequence, until very recently, scholars have confined themselves to specialized problems connected with the Forum.

Our aim, on the contrary, has been to present a general account of the architecture of the Forum as a whole. In Part I, after reviewing the history and destruction of the Forum, its later fortunes, and its excavation in the last two centuries (chapters 1, 2), we focus on the lesser monuments (chapters 3, 4). Some of these—the three triumphal arches at the south end of the forum square, the Equus Traiani (the equestrian statue of Trajan which stood at the center of the open plaza in the Forum), most of the West Colonnade and Hemicycle, and the East Library—are still buried five meters (fifteen feet) below the level of the modern streets. Others—the East Colonnade and Hemicycle, and the West Library—are now completely excavated.

For the unexcavated buildings, unpublished documents and drawings, representations on coins, and those chance finds reported in the past provide much new information. For the East Colonnade and Hemicycle and the West Library, the abundant architectural fragments on the site, the restoration drawings of Italo Gismondi, and the new Getty photographs, plans, and sections of the existing ruins now permit accurate restorations.

Yet, apart from the reliefs on the Column of Trajan, the Basilica Ulpia has always been the major focus of interest for students of the Forum. Consequently, instead of discussing the Basilica Ulpia contextually, we separate it from the other monuments in the Forum and use them to shed light

on the complicated problems connected with the architecture of the Basilica. Six major essays discussed these problems in the nineteenth century; the twentieth century produced three similar studies. Some were unfortunately never published; most of those that were cannot be found outside specialized archaeological libraries in Rome. As a result, these works have never been studied as a group. In the opening chapter of Part II, we therefore review these essays. By comparing their views, we attempt to determine which of the problems connected with the restoration of the Basilica they have identified and perhaps solved; and, in so doing, we have tried to correct their misconceptions while accepting their many valid insights.

Combined with the other abundant evidence for the site, these works permit a considerably more accurate reconstruction of the Basilica Ulpia than was previously possible. This new reconstruction, our subject in chapter 6, is fleshed out from a variety of sources: depictions of the Basilica on the Forma Urbis (Fig. 130) and Trajanic coins (Figs. 131, 132), and study of the architectural fragments discovered in the Fascist excavations of the 1930s, of that part of the Basilica cleared by the Fascists, and of the new comparative evidence from the East Colonnade and Hemicycle and the West Library.

In Part III, we discuss the techniques used to construct the Forum and in chapter 8, we consider the proportions of the plan, the characteristics of the architecture, and the design and significance of the complex as a whole. Thus, we do not review the history of the basilica as an architectural type, attempt to set the Forum of Trajan within the context of Trajanic architecture, or treat the provincial copies of the Forum of Trajan. Rather, we concentrate on the difficult problems associated with the fragmentary architecture of the site. By establishing its general character—long obscured by the complex and sometimes contradictory character of the surviving evidence—we try to determine, insofar as possible, the precise ancient appearance of the monuments: the essential architectural texts for all further study.

Nonetheless, there are still large gaps in our knowledge. Even a mathematical comparison of the measurements of many of the architectural elements fails to indicate their former position, and we still lack a comprehensive catalogue of *all* the fragments preserved in the various storerooms on the site—of which the largest is that under the park (the "Esedra Arborea") that borders the east side of the via dei Fori Imperiali (Figs. 1-2, 135-137). Under these circumstances, the discussions and reconstructions of the various monuments offered below establish only broad outlines of their plans and elevations. Naturally, these hypotheses will be revised whenever additional parts of the site are excavated.

James E. Packer
San Francisco and Rome
Winter, 1992

The text below necessarily omits the supporting notes, appendices, and technical photographs, the individual sheets of the new archaeological map of the site (the "Getty Plan") and the other drawings included in the original three-volume version of this work, *The Forum of Trajan in Rome: A Study of the Monuments* (Berkeley and Los Angles: University of California Press, 1997). Readers who wish to review that material will find it there.

James E. Packer
Chicago and Rome
Summer, 2000

Part I
The Forum of Trajan
Chapter One

The Construction and History of the
Forum of Trajan

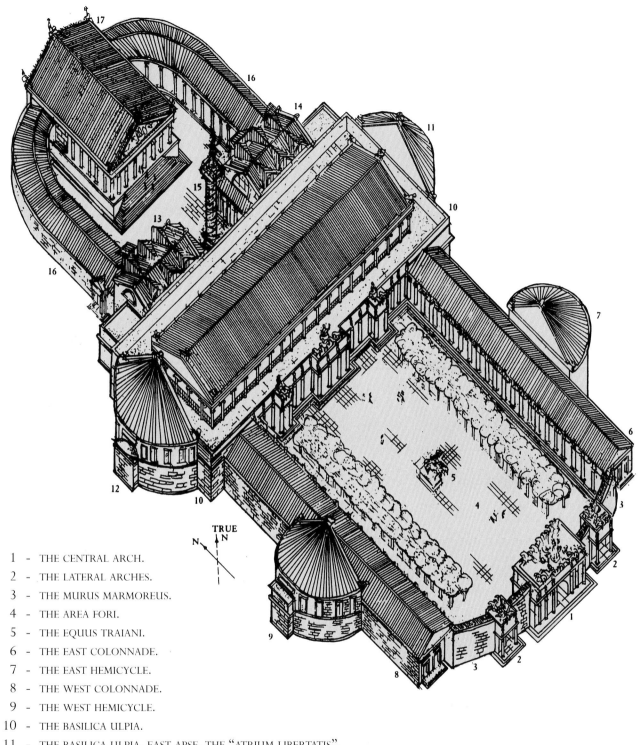

1 - THE CENTRAL ARCH.

2 - THE LATERAL ARCHES.

3 - THE MURUS MARMOREUS.

4 - THE AREA FORI.

5 - THE EQUUS TRAIANI.

6 - THE EAST COLONNADE.

7 - THE EAST HEMICYCLE.

8 - THE WEST COLONNADE.

9 - THE WEST HEMICYCLE.

10 - THE BASILICA ULPIA.

11 - THE BASILICA ULPIA, EAST APSE, THE "ATRIUM LIBERTATIS".

12 - THE BASILICA ULPIA, WEST APSE.

13 - THE WEST "GREEK" LIBRARY.

14 - THE EAST "LATIN" LIBRARY.

15 - THE COLUMN OF TRAJAN.

16 - THE COLONNADES OF THE TEMENOS OF THE TEMPLE OF TRAJAN.

17 - THE TEMPLE OF TRAJAN?

THE FORUM OF TRAJAN
Color indicates the areas discussed in this chapter

The Forum of Trajan was the last in a series of grandiose imperial fora intended to supplement the limited space of the hallowed Forum Romanum. Julius Caesar undertook the first of these ambitious projects, and his immediate successors followed his example (Figs. 3-6). By the time of the Emperor Domitian (A.D. 81-96), there were three new fora: that begun by Caesar (and completed by his heir Augustus), the Forum of Augustus himself, and the Temple or "Forum" of Peace built by Vespasian. Domitian took a personal interest in the monuments of his capital, and it was only natural that he should add to the existing imperial fora. His first project, the small-scale "Forum Transitorium" united the Temple of Peace to the south with the Forum of Augustus to the north. Useful as it was, however, this small complex did not give Domitian full scope for his architectural ambitions. Accordingly, before his death, he had initiated preparations for the construction of a huge Forum to the north of that of Augustus.

With the Emperor's death, however, work on his new forum must have immediately halted. Although the emperor Nerva dedicated the Forum Transitorium (virtually complete by A.D. 96), his short reign (A.D. 96-98) did not permit resumption of the more ambitious project to the north. This neglect apparently continued during Trajan's early years. Foreign affairs occupied the Emperor's attention, and Domitian's luxuries and costly buildings had temporarily exhausted the imperial treasury. Yet, the completion of the first round of Dacian Wars provided Trajan with the funds to construct the lavish buildings which had become a traditional expression of imperial propaganda. One of his first cares, therefore, was to resume work on Domitian's forum. Henceforth, the entire complex, designed by the famous architect Apollodorus of Damascus and built with the help of sculptors perhaps imported from the Greek East, glorified the new emperor and his military victories in Dacia (modern Romania).

Construction on the new project began in A.D. 106/107, and the buildings surrounding the Forum, including the Basilica, were substantially complete by A.D. 112, the year when, according to an inscription found at Ostia, the seaport of imperial Rome at the mouth of the Tiber River, the complex was officially dedicated. The Column of Trajan was dedicated the next year, and, on his death in A.D. 117, Trajan was buried in a small chamber in the base of his Column. In the next eleven years, on a site just north of the Column of Trajan, Hadrian completed a temple to his deified predecessor. Together with its surrounding colonnades, this shrine had been finished by A.D. 128.

Later references to the Forum are distressingly scanty, but, as was only natural, it became one of the capital's chief official centers. Here Hadrian burned official records of debts owed the state; and in the reign of his successors, numerous imperial acts took place in the Forum. Following the example of Hadrian, Marcus Aurelius may have destroyed tax records there, and he adorned the Forum with statues: one dedicated to his tutor, Marcus Fronto; and several to those honored for their achievements in the Marcomannic Wars. There too, he auctioned the imperial jewels and official robes in order to pay for the Marcomannic Wars. As a special honor, his official heir, Commodus, while still a child, handed out imperial donations and presided in the Basilica Ulpia, the east apse of which was called the Atrium Libertatis ("Liberty Hall"). One of the Forum's chambers, called

FIGURE 1. *The Forum of Trajan: aerial view, looking southwest. G.R.L.*

Opes ("riches"), was a bank for the deposit of senatorial valuables. New laws were frequently posted in the Forum, while the *summi viri* ("public heroes") were honored with statues like that set up to commemorate the Emperor Aurelian (A.D. 270-275), justly saluted in his own day as *Restitutor Orbis* ("the restorer of the world"). Indeed, these honorary statues were only part of what must have been a program of conscientious maintenance kept up by the imperial government throughout the third century.

At the beginning of the next century, the Forum apparently suffered the loss of of some of its architectural ornaments, which were used to adorn the Arch of Constantine next to the Colosseum (Fig. 143). Yet, the Forum was still substantially intact in A.D. 359 when Constantine's son, Constantius II, in Rome for the first time as an imperial tourist, admired its enormous scale and perfection and had to be dissuaded from carrying off to Constantinople as an imperial souvenir the equestrian statue of Trajan in the center of the Forum. In the latter part of the fourth century and the beginning of the fifth, slaves still gained their freedom in the Atrium Libertatis, and statues in the Forum continued to honor public figures like Sidonius Apollinaris. Even as late as the early sixth century, Decius Marius Venatus Basilus, *praefectus urbi* ("prefect of the city") and *consul ordinarius* ("ordinary consul") for the year 508, apparently repaired the Forum, a complex which yet excited the wonder of Cassiodorus. In the days of Venatius Fortunatus (A.D. 600), the Libraries were still suitable settings for public recitations.

FIGURE 2. *The Forum of Trajan: aerial view, looking northwest. G.R.L.*

The middle ages

In the seventh century, however, The Forum sustained some damage. The Byzantine Emperor Constans II marked his visit to Rome in A.D. 663 by removing some of its bronze statues and other ornaments, intending to send them to Constantinople. But Constans died in Syracuse in A.D. 668, and Arab raiders seized his spoils. Even with this loss, however, most of the Forum survived. About A.D. 750, an anonymous traveler was able to copy the inscription on the base of the Column of Trajan; and fifty years later, as Paul the Deacon attests in the life of Gregory the Great, the monuments of the Forum were still the wonder of contemporaries.

Nonetheless, excavations around the Column of Trajan in 1906 uncovered the remains of the small church of St. Nicholas (Nicolai de Colupna), which was already in existence by the early part of the ninth century. Since a wing of this shrine utilized the south side of the base of the Column of Trajan as one wall, the appearance of St. Nicholas suggests that the Forum had fallen into ruins not later than the first half of the ninth century.

What were the causes of this destruction? The excavators of the nineteen-thirties found many of the columns which had surrounded the nave of the Basilica Ulpia in the positions in which they had fallen: the broken shafts and capitals lying, in many cases, in straight lines facing south (Figs. 8, 34, 36). This circumstance may indicate that it was an earthquake which threw down the complex, burying its structures under the debris of roofs and walls.

And in fact, two serious earthquakes shook Rome during the ninth century. The first took place on April 25, A.D. 801. Its effects reached as far as Germany, and in Rome, a number of ancient buildings must have disappeared. In A.D. 847, the second—and the serious fire which resulted from the initial tremors—demolished the pilgrims' quarter around Old St. Peter's Basilica. However, since the church of St. Nicholas was constructed in the early nineth centry A.D., the first of these earthquakes probably destroyed the Forum of Trajan, and the fact that contemporary sources do not mention its ruin means simply that they were not concerned with the fate of antiquities.

Yet, the Forum was too vast to be completely destroyed. Numerous walls and columns stood above ground in an area which a document from the archive of the church of St. Mary in via Lata describes as a garden "in which are fig trees with rocks and a column among them...near the area formerly called 'campo Kaloleo [Carleo]." Henceforth, until comparatively recent times, the Forum of Trajan was known as the "Campo Carleo." The Forum Transitorium became the "Forum of Trajan," and in A.D. 1162, only the direct intervention of the medieval Roman Senate preserved the Column of Trajan from further damage. Yet, by this time, the walls of the Church of St. Nicholas concealed the inscription, and the Column had become "the Column of Hadrian," a name it retained until the end of the thirteenth century. By the next century, the compound of the Colonna family, which controlled the largely abandoned wasteland around the Forum, dominated a zone commanded from the slopes of the Quirinal Hill above and behind the ruins by a stronghold known as the Torre delle Milizie.

Only a few buildings rose above the desolation. Sometime prior to the twelfth century, the Church of St. Mary in Campo Carleo (Spoglia Christo) had been erected at the southeast corner of the site of the Forum, a plot at

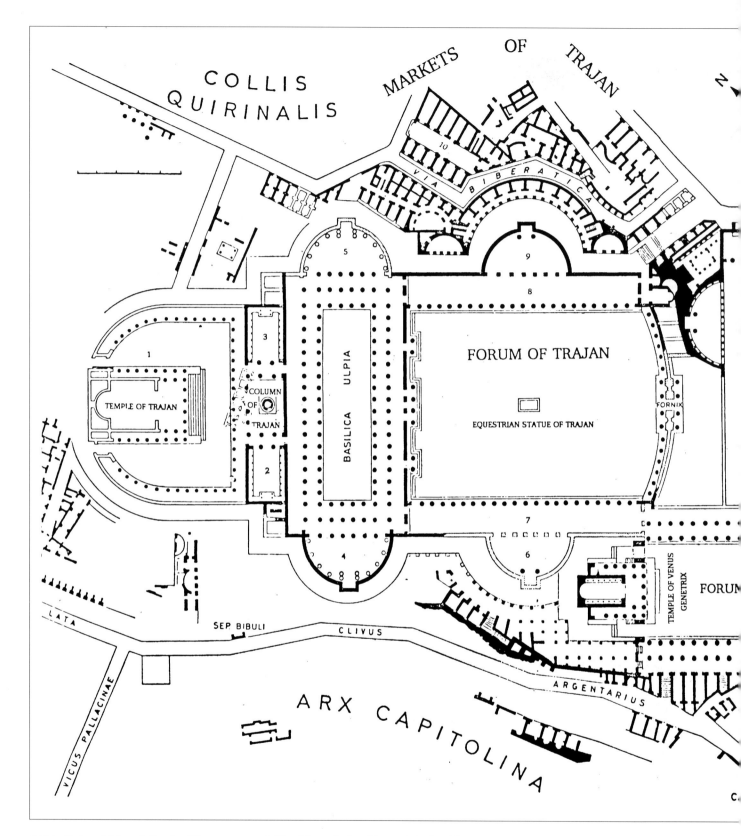

FIGURE 3. *Imperial fora: 1. Temple of Trajan: precinct; 2. West Library; 3. East Library; 4. Basilica Ulpia: west apse; 5. Basilica Ulpia: east apse; 6. West Hemicycle; 7. West Colonnade; 8. East Colonnade; 9. East Hemicycle; 10. Markets of Trajan: great hall. 11. Temple of Peace; 12. Temple of Peace: hall of the Forma Urbis. D.A.I.R.*

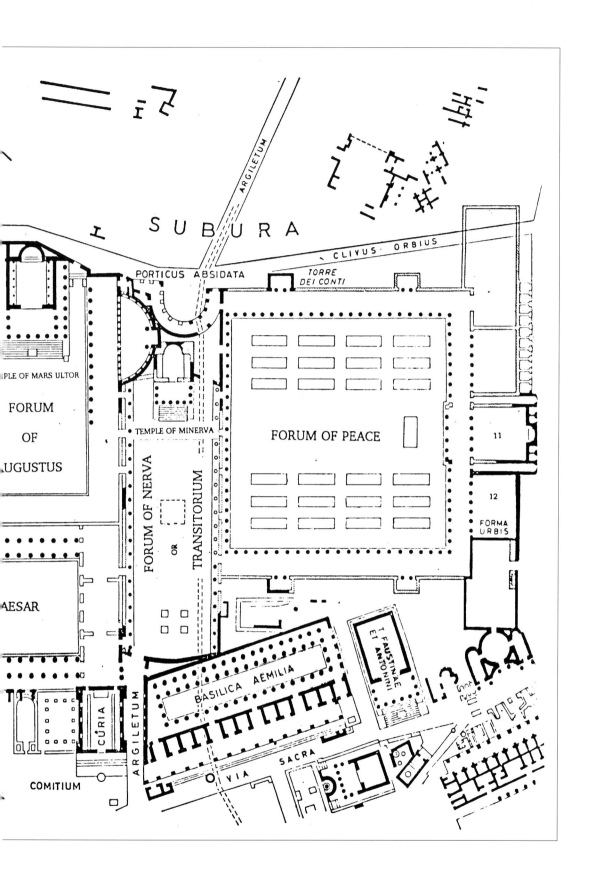

SUBURA

ARGILETUM

CLIVUS ORBIUS

PORTICUS ABSIDATA

TORRE
DEI CONTI

PLE OF MARS ULTOR

FORUM
OF
UGUSTUS

TEMPLE OF MINERVA

FORUM OF NERVA

OR

TRANSITORIUM

FORUM OF PEACE

11

12

FORMA
URBIS

AESAR

ARGILETUM

CÚRIA

COMITIUM

BASILICA AEMILIA

T FAUSTINAE
ET ANTONINI

VIA

SACRA

the southest corner of the later via Campo Carleo and via Alessandrina (Figs. 13, 14). Temporarily abandoned in the twelfth century, that sanctuary—which derived its name from the painted decoration of the facade which depicted the scourging of Christ—appears in a contemporary document as one of the sanctuaries "which are little known and without priests." West of the church lay its orchard, crossed by a marble wall, the Murus Marmoreus that stood until at least the sixteenth century, by which time the church had been known for nearly a hundred years as St. Mary in Campo Carleo.

The Renaissance

In 1432, the widow Petronilla Capranica used her own house, located in an area called Macel dei Corvi, to found the Monastery and Church of the Holy Spirit. It was apparently an originally modest structure which took up only the west side of a large walled enclosure, presumably a garden. By the time the French destroyed the building in 1811-1814 (Figs. 7, 12), it occupied most of an entire block, bounded to the north by the Piazza di Traiano, to the south by via S. Lorenzo ai Monti, to the east by Campo Carleo, and to the west by a street of uncertain name (Figs. 13, 14). An arcaded courtyard lighted the interior, and the Church of the Holy Spirit, reached from the via S. Lorenzo ai Monti, stood at the southwest corner of the complex.

Other churches also went up in the vicinity. The first was St. Bernard of the Campagna, built by Francesco Foschi di Berta just west of the site of the later Church of The Most Holy Name of Mary. The founder's house stood nearby on the site of the Imperiale-Valentini Palace (now the Prefecture), and when di Berta died, he was buried in the garden which adjoined the Church and served as its cemetery. Before 1461, another small church dedicated to St. Eufemia had been erected. Situated a block (125 meters) south of the Church of St. Bernard, the new shrine also faced south onto the via S. Lorenzo ai Monti.

Between 1507 and 1527, on a site northwest of the Column of Trajan, Antonio da Sangallo the Younger constructed the still extant Church of the Madonna of Loreto (Figs. 2, 7, 8-10, 16). Excavations for the foundations disclosed a number of large fragments of marble, probably from the Temple of the Deified Trajan; and Michelangelo may have carved one of the larger pieces into the base for the equestrian statue of Marcus Aurelius, still in the center of the Piazza del Campidoglio (as support for a bronze reproduction of the original statue). The other marbles probably also served as raw materials for contemporary buildings or sculpture. In 1513, similar fragments, perhaps from the same trenches, were certainly used in this fashion for the repair of the Church of St. Mary Navicella. Only a few fragments, like the famous eagle, discovered in 1515 and now exhibited in the porch of the Church of the Most Holy Apostles, survived in their original form.

On March 3, 1526, the minutes of the Consiglio del Comune record that the "Magistri Stratarum", the officials in charge of the streets, were ordered to prevent further harm to the "Arcus Traiani," which had apparently been damaged during excavations on the site. This arch was probably the easternmost of the three triumphal arches on the south side of the Forum (Figs. 149A, 149B), the main ancient entrances to the Forum. Standing near the Church of St. Mary in Campo Carleo, this "Arcus Traiani" was probably part of the Murus Marmoreus in the orchard of the

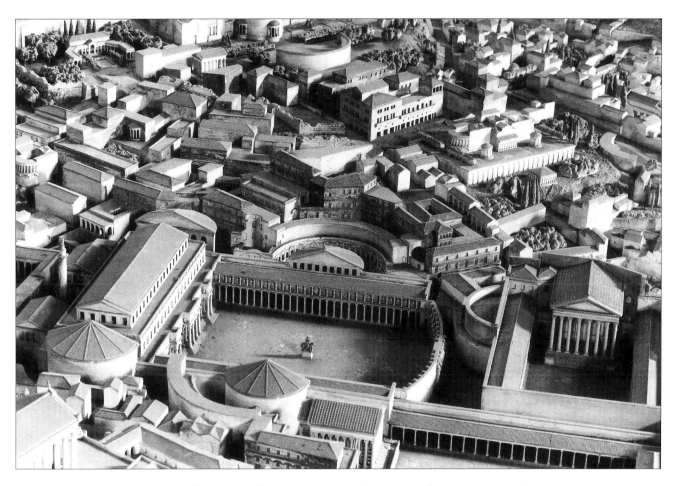

FIGURE 4. *Model of Constantinian Rome.* Left: *The Forum of Trajan, looking east.* Right: *The Forum of Augustus with Temple of Mars Ultor.* D.A.I.R.

church. Eight years later, at the opposite end of the site near the Church of St. Mary (the Madonna) of Loreto, new excavations partially exposed gray granite shafts from the porch of the Temple of Trajan.

The new churches served a growing population housed in the crowded blocks of three-and four-story tenements which appear on the late sixteenth-century plans of Rome by Étienne Du Pérac and Antonio Tempesta. The construction of these buildings necessitated frequent excavations, which were concentrated at mid-century on the sites of the Forum's East Colonnade and Hemicycle and the Basilica Ulpia in the areas called Spoglia Christo and Macel dei Corvi. Probably between 1532 and 1535, four giallo antico columns, almost certainly from the porches of the Basilica Ulpia, were removed from the foundations of the Monastery of the Holy Spirit, repaired, and reerected in the transept of St. Peter's Basilica, two at each end (Fig. 139). For some years afterwards, the Fabbrica di San Pietro used the Forum of Trajan to supply materials for the new Basilica and even for the Farnese Palace. Between 1541 and 1543 alone, workers removed 53 cartloads of marble, and the excavations were so extensive that they damaged the walls of the Monastery of the Holy Spirit, which required repairs in 1547. The previous year, a fragment probably from the facade of the East Colonnade, "a rather larger than life-size head of Julius Caesar with the whole chest covered," appeared in excavations in the area of Spoglia Cristo, where in 1548, several statues came to light. In 1555, while digging in via Taroli for the foundations of the house of Marino and Geronimo Cuccini, workmen uncovered remains of both the Colonnade and the Hemicycle: white marble capitals, parts of giallo antico pilasters, and "two round frames to set a head."

Such extensive excavation and construction apparently threatened even the Column of Trajan. Accordingly, in 1536, Pope Paul III undertook some preliminary clearing around the base of the monument. Nine years later, the same pontiff completely isolated the Column, demolishing the little Church of St. Nicholas which had adapted the

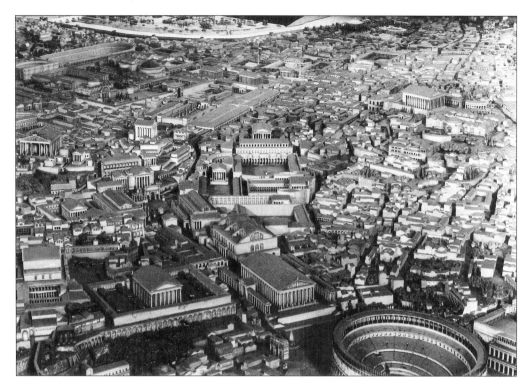

FIGURE 5. *The Forum of Trajan, looking northwest. D.A.I.R.*

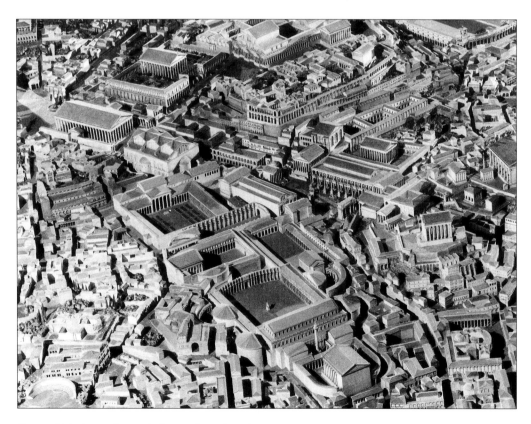

FIGURE 6. *The Forum of Trajan, looking southwest. D.A.I.R.*

12

Column as its campanile: the bell hung in the uppermost window of the internal spiral stair. Thereafter, completely freed of accumulated debris, the Column stood at the center of a square pit (Figs. 9, 10). In order to complete his project, Paul also took down a number of adjacent dwellings, creating a small piazza around the Column. To the north, this square was bounded by the Church of the Madonna of Loreto and the Chapel of St. Bernard, separated by private residences; to the south, by the Monastery of the Holy Spirit; to the east and west, by private houses. And finally, in April of 1546, in order to provide for the future safety of the Column, the Pope appointed as its

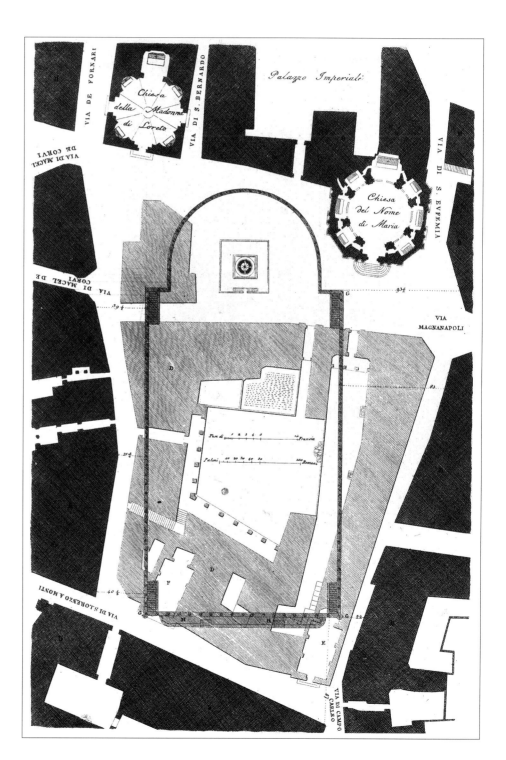

FIGURE 7. *The area of the 1811-14 excavations in 1817 (the demolished buildings in gray). Uggeri.*

custodian Vincenzo della Vetera, owner of one of the demolished residences. Nearly twenty years later (1564), Pius IV granted the same concession to della Vetera's heirs.

Following Paul's example, subsequent popes continued to maintain and embellish the Column and its immediate vicinity. Pope Paul IV commissioned Michelangelo to buttress the surrounding earth. Designed with inset panels, set off by rectangular pilasters, his retaining walls were repaired in 1569 and 1573. Pope Gregory XIII enlarged the surrounding piazza with demolition of additional houses; and in May, 1588, his successor, Sixtus V, replaced the long-vanished statue of Trajan with a bronze St. Paul designed by Leonardo Sorman and Tommaso della Porta (Fig. 11). The workmen discovered the feet of the ancient colossal statue of Trajan atop the Column and unearthed the head in fill not far from the base of the monument. Unfortunately, after passing into the collection of Cardinal della Valle, the head disappeared. In the same year, to set off the Column to better advantage, the Pope took down six additional houses, opening a new "Strada Troiana" [sic]. From the piazza around the Column, that road ran west under an "arco di S. Marco," intersecting with the via di S. Marco, a narrow street which led north to Piazza Venezia. To meet the heavy expense of the project, Sixtus imposed a special tax on the citizens.

Yet, if civic pride constrained the popes to care for the Column, they had no comparable interest in any of the other buried monuments of the Forum. Consequently, they licensed haphazard excavations and building projects on all parts of the site. In 1555, under the house of Joanne Zambeccario (the location of the present Prefecture in the old Imperiale-Valentini Palace), there appeared shafts of cipollino (greenish-gray marble from the island of

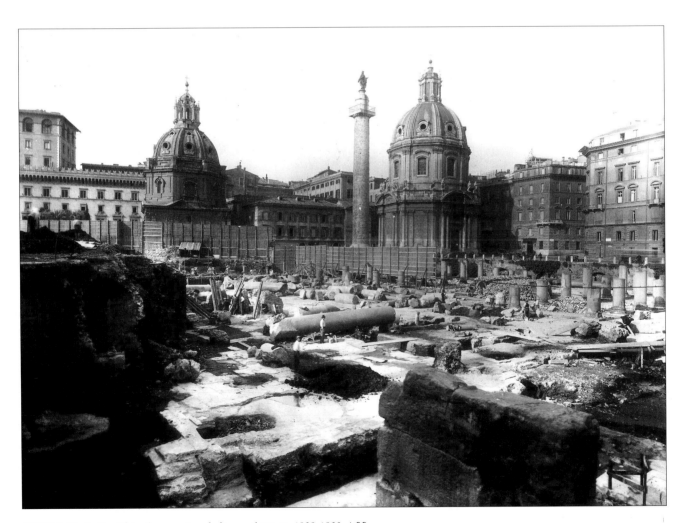

FIGURE 8. *The Basilica Ulpia: the excavations, looking northeast, ca. 1930-1932. A.P.B.*

Euboea in Greece) and giallo antico (golden marble with purple-red veins from Tunisia). When the excavation was extended towards the south, larger fragments of shafts from the porch of the Temple of Trajan came to light.

The next year, Giovanni Giorgio, the Duke Cesarini, bought a large cipollino column that had been discovered, still in situ, in the house of Bastiano Piglialarme. Carrying off the column to his garden near S. Pietro in Vincoli (St. Peter in Chains), the Duke intended to combine it with a bronze bear and eagle to assemble a three-dimensional representation of his family's coat-of-arms. Only death prevented Cesarini from executing this novel project. The same year, excavators also discovered a bust of Trajan flanked by Hercules and Mercury; and in 1562, work at Spoglia Christo produced a handsome handsome cornice, apparently from the facade of the East Colonnade. On January 15, 1564, in the nearby Monastery of the Holy Spirit, diggers uncovered fragments of giallo antico with a diameter of "p.[almi] 4 3/4 [1.061 meters]." Their measurements suggest that these pieces, subsequently purchased at a price of sixty *scudi* for the Sala Regia in the Vatican, came from one of the south porches of the Basilica Ulpia.

Random discoveries and construction continued until late in the century. In 1570, a certain Prospero Bocca-padullo, a magistrate in charge of work near the site of the East Lateral Arch, found a number of large-scale reliefs, appropriating for himself "a mounted Trajan crossing a river." Another relief, probably from an adjacent bay in the south wall of the Forum, depicted a Dacian captive being led away in chains (Fig. 51). In 1586, two building permits were issued: one on May 28 to Cardinal Michele Bonelli for a palace in the area between the Column of Trajan and the Church of the Most Holy Apostles; the other, on July 9 to the "nobile Faustina Muti" for a site previously occupied by the house of Joanne Zambeccario (supra p. 12). Seven years later, workers in the foundations of another dwelling reached the level of the ancient Forum. According to Vacca, it was "all built of marbles, with some pieces of giallo antico, which, I believe, enscribed compartments... three pieces of statue marble [pavonaz-zetto] with upper diameters of five palms [1.117 meters] and each thirteen palms long [2.904 m] were found". Vacca suggests that these pieces came from the portico which framed the Forum "in the middle of which was the Column with spiral historical friezes." From his description and the diameter of one of the shafts, however, it appears that the excavators had found the floor of the Basilica Ulpia and fragments of the building's south exterior colonnade. In 1598, large quantities of marble from "Macelli de Corvi" were still being sold, and Bertoldi notes and marbles from the Forum were dispersed to palaces in all parts of the city.

The Seventeenth and Eighteenth Centuries

By contrast with the extensive activity on the site in the sixteenth century, the few notices which have reached us from the seventeenth century indicate that the area witnessed few changes during this period. Early in the reign of Pope Clement VIII (1592-1605), a new orphanage for abandoned children went up north of the Church of St. Eufemia, east of and adjoining the Monastery of the Holy Spirit. A cramped court separated this long, narrow building from the older Monastery (Fig. 7). Probably at the time of the construction of the orphanage, the Church of St. Eufemia received a new baroque facade and thus now matched the Church of the Holy Spirit which had been similarly renovated in 1582. These were the last major changes in the neighborhood for the remainder of the century. There were, of course, a few minor problems. On April 22, 1626, we hear that the door of the enclosure around the Column of Trajan had been ripped off and that "inside scandals and unworthy actions were perpetrated" and that "the enclosure where the base of the Column was located had become a rubbish heap from whence wafted a terrible smell". Understandably, the gate was immediately replaced on that occasion, but, by the end of the century, the minutes of the Consiglio del Comune for January 13, 1696 note the installation of yet another new gate; and in 1699, to insure the safety of the Column, the

Consiglio named a certain "Sr. Michelangelo Taddei" as its guardian. In 1700, work in the foundations of the Monastery of the Holy Spirit revealed broken gray granite shafts from the internal order of the Basilica Ulpia and some of the large-scale giallo antico squares from the pavement of the interior.

In the same year, excavation in front of St. Bernard uncovered a dedicatory inscription from the precinct of the Temple of Trajan, and a few decades later, the congregation of that church, virtually extinct by the end of the seventeenth century, reformed under the protection of the "Most Holy Name of Mary." Begun in 1736, work on the new church was complete by 1741; and seven years later, the older chapel was destroyed.

Then, in 1765, workmen digging the foundations for a small house opposite the Column of Trajan, near the Church of the Name of Mary, unearthed fragments of gray granite columns eight and one half palms in diameter (1.899 meters) and two cornices. Although the latter had identical profiles and decorations, one was somewhat smaller than the other. The larger cornice and the columns presumably belonged to the Temple of Trajan; the smaller one came from the colonnades of its precinct. Since no one wished to pay for their excavation, these shafts remained buried, serving to support the foundations of the new house. The larger cornice was transported to the

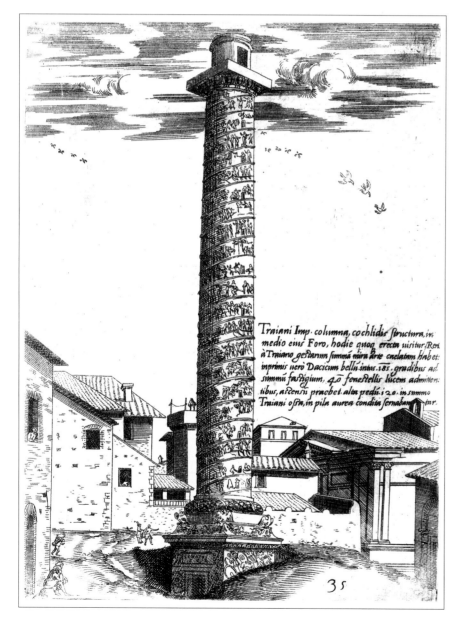

FIGURE 9. *The Column of Trajan looking northwest (ca. 1569). Dosio. F.U.*

16

Villa Albani where it remains; the smaller cornice, left in the enclosure around the Column of Trajan, is still in the Forum today.

By the late eighteenth century, the square had thus assumed the appearance it was to retain until the French excavations of 1811-1814 (Figs. 7, 11). The Column stood sunken in a deep square pit with sides of "fifty feet," the surrounding earth buttressed by Michelangelo's brick walls. At street level there was a low parapet, apparently of travertine. A modest gate on the north side admitted visitors to the landing of a stair with two opposed flights which led down to the original level of the peristyle around the Column.

To the northwest rose the Church of the Madonna of Loreto; to the northeast, that of the Most Holy Name of Mary. Four irregular three-story buildings separated the two churches, closing the courtyard of the Imperiale-Valentini Palace (the Prefecture). The Monastery of the Holy Spirit and the Convent and Orphanage of St. Eufemia stood to the south: the former six stories high; the latter, five. To the east and west, four-story private houses, all apparently remodeled in the late seventeenth or early eighteenth century, overlooked the square (Figs. 7, 11). And finally, after centuries of dust in summer and mud in winter, the piazza itself had been paved with flint cobblestones (Fig. 11).

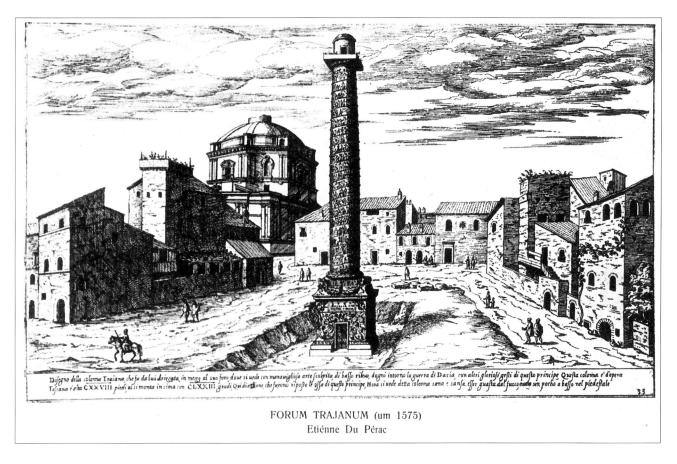

FORUM TRAJANUM (um 1575)
Etiénne Du Pérac

FIGURE 10. *The Forum of Trajan in 1575. Du Pérac. F.U.*

Chapter Two

Archaeological Investigations
in the Forum of Trajan

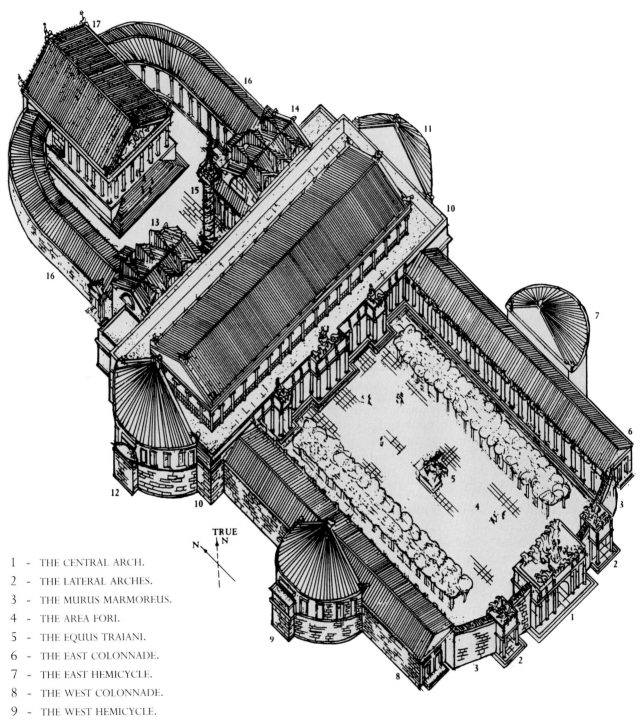

1 - THE CENTRAL ARCH.
2 - THE LATERAL ARCHES.
3 - THE MURUS MARMOREUS.
4 - THE AREA FORI.
5 - THE EQUUS TRAIANI.
6 - THE EAST COLONNADE.
7 - THE EAST HEMICYCLE.
8 - THE WEST COLONNADE.
9 - THE WEST HEMICYCLE.
10 - THE BASILICA ULPIA.
11 - THE BASILICA ULPIA, EAST APSE, THE "ATRIUM LIBERTATIS".
12 - THE BASILICA ULPIA, WEST APSE.
13 - THE WEST "GREEK" LIBRARY.
14 - THE EAST "LATIN" LIBRARY.
15 - THE COLUMN OF TRAJAN.
16 - THE COLONNADES OF THE TEMENOS OF THE TEMPLE OF TRAJAN.
17 - THE TEMPLE OF TRAJAN?

THE FORUM OF TRAJAN
Color indicates the areas discussed in this chapter

ON FEBRUARY 2, 1808, the Napoleonic army of occupation entered Rome. A little over a year later, the uncooperative Pope Pius VII was in prison, and an enlightened government of the "Free and Imperial City of Rome" under the direction of Camille, Comte De Tournon, began a program of public works intended to restore the "second city of the Empire" to something of its ancient grandeur. Among Rome's antiquities none had been more famous than the Forum of Trajan, and few had disappeared so completely (Figs. 7, 10, 11), considerations which motivated the French to make the site one of their first projects.

The Excavations of 1811-1814

Deciding on systematic excavation of the monument, the French first removed Michelangelo's retaining walls around the Column of Trajan and then, quickly condemning both the Monastery of the Holy Spirit and the Convent of St. Eufemia, as "without interest for the arts," they demolished the former. Beginning on November 26, 1811, this work was complete by October 1812. Since the destruction rendered the two adjacent houses unstable, these buildings were also purchased from their owners and taken down in January of 1813. Despite De Tournon's later assertions to the contrary, in the early months of 1813, the French also seriously considered removing the Church of the Most Holy Name of Mary; and the architect Giuseppe Valadier proposed to shape the excavated area into the form of a Greek stadium. The Column of Trajan would have dignified the semicircular north end; a new fountain, the south end. Ultimately, however, Pietro Bianchi's less ambitious project prevailed. The site was cleared in the form of an abbreviated circus in which the Column served as the sole "meta" (goalpost), and the Church was spared. The project continued until 1814; and, on his return to Rome, Pius VII completed the brick retaining wall. With Pius' commemorative inscription it is still largely preserved. The area uncovered was 50.40 meters wide, 113.70 meters long, and extended around the Column as a circular zone with a radius (from the center of the pedestal) of 19.70 meters (Figs. 7, 13-17).

Numerous plans of the work appeared (Figs. 7, 13, 15), the most important, a measured rendering of 1813 executed on the site by Antonio De Romanis, has, until very recently, remained entirely unknown. This important document, which supplements the published plans of De Romanis himself, Lesueur, and Uggeri, delineates not only the part of the Forum which was cleared, but also the exact state of preservation in which its various architectural features emerged.

In the circular zone around the Column of Trajan (Figs. 7, 17), a large inscription commemorating Hadrian's burning of tax records in the Forum came to light (above p. 4), and the bedding mortar of the original peristyle was laid bare. A perforated marble screen had framed the column; and at least one of the fragments of this barrier had been known since the eighteenth century.

To the north, east, and west stood colonnades; to the south lay the north wall of the Basilica Ulpia. The columns had long since fallen, but some of the travertine foundations, which had supported their bases, were still in position (Fig. 44). On both the east and west sides of the colonnade around the Column of Trajan, four of the original foundations survived; on

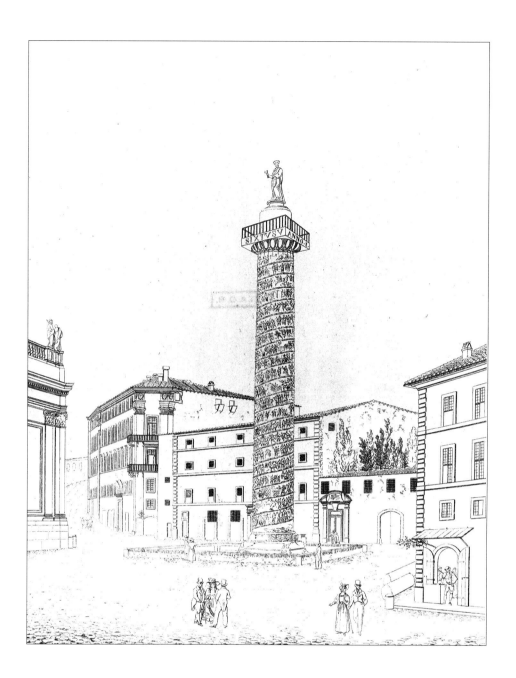

FIGURE 11. *The area around the column of Trajan before 1811–1814. Uggeri.*

the north, where the columns were removed in antiquity (below p. 72), four of the original eight foundations remained. Elsewhere, however, most of these foundations had disappeared together with the peperino blocks that had connected them. Thus, for the most part, only empty trenches marked the positions of the colonnades on the podium of the Basilica Ulpia. Probably without clearing away the earth inside these trenches, the excavators erected some fragments of the gray granite shafts on concrete reproductions of the original bases (Figs. 15, 16).

Inside the east and west branches of the colonnades around the Column of Trajan, many of the marble slabs of the pavement remained in place. East and west of these colonnades, a columnar screen originally marked the portals of the two Libraries. At the entrance to the East Library, the column bases were still partially preserved; and even today, although the south base has been damaged by fire and the north base is fragmentary, both survive.

Their measurements showed that these bases were smaller than the vanished bases of the peristyle, proving that the two orders were of different sizes. The complete entablature from the portico around the Column also came to light: the architrave, the frieze of griffins and candelabra (Figs. 69, 70), and a complete block of the original cornice.

21

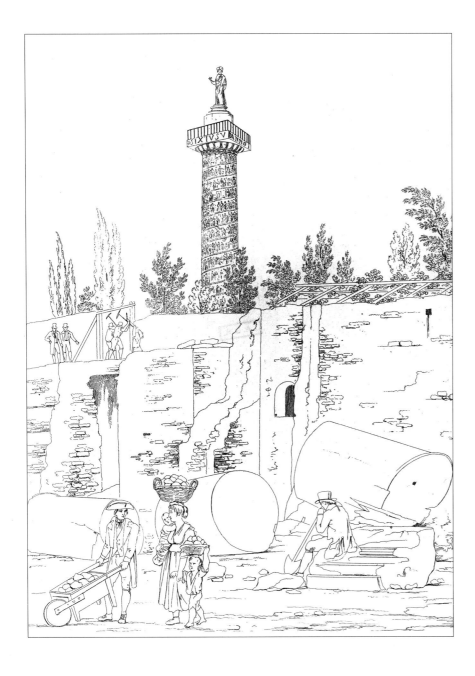

FIGURE 12. *The excavations of 1811-14. Uggeri.*

Consequently, the order was tentatively restored on paper (Fig. 67). Unfortunately, the shafts were later removed for use in the reconstruction of the Basilica of St. Paul's Outside-the-Walls; and much of the frieze was shipped to Paris.

Only the west end of the south wall of the East Library was cleared (Fig. 71). Part of one niche and the three-stepped podium in front of it appeared; and the workers found some of the architectural elements. The excavators likewise revealed the central section of the Basilica Ulpia (Figs. 15-17). The remains were in poor condition, but the general plan was clear, and the site yielded a large number of architectural fragments. The building stood on an intact concrete podium. On the south side were the foundations of three projecting porches (Figs. 15, 133-34). Completely exposing the central one, the workers excavated only half of each of the lateral porches. These porches—and the whole south facade—had been reached by a stair of six treads executed in blocks of giallo antico (Figs. 149A, 149B, 150, 152). A few treads survived (Figs. 133, 138), and the concrete foundations clearly indicated the positions of the others.

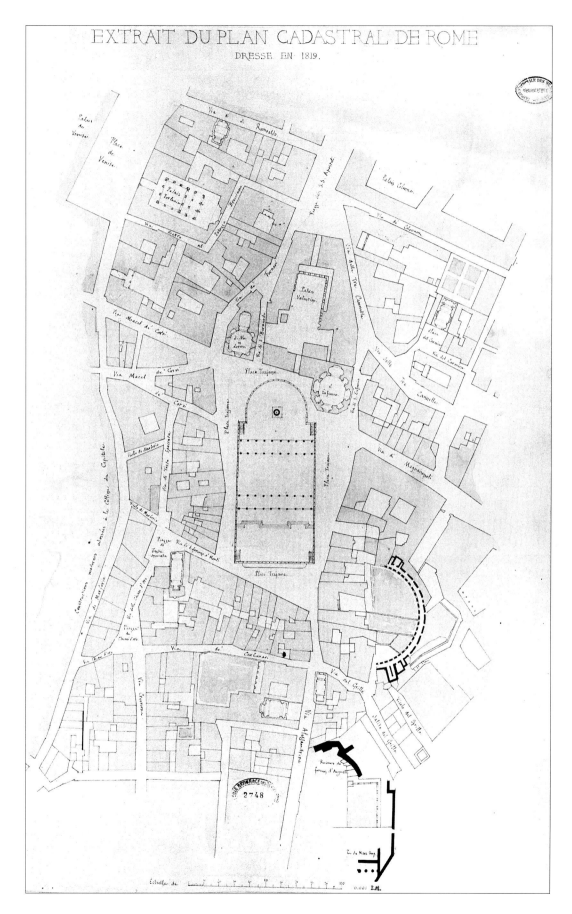

FIGURE 13. *The
Forum of Trajan: the
environs in 1819.
Guadet. B.É.B.A.*

North of the stair lay an empty foundation trench (Fig. 133) beyond which, on the podium of the Basilica, was the pavement of the two south aisles (Fig. 134). Most of the pavement had vanished, although a few fragments survived to show that the short sides of the rectangular slabs faced east and west. Only a travertine foundation marked the position of the colonnade that had divided the south inner aisle from the nave. Of the colonnade between the nave and the north inner aisle, five travertine foundations survived and on one there was still a fragmentary white marble base. Six travertine foundations and a complete, though battered, white marble base marked the colonnade between the north inner and outer aisles.

The excavators also uncovered an extensive tract of the foundation of the north wall of the building. These foundations extended a distance of 23.70 meters from the east side of a door which led from the Basilica into the west branch of the Colonnade around the Column of Trajan. Adjacent to the door, one travertine block from the

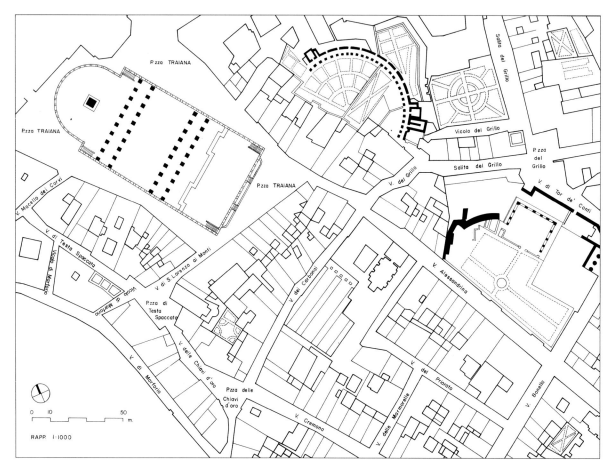

FIGURE 14. *The Forum of Trajan after the excavations of 1811-14. G.R.L.*

first course of the wall was—and still is—in position. Inside the Basilica, at intervals along the south side of this foundation, projections supported pilasters. Three were complete and half of a fourth survived. On one of these projections the excavators found a white marble pilaster base and a section of the adjacent base molding.

Large sections of the pavement of the north inner and outer aisles were complete, mainly on the east side of the excavated area; and there were abundant remains of the pavement in the nave. The most significant architectural fragments of the large number found during the excavations included the previously mentioned pilaster base, the gray granite shafts of the columns of the lower interior order of the Basilica (Figs. 15-16, 133-34), and matching shafts of pavonazzetto and giallo antico. All these shafts exhibited variations of the same dimensions: a lower diameter of approximately 1.10 meters (with a Roman foot of 0.2938 m = 3 ¾ Roman feet: the diameters varied) and,

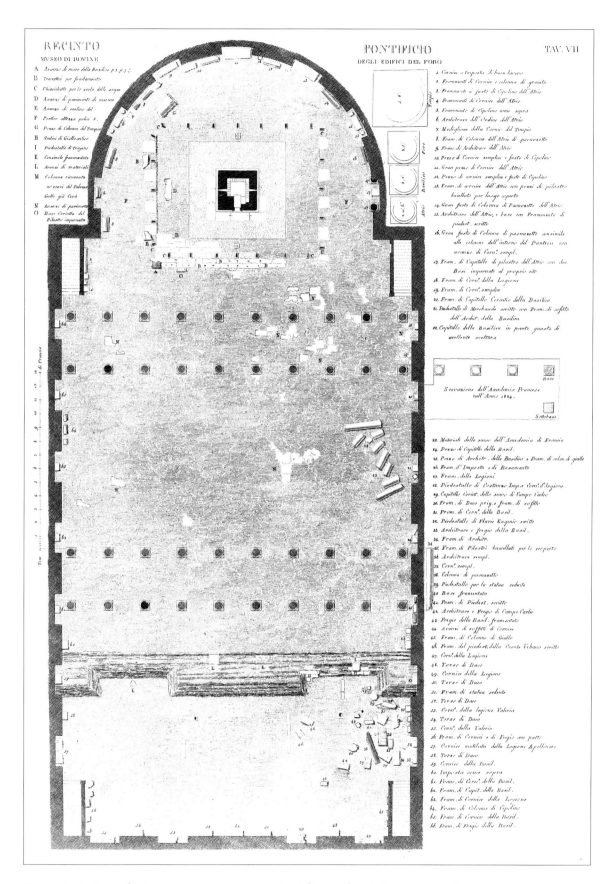

FIGURE 15. *The Forum of Trajan: zone excavated in 1811–1814 with fragments found by Lesueur in 1823. Uggeri.*

where complete, a length of 8.83 meters. The excavators set up fragments of the gray granite shafts on the original positions of the interior columns of the Basilica (Figs. 13-16). In addition, the workers found some of the capitals of the gray granite columns, several pieces of the architrave/frieze from the lower order of the facade, and an almost completely preserved section of the corresponding cornice (Figs. 18, 140). They likewise unearthed parts of the facade of the attic: segments of the base moldings between pedestals for over life-size atlantes (Fig. 143), pavonazzetto fragments of the bodies of the atlantes, and a number of broken sections of the cornice. On the returns were fasciae with inscriptions; on the cantilevered projections, friezes with rosettes (Fig. 152). The excavators also found part of the frame of the frieze of heaped-up weapons that had decorated the attic. On the front steps, three large pedestals with identical inscriptions appeared, one still in its original position.

In the forum square (*Area Fori*), the workers laid bare only a small fragment of the original white marble pavement embedded under the lowest tread at the northeast corner of the central porch on the south facade of the Basilica Ulpia (Fig. 138), but the well preserved bedding mortar showed clearly the pattern of the other vanished rectangular slabs. While the excavators did not penetrate beyond the forum square to either the East or West Colonnades, they did discover one of the white marble Dacian atlantes which had stood on the facade of the attic of one of these buildings. Finally, among the finds were a number of miscellaneous pieces: part of a shaft from the porch of the Temple of Trajan, a fragment of a large cornice with modillions, three cornices (perhaps from imposts), and parts of a coffered ceiling in white marble.

Later Excavations

These large-scale excavations naturally caused a sensation among members of the cultivated public; and, in the next decades, the site witnessed a number of smaller related investigations.

Lesueur's Excavations. By 1823, the south side of the hemicycle of the Markets of Trajan had been cleared, and in the same year, Jean-Baptiste-Cicéron Lesueur, a *pensionnaire* (fellow) in architecture at the French Academy in Rome at the Villa Medici, seeking additional evidence for his restoration study of the Basilica Ulpia (infra pp. 88-91), opened three test trenches. The first was in the modern piazza, slightly over six meters west of the northwest corner of the Roccagiovine Palace. Here Lesueur laid bare the positions of four of the columns of the Basilica. Two belonged to the colonnade between the nave and the inner aisle; two, to the colonnade at the east end of the building between the nave and the inner aisle. The latter two, on which the marble bases still survived, determined the length of the nave. Lesueur's second trench, which completely cleared the east lateral porch of the Basilica, proved that the side porches on the south facade, unlike the central one, had only two columns apiece. Beginning approximately in front of the southeast corner of the Roccagiovine Palace at a distance of 1.75 meters from its facade, the third trench ran for nearly thirty meters, revealing the podium of the East Colonnade at a depth of 3.80 meters below the level of the street.

This concrete podium rose considerably above the pavement of the forum square, and the marble pavement of the interior consisted of pavonazzetto squares framed by giallo antico borders. The same trench also proved that the exterior stairs of the Basilica Ulpia and the East Colonnade were continuous, although the podium of the Colonnade was half the height of that of the Basilica. The foundations for the facade of the Colonnade had apparently consisted of massive stone blocks, most of which had apparently been robbed, leaving a trench 1.69 meters wide.

Excavations of 1828. Four years later, in October of 1828, work on a drain under the street near the Church of St. Mary in Campo Carleo revealed "the noble continuation of the Forum of Trajan, various pieces of a grandiose, large-scale cornice finely cut with arabesques, and a statue in pavonazzetto, without its head, since it had been inset," and the base for a statue of Septimius Severus in military dress. These excavations produced a rich harvest of fragments from the East Colonnade: the architrave/frieze, the cornice, parts of the cabled, fluted pavonazzetto shafts with their bases and capitals of white marble, and one of the ressauts which had been carried by the Dacian atlantes on the facade of the attic (Fig. 61). There were also a number of less identifiable pieces. The most important were the lower section of a white marble shaft ornamented with floral festoons and a monumental modillion (Fig. 29).

1829-31. In April of 1829, additional discoveries were made. In a street near St. Mary in Campo Carleo, workmen uncovered the pedestal of a statue dedicated to Constantine by Q. Attius Granius Caelestinus. In 1830, during work on the foundations of the "former house of the Marquis Ceva, now owned by del Gallo [the present Roccagiovine Palace]" at a depth of about 3 meters under the street, 0.89 meters from the facade of the building, laborers recovered one of the gray granite shafts of the Basilica Ulpia and some fragments of bases and capitals belonging to the same order (Figs. 133, 134, 151, 153, 154). In the next year, according to Angelo Uggeri, workmen found part of the wall of the east apse.

Morey's Excavations, 1835. Then in 1835, Mathieu Prosper Morey, another *pensionnaire* at the French Academy engaged in a second restoration study of the Basilica Ulpia and the Forum of Trajan (infra pp. 95-102), made a test trench under a small house across the street from the south facade of the Roccagiovine Palace. Like Lesueur, Morey was interested in the structure of the East Colonnade, and his trench, about twenty meters long, was south of and parallel to the site of Lesueur's. It brought to light a tract of the forum square, the steps of the East Colonnade, the base of one of its columns, a segment of a fluted, cabled pavonazzetto shaft, and part of the marble pavement of the Colonnade.

Canina's Excavations, 1849. Some thirteen years later, in September of 1849, on the opposite side of the Forum at the west porch of the Basilica, workers enlarging a drain found fragments of worked marble which included inscriptions honoring Nichomachus Flavius and Flavius Sallustius. Given charge of the excavations, Luigi Canina, a prominent contemporary architect and student of ancient architecture (infra pp. 108-119), uncovered nearby a large number of fragments from the Basilica Ulpia: parts of the cabled, fluted giallo antico shafts from the columns of the porch, pieces of the corresponding bases and capitals of white marble, and fragments of cornices from ressauts. The returns bore inscriptions in honor of legions which had served in Dacia. Even more important than the recovery of the actual fragments, however, was their close association with the site of the porch. Previously, as Canina noted in his published account of the excavations, the find-spots for similar fragments had never been recorded. Thus architectural fragments had been scattered about the interior of the excavated zone in a haphazard manner, and it had earlier proved impossible to attribute these elements to one or another of the buildings of the Forum. Canina's investigations thus proved that the lateral porches had only two columns apiece, a fact apparently forgotten after Lesueur's excavation of the east porch had been reburied and Pius VII's retaining wall had been rebuilt across its site. Canina's work also suggested that the pavonazzetto statues of Dacian captives which had appeared in such abundance during the previous excavations had stood on the attics of the porches. Consequently, from these excavations, Canina was able to design a restored view of the west porch (Fig. 18).

Excavation of the East Lateral Arch. The Church of St. Mary in Campo Carleo was destroyed In 1862, and the lot was sold to the Architect Tommaso Bonelli for the construction of a house. During this project the workmen came upon the foundations of a triumphal arch. They also recovered thirty-three architectural fragments which included two from the cornice of a composite order with "dentils, ovolos, and engravings of superb workmanship," a Dacian atlas "of the best style," part of a relief, capitals and bases from columns, and "some brackets with the most exquisitely worked ornaments." Supposedly acquired by the Minister of Public Works, these now vanished pieces were alleged to have been displayed in their own special area within the zone enclosed by Pius VII's wall.

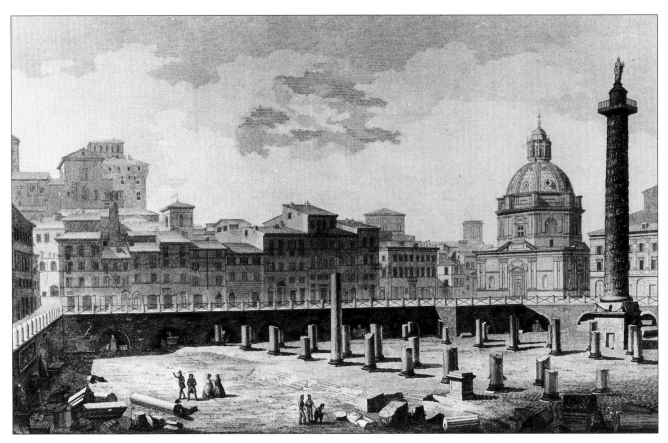

FIGURE 16. *The Forum of Trajan in the mid-nineteenth century, looking northwest. C.E.*

1866. Four years later, in connection with repairs to the surrounding buildings, several new excavations took place. Two explored the zone under the courtyard of Imperiale-Valentini Palace during the reconstruction of the stables. The first, in October of 1866, revealed two fluted pavonazzetto shafts, one 2.904 meters long (*cf.* above p. 15); the other, 1.56 meters, both with a lower diameter of 1.0 meter. The workers also exposed "four large blocks of large-scale, finely worked cornice." The second trench, dug on October 20, 1866 exposed additional parts of the Temple: a gray granite shaft, a corresponding white marble capital from the pronaos, architrave/frieze blocks, and a cornice from ressauts in the interior. Acquired by the Minister of Fine Arts, these pieces went on display in the excavated zone next to the Column of Trajan. A little over a month later, on November 29, 1866, trenches dug to reenforce the foundations of the del Gallo (Roccagiovine) Palace exposed additional remains of the Basilica Ulpia: some of the paving slabs of giallo antico, a Corinthian capital, and two bases, presumably from columns.

Guadet's Excavations. Then, in 1867, Julien Guadet, the third and last fellow from the French Academy to undertake a restoration study of the Basilica Ulpia (infra pp. 120-31), with the permission of "M. le Marquis del Gallo," visited the site of these recently concluded excavations. He determined that a base left exposed in the cellar of the del Gallo (Roccagiovine) Palace was that of the column at the southeast corner of the south inner aisle of the Basilica. Thus he had additional proof that the two side aisles, continuing around the east side of the building, separated the nave from the east apse.

In order to establish the position of the wall of the apse, he obtained a permit, dated January 23, 1868, to excavate under a small house "at the beginning of via Magnanapoli near the del Gallo Palace to determine the plan of the Forum of Trajan." There he found two contiguous rooms of brick-faced concrete, probably a buried wing of the Markets of Trajan (Fig. 19). In these rooms the barrel vaults, mosaic floors, and some traces of stucco still survived;

FIGURE 17. *The Column of Trajan in the mid-nineteenth century, looking west. C.E.*

and the curve of the facades responded to that of the apse of the Basilica Ulpia. He also uncovered part of the south wall of the East Library and a section of the adjacent wall of the Basilica, "a continuation of the enclosure of the nave." In order to determine whether or not the East Colonnade had a single or double row of columns, he exposed a section of its pavement in "the courtyard of a house called the House of the Widow belonging to Prince Ruspoli and situated in Trajan Square at the beginning of via di Campo Carleo" (Figs. 13, 14)."

Excavations in the Imperiale-Valentini Palace. The last excavations of the nineteenth century took place in and around the Imperiale-Valentini Palace (the Prefecture). In 1886, during work on the foundations for a new wing of the Palace, the workmen discovered another gray granite shaft from the Temple of Trajan. Measuring the shaft, which had a diameter of 1.80 meters, the laborers noted that it lay 5.10 meters below the level of the modern street and left it in its original position. Two years later, there was another chance find near the Imperiale-Valentini Palace. In the trench for a sewer in front of the Franchetti Palace, on the via delle Tre Cannelle, 4 meters southeast of its intersection with the via di Sant'Eufemia, workmen unearthed two walls 10 meters high, which may have been oriented on the axis of the Forum. The two were 5 meters apart, and a threshold of white marble was built into the west wall. Found in a previously unexcavated area, these walls may have belonged to the Temenos of the Temple of Trajan.

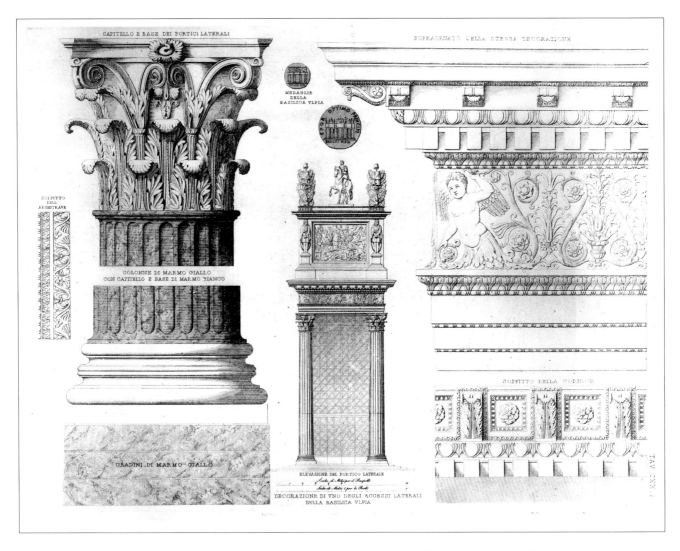

FIGURE 18. *The Basilica Ulpia, west porch.* Left: *three of the steps and a column;* center: *elevation.* right: *entablature and its soffit. C.E.*

II

PLAN GENERAL

FIGURE 19. *The Forum of Trajan, ca. 1868 showing the excavated zones Guadet. B.É.B.A.*

At the beginning of the last century, the archaeological exploration of the Forum continued. In 1907, Giaccomo Boni sank test trenches in the West Library, in the peristyle around the Column of Trajan, in the substructures of the Basilica, and in the Markets of Trajan.

Ricci's Excavations, 1928-1934

A few years later, in 1911, after a survey of the ancient remains visible in the cellars of the monastery of the Annunziata dei Pantani and various houses west of the via Alessandrina (Figs. 13-14), Corrado Ricci proposed a far more audacious project: nothing less than the isolation and exploration of all the imperial fora. Ricci's idea suited the political objectives of the new Fascist Regime, and on November 5, 1924, the government enshrined Ricci's proposal in a new law which financed the excavation of the imperial fora.

The Markets of Trajan. In 1928, the work began with the clearance of a vast complex of ancient halls and shops built into the southwest slope of the Quirinal Hill. Under the direction of Ricci himself, workers tore down the overlying buildings and exposed a multi-storied Trajanic fabric that Ricci christened the "Markets of Trajan" (Fig. 2-4, 24). Ricci's workers repaired, consolidated, and partially reroofed the remains; and then moved into the Forum of Trajan.

The East Colonnade and Hemicycle. Ricci's crews subsequently cleared the East Hemicycle (Figs. 20-23, 53), some of which had already been exposed in 1925-1926 (Fig. 21) and the East Colonnade (Fig. 52). Impressions on the bedding mortar recorded the pattern of the marble pavement of these structures (Figs. 22, 23); the preserved marble slabs showed the kinds of marbles used. In order to prevent further deterioration of these pavements, Ricci's men repaired the surviving sections.

In both the Hemicycle and the Colonnade, the walls had largely disappeared (Fig. 24), but in the Colonnade, a tract of the east exterior ashlar wall, of peperino blocks externally rusticated remained in position (Fig. 26), although the south wall had been reduced to a few blocks, and that to the north remained buried under the Roccagiovine Palace. The exterior wall of the Hemicycle had fallen, but many of the blocks lay scattered about for the excavators to use in a partial reconstruction (Figs. 22-24). On the west facade of the Colonnade, only parts of the travertine foundations that had supported the cabled, fluted pavonazzetto columns had survived (Figs. 26, 28, 54, 61). In order to show the manner in which the building had been constructed, Ricci's men erected a surviving column on one of these blocks (Figs. 28, 52). They also set up another fragmentary column, reproducing the missing parts in modern brick. A few slabs of the giallo antico stairs of the Colonnade remained in place (Figs. 27, 28), but the bedding concrete preserved the pattern of many of the vanished treads; and on this foundation, Ricci reproduced the original stair in a terazzo composed of small formless fragments of giallo antico and other marbles from the site (Figs. 27-28, 52). With the clearance of a narrow section of the south perimetric wall of the Forum, the work finally halted. The peperino foundations of this completely destroyed wall exhibited a shallow curve (Fig. 149A, 149B).

FIGURE 20. *The East Hemicycle in 1911. D.A.I.R.*

FIGURE 21. *The East Hemicycle, looking west, ca. 1925-1926. A.P.B.*

33

FIGURE 22. *The East Hemicycle, excavation plan, ca. 1934. X Rip.*

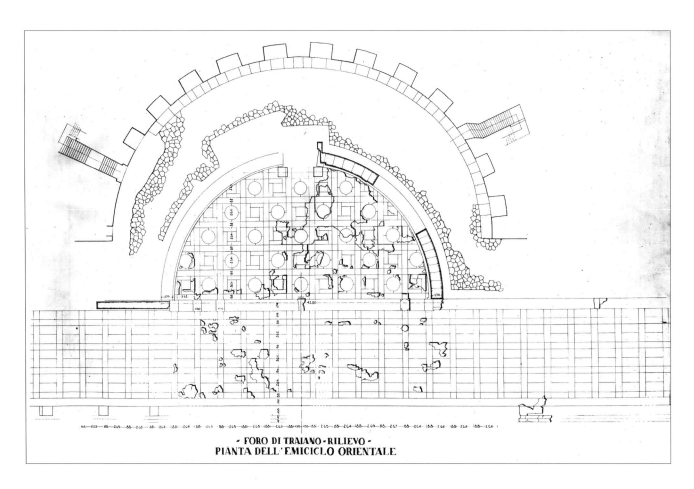

- FORO DI TRAIANO · RILIEVO ·
PIANTA DELL'EMICICLO ORIENTALE

FIGURE 23. *The East Colonnade and Hemicycle: provisional plan, ca. 1928-34. X. Rip.*

As might have been expected, these excavations produced a rich harvest of architectural fragments (Figs. 29, 30). From the columns on the facade of the East Colonnade came bases, shafts, and capitals, several pieces of the corresponding cornice, two of the pedestals that had supported the atlantes on the attic facade, the handsome frames from some of the *imagines clipeatae* (shields framing portraits of historical personages) that had occupied the spaces above the intercolumniations in the attic (Fig. 55), a headless bust in a cuirass from one of the clipei (Fig. 57), several of the ressaut cornices once carried on the heads of the Dacian atlantes (Figs. 30, 59, 61), a complete block from the upper cornice from the attic (Fig. 60), and three of the pedestals that had stood on that cornice (Figs. 54, 61). In the interior, the excavators found fragments of the white marble pilaster bases, the corresponding base molding, and fragments of the cabled, fluted pavonazzetto shafts from the pilasters. Supplemented in brick, the bases were reerected along the interior of the north half of the east wall of the building.

The excavations also produced a large number of important fragments from the East Hemicycle. Among the most significant were: modillions from the travertine cornice from the facade toward the Markets (Fig. 66), four of the travertine foundations, still in situ, for the line of piers between the interior of the Colonnade and that of the Hemicycle (Figs. 22, 23, 53, 62); a rectangular white marble base from one of the piers, also in situ; white marble bases and numerous fragments of the cabled, fluted giallo antico shafts of the pilasters that had divided the upper story of the interior into bays (Figs. 66, 150); a partially intact corresponding Corinthian capital; and various decorative cornices. A fragment of one of the two gray granite shafts from the lower order of the central recess matched previously known fragments; and, restoring the bases in brick, Ricci's workers raised on original positions one of these columns and part of its mate (Fig. 53). Associated statues included the heads of three colossi, a Livia, an Agrippina the Younger (Fig. 58), and a Nerva (Fig. 56), and two heroic male torsos, one in an elaborately decorated cuirass (Fig. 64), the other in a toga (Fig. 65). Fragments of Dacians in both pavonazzetto and white marble also appeared. There were likewise two monumental modillions of uncertain attribution (Fig. 29) and numerous fragments of a large-scale frieze of weapons in high relief similar to that on the base of the Column of Trajan (Fig. 144).

The West Colonnade and the Basilica Ulpia. These exciting discoveries stirred intense public interest in the Forum of Trajan; and the Fascist Government decided to extend the scope of the excavations, entrusting the work after 1927 to "Department 10, Antiquities and Beaux-Arts" of the city of Rome. In October, 1931, with the demolition of the three blocks of houses between Foro Italico and the west retaining wall around the zone excavated by the French in 1811-1814, work actually began in the Forum (Fig. 31); and on December 31, 1931, the Government appropriated an additional sixty million lire for the project.

In a preliminary article, Ricci announced that major finds had been revealed in the less disturbed soil under what had formerly been the gardens and courts under the dismantled houses (Figs. 34-37). The first stages of the demolition had uncovered a large cornice of white luna marble, two blocks of the architrave/frieze from the lower interior order of the Basilica Ulpia (Figs. 38, 39, 146), and column shafts of various materials. Those in gray Egyptian granite came from the interior of the Basilica (Figs. 8, 34); the diameter of a fluted pavonazzetto shaft linked it to the East or West Colonnade. The diameter and characteristics of a cipollino shaft, "part engaged in the wall, part grooved to position a screen," connect it to the upper order of the Basilica Ulpia. Of special interest was the appearance of the rear wall of the West Colonnade (Fig. 32). Constructed of rusticated ashlar blocks of peperino, it corresponded precisely to the recently uncovered wall of the East Colonnade (Fig. 26). The exposed tract of the floor in the West Colonnade showed that, on both sides of the Forum, the designs of the pavements had been identical. But, in late antiquity, the floor of the west building, like the adjacent south outer aisle of the Basilica Ulpia, had been crudely patched without regard for the original pattern.

Within a year, the remains of the surviving modern houses were taken up, the earth behind Pius VII's wall had been removed, and the excavation of the Basilica Ulpia had progressed 28.80 meters west of this wall (Figs. 31, 34-37). Clearing the line of the south facade east of the west porch, the excavators laid bare the whole west half of the nave of the Basilica, previously unexplored sections of its north inner and outer aisles, and the inner west aisle. In the north aisles, they found extensive remains of the marble pavement and large fragments of the vaulting, which lay on this floor where it had originally fallen (Fig. 37). In the colonnade between the south inner and outer aisles, three of the travertine foundations that had supported the columns survived, and on one foundation, a battered fragment of a white marble base was preserved. On the south side of the Basilica, about 35 meters west of Pius

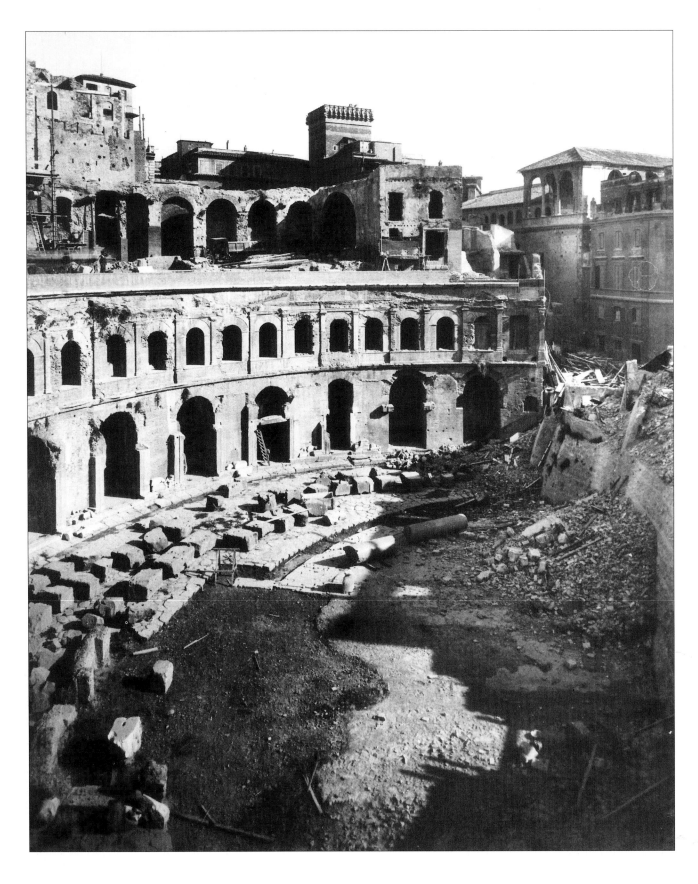

FIGURE 24. *The East Hemicycle, looking south, October, 1929. A.P.B.*

FIGURE 25. *The East Colonnade: post-antique walls on the stairs, looking south, ca. 1928-34 A.P.B.*

FIGURE 26. *The East Colonnade: travertine foundation block for the portico and stair, looking northeast, ca. 1928-1934. A.P.B.*

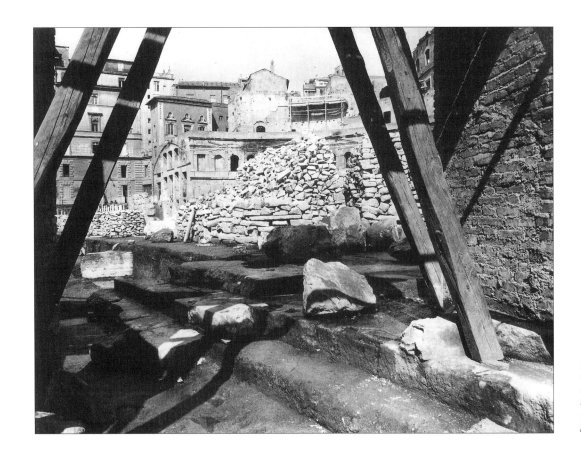

FIGURE 27. *The East Colonnade: the foundations and stair toward the south end, taken ca. 1928-1934 from same position as Fig. 28. A.P.B.*

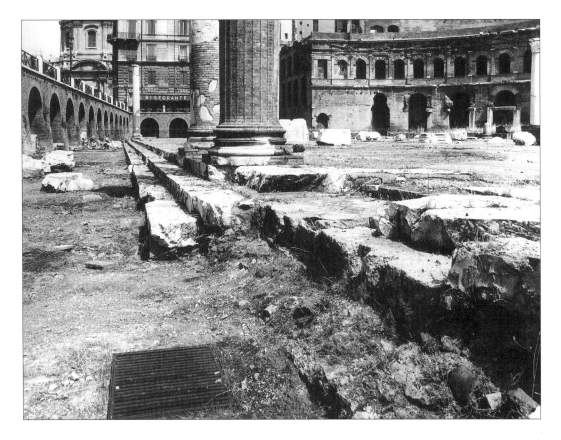

FIGURE 28. *The East Colonnade: detail of the foundations, stair, and restored columns in 1986, taken from the same position as Fig. 27. A.P.B.*

FIGURE 29. *The East Hemicycle, the East, West Colonnades: architectural elements excavated in 1928-1934. X Rip.*

VII's retaining wall, Ricci's men cleared the marble pavement at the southwest corners of the inner and outer aisles and found a design of large-scale inscribed circles. Opening a connected trench (6.70 meters wide, 17.20 long) further to the west along the north side of the west apse, the excavators found that most of the travertine wall of the apse was missing (Fig. 137). Only a tract between the apse and what was probably the north intermediate block on the west side of the building still survived. In the apse, the excavators did, however, uncover remains of the pavement: part of the bedding mortar and fragments of the associated marble slabs.

The West Library. North of the Basilica, removal of the earth in an area which extended 17 meters north and 29 meters west of Pius VII's wall brought to light the whole West Library, identified by the excavators as the "Greek" Library (Figs. 38, 43-45, 149A, 149B). Although the pattern of its marble floor survived in the underlying bedding mortar, only a few of the marble and granite slabs remained in position (Fig. 149A, 149B). Of brick-faced concrete,

FIGURE 30. *The East Colonnade and Hemicycle: architectural elements excavated in 1928-34. X Rip.*

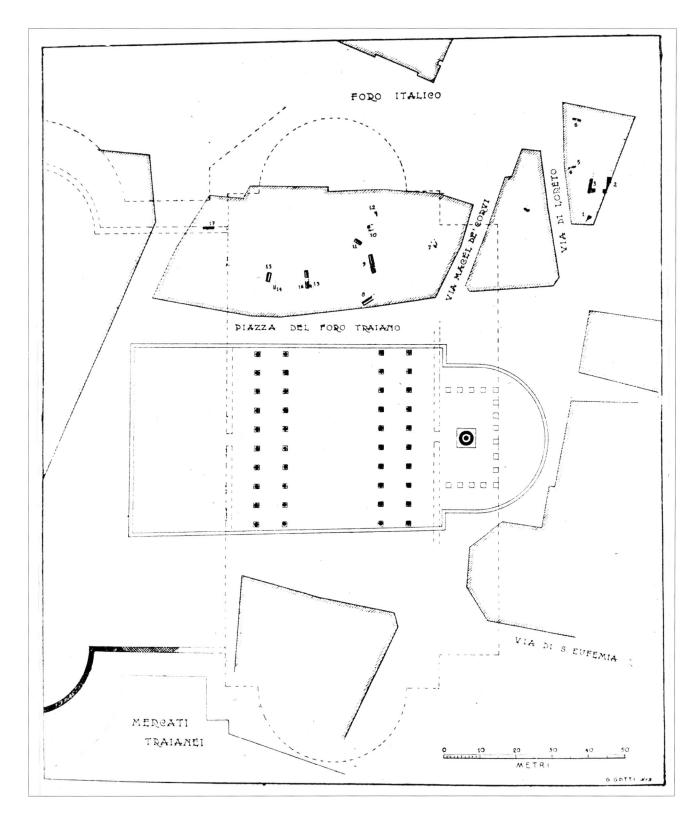

FORO ITALICO

PIAZZA DEL FORO TRAIANO

VIA MACEL DE' CORVI

VIA DI LORETO

VIA DI S. EUFEMIA

MERCATI TRAIANEI

0 10 20 30 40 50
METRI

G. GATTI

FIGURE 31. *The Basilica Ulpia: zone excavated in 1928-34 (No. 7: location of the architrave/frieze fragment of the lower interior order. See Figs. 38, 39, 146). R. E.*

the south and west walls had largely disappeared; and the north wall, preserved to only about a third of its original height, required extensive refacing (Figs. 44, 45).

Further work. West of the Library, the stair which led to the second floor of the Basilica appeared (Fig. 41); and just to the north of it, the excavators opened another trial trench which, widening from 3.20 meters on the East to 4.30 meters on the west, ran for a distance of 15.90 meters beyond the west side of the wall supporting the stair of the Basilica Ulpia (Figs. 41, 46). Although now closed, this last trench uncovered a great number of architectural fragments, some of which were removed to those areas of the Basilica left exposed. The excavators then reerected many of the gray granite shafts from the lower interior order of the Basilica (Fig. 42) and set up three cipollino shafts with their corresponding bases and capitals (Fig. 148)—remnants,they believed of the Basilica's upper internal order—on the east side of the area excavated in 1811-1814 and concluded their work with the construction of heavy piers of reenforced concrete, the supports for a concrete canopy which was to extend over nearly the whole newly excavated zone (Figs. 1, 2, 41, 135-137). Inside the enclosure of Pius VII, they also constricted the circular space around the Column of Trajan and created a hexagonal enclosure that opens on the south into the area cleared in 1811-14. The sole part of the excavations left visible is a zone which begins just north of the colonnade between the nave of the Basilica and the south inner aisle (Figs 2, 133-34). There, Ricci's workers removed Pius VII's wall, duplicating it 5.60 meters west of the old site. They closed the formerly blind arches in the walls of 1815 and the matching ones in those of 1933-1934 with heavy grills and thus converted nearly all of the recently cleared part of the site into a vast, sheltered storeroom for the materials found in the excavations (Figs. 135-37). Finally, Ricci concluded his investigations with an an additional excavation just north of the Column of Trajan. In 1934, this work brought to light the foundations for the north branch of the peristyle around the Column of Trajan (removed when the Temple of Trajan was built), a number of sealed, barrel-vaulted rooms that had supported the pavement on the north, east, and west sides of the open area around the Column of Trajan, and, at a lower level, a row of pre-Trajanic shops.

The number of objects recovered in this vast project was enormous; and, although a formal catalogue does not exist, some of the most important elements not cited above include an engaged base on a high plinth from the lower interior order of the Basilica and a great number of broken shafts in a variety of materials: gray Egyptian granite, two of the red variety, and some of portasanta, of porphyry, and of white marble. The white marble shafts are

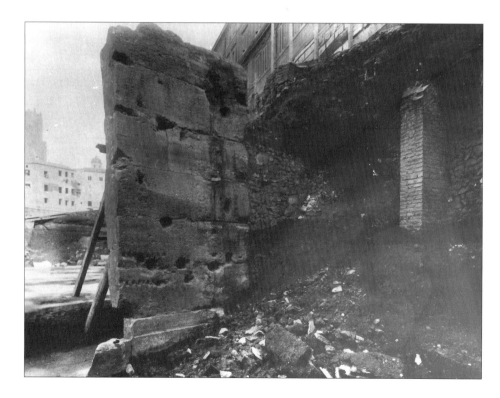

FIGURE 32. *The West Colonnade looking east, ca. 1928-1934. Exterior wall:* left: *smooth finish where the wall abutted the wall of the Basilica Ulpia;* right: *the beginning of the rustication. A.P.B.*

42

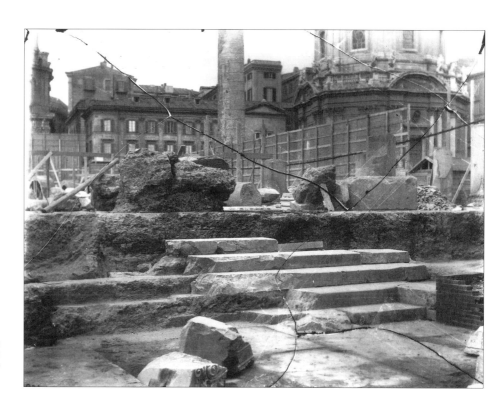

FIGURE 33. *The Basilica Ulpia, the excavations of 1928-1934: the west porch, steps at the northwest corner (lower right). A.P.B.*

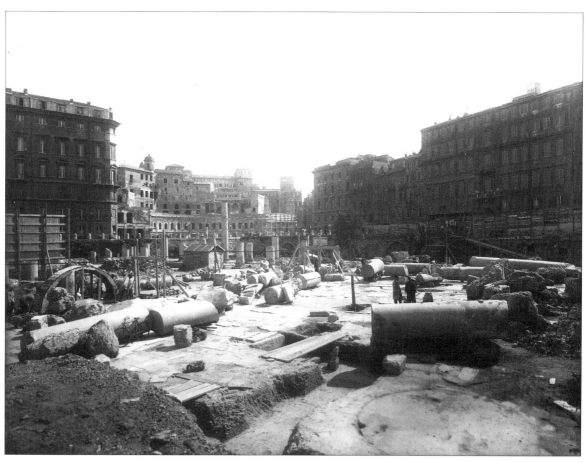

FIGURE 34. *The Basilica Ulpia: northwest side, near the West Library during the excavations of 1928-1934. A.P.B.*

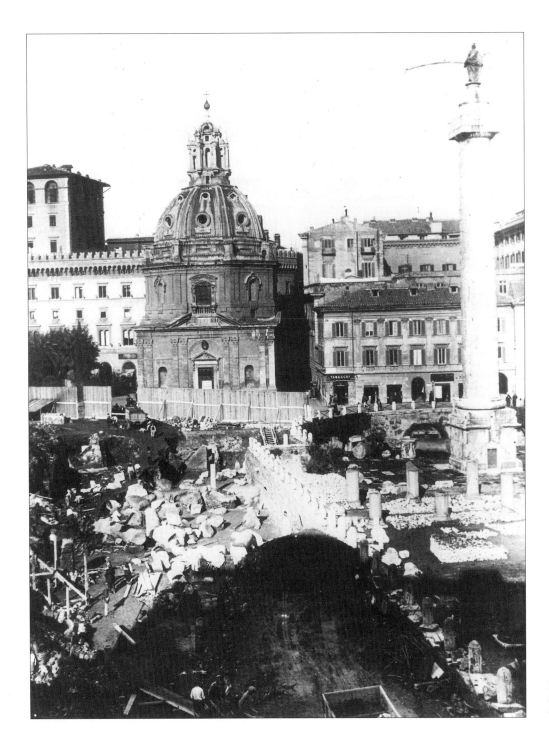

fluted and one belongs to a pilaster. Almost all the giallo antico and pavonazzetto shafts are fluted, but an africano shaft and ten unfluted cipollino shafts ranging in diameter from 0.564 meter to 0.94 meter are plain. The twenty-three surviving Corinthian capitals recovered range in height from 0.428 meter to 1.30 meters. There are also two voussoirs, two (door?) frames (one terminating in a plain cyma reversa) and two blocks from the architrave of the lower exterior order, one with a large-scale inscription in place of fasciae. One of the smaller decorated cornices probably belongs to a niche in the apse. A number of fragments of the cornices of the exterior and interior lower orders also survive.

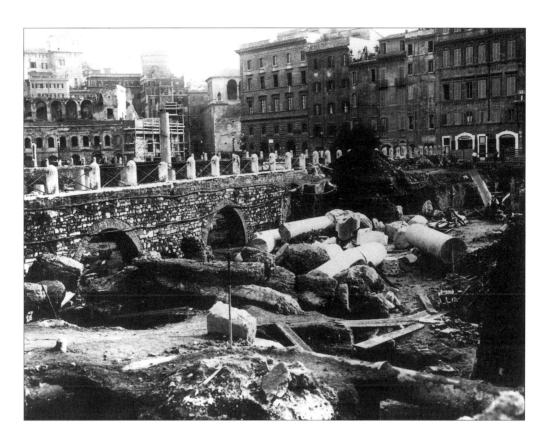

FIGURE 36. *The Basilica Ulpia, the nave: west end looking southeast, ca. 1928-1934. D.A.I.R.*

FIGURE 37. *The Basilica Ulpia, the aisles: collapsed vaulting, looking southwest, ca.1928-1934.* Background: *piers for the concrete canopy of the Esedra Arborea. A.P.B.*

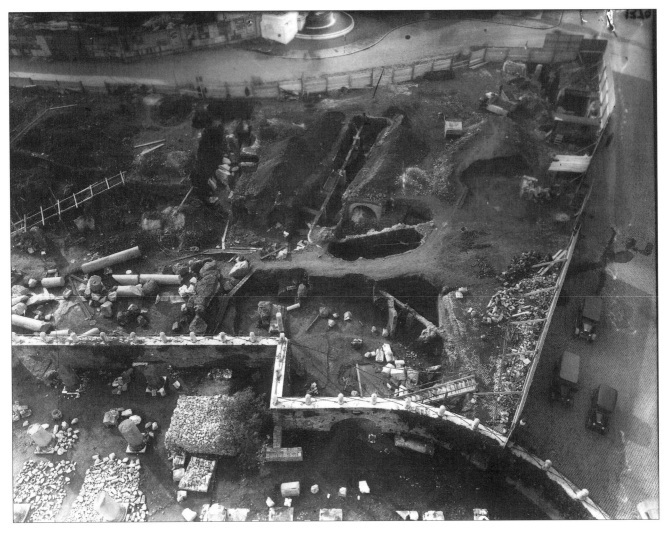

FIGURE 38. *The West Library looking west from the top of the Column of Trajan, c. 1928-1934.* Foreground: *travertine foundations for the columns of the portico around the Column of Trajan.* Upper left background: *trench with the wall and a block of the architrave/frieze of lower interior order of the Basilica Ulpia.* A.P.B.

Although a large block of the cornice from the portico around the Column of Trajan had been known since 1811-1814 (Fig. 67), the work of 1928-1934 uncovered an additional fragment of the frieze (Fig. 70). In the adjacent West Library, parts of virtually all the architectural elements appeared, most of Fig. them heaped up in the northeast and southwest corners of the building (Figs. 43-45, 72). These fragments include two fluted pavonazzetto shafts with sockets for a bronze screen, which came from the entrance, and the bases, shafts, capitals, and entablatures from the upper and lower interior orders. Parts of the frames of the niches for the books also survive as do a number of the decorated cornices from these niches. All these elements (save for the fluted, monolithic pavonazzetto shafts) are in white marble. Ricci's crew left the less valuable pieces, the fragments of shafts, architraves, and cornices from the Basilica, scattered about in the area of the Basilica Ulpia excavated in 1811-1814 (Figs. 133-34); the more valuable fragments were kept in the storerooms under the small park known as the "Esedra Arborea" (Figs. 1, 2). The outbreak of the Second World War effectively ended any further work on the site, but during construction of an air raid shelter under the south wing of the Valentini Palace, the workers digging a secondary entrance to the shelter, a tunnel that opens into the excavated zone behind the Column of Trajan, found two broken gray granite shafts from the facade of the Temple of Trajan. One had a diameter of 1.80 m with a length of 4.0 meters. The other appeared to have similar dimensions. Both were left in their original positions. Various marble fragments, including a large modillion and part of a cornice, also came to light.

46

Recent excavations

In 1982, American group thoroughly cleaned a strip 6 meters wide and 25 meters long next to the east side of the zone uncovered in 1811-1814. These excavators examined the bedding mortar and rubble foundation which supported the marble pavement in the forum square and located a planting pit for a tree from one of the four avenues which stood there, two centered on each of the Basilica's lateral porches (Frontispiece, Fig. 149A, 149B). Situated 21 meters from the edge of the foundations of the east porch, this pit probably represents the location of the first tree of the west row on the east avenue. In November of the same year, a second small excavation, directed by M. Medri, R. Santangeli Valenzani, and R. Volpe brought to light the remains of the early medieval church of St. Urbano, which had been constructed above the remains of the forum square just north of the Central Arch. With the surrounding buildings, this church had been demolished during the construction of the via dei Fori Imperiali. And finally, in 1986-1987, after thoroughly cleaning the site of accumulated weeds and debris, the City of Rome and the Getty Research Institute sponsored the execution of the first detailed plan and sections of the Forum made after the excavations of the 1930s.

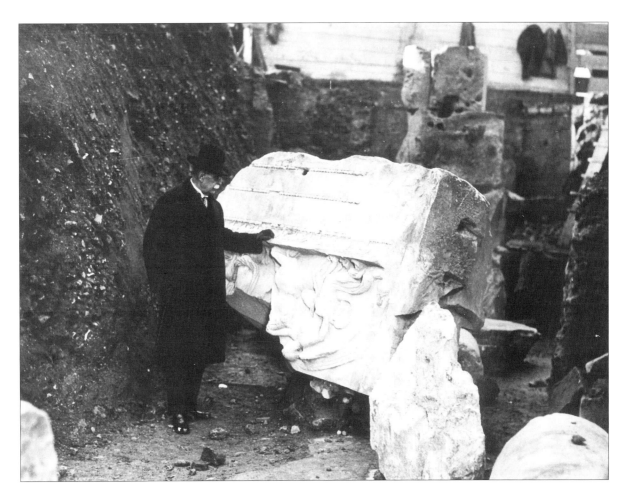

FIGURE 39. *Corrado Ricci, ca. 1930-1931, inspecting a fallen block of the architrave/frieze from the lower interior order of the Basilica Ulpia (Fig. 31, No. 7: see also Figs. 38, 146). D.A.I.R.*

47

FIGURE 40. *The Basilica Ulpia: a wall as excavated ca. 1928-34. A.P.B.*

FIGURE 41. *Behind the west end of the West Library, ca.1928-34, looking northeast: stair to the upper floor of the Basilica Ulpia.* **Background:** *shuttering for the concrete slabs that will support the Esedra Arborea above the West Library. A.P.B.*

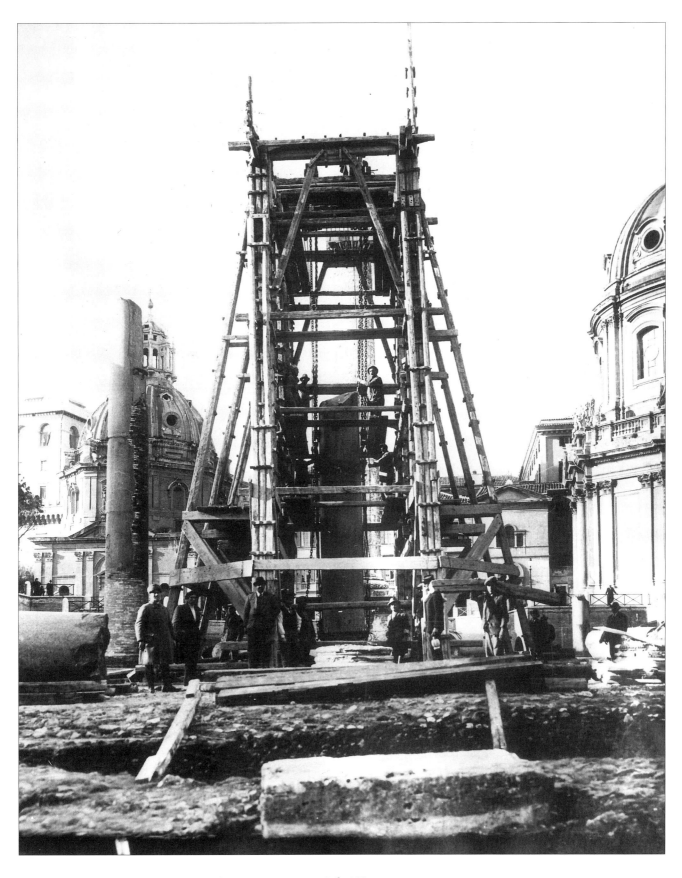

FIGURE 42. *The Basilica Ulpia, the nave, south side, ca. 1932: reerecting a shaft. A.P.B.*

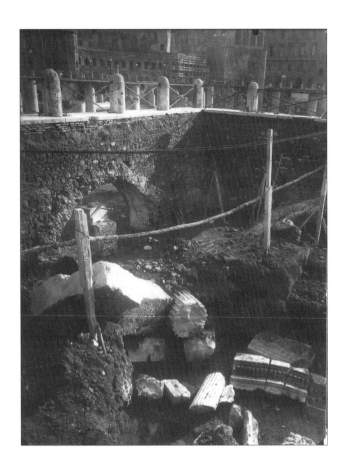

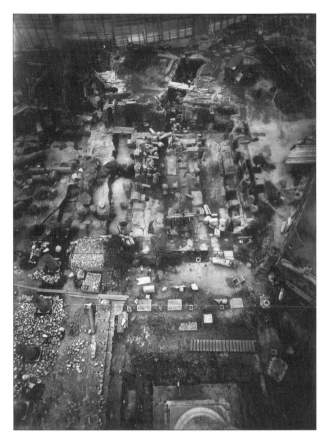

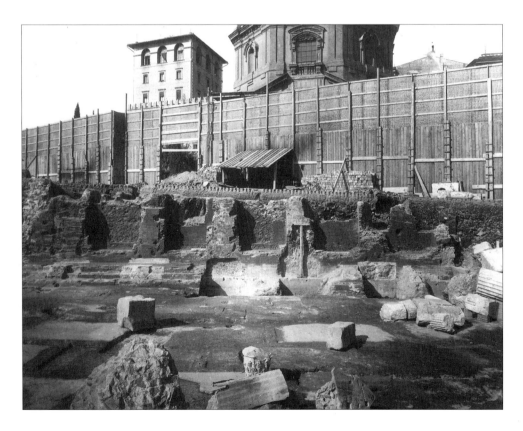

FIGURE 43 (upper left). *The West Library: excavation, ca. 1928-1934.* Right foreground: *the elements of the entablature of the upper interior order;* center: *a shaft from the columnar screen at the entrance. A.P.B.*

FIGURE 44 (upper right). *The West Library, ca. 1932: view west from the top of the Column of Trajan. A.P.B.*

FIGURE 45 (below). *The West Library: the interior, ca. 1932, looking north.* Lower center right foreground: *Corinthian capital from the lower interior order;* lower left: *top of a groin vault fragment. A.P.B.*

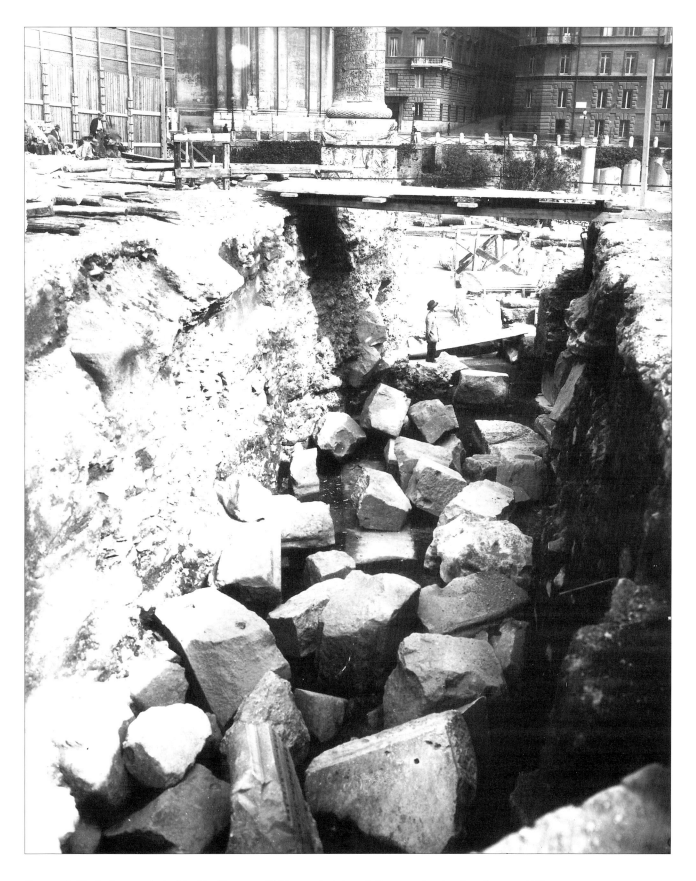

FIGURE 46. *The Via Loreto, in back of the West Library, ca. 1932: now reburied trench;* foreground: *a door frame fragment. A.P.B.*

Chapter Three

The Monuments South
of the Basilica Ulpia

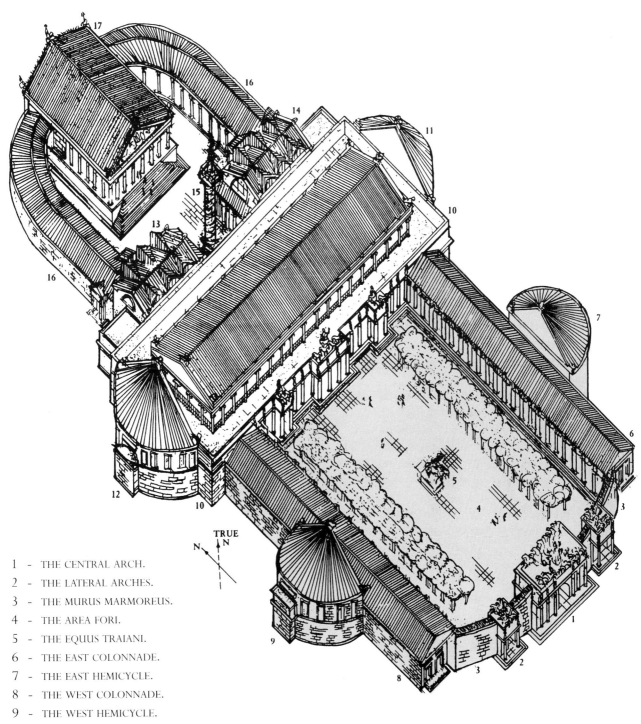

1 — THE CENTRAL ARCH.

2 — THE LATERAL ARCHES.

3 — THE MURUS MARMOREUS.

4 — THE AREA FORI.

5 — THE EQUUS TRAIANI.

6 — THE EAST COLONNADE.

7 — THE EAST HEMICYCLE.

8 — THE WEST COLONNADE.

9 — THE WEST HEMICYCLE.

10 — THE BASILICA ULPIA.

11 — THE BASILICA ULPIA, EAST APSE, THE "ATRIUM LIBERTATIS".

12 — THE BASILICA ULPIA, WEST APSE.

13 — THE WEST "GREEK" LIBRARY.

14 — THE EAST "LATIN" LIBRARY.

15 — THE COLUMN OF TRAJAN.

16 — THE COLONNADES OF THE TEMENOS OF THE TEMPLE OF TRAJAN.

17 — THE TEMPLE OF TRAJAN?

TRUE
N

THE FORUM OF TRAJAN

Color indicates the areas discussed in this chapter

THE BASILICA ULPIA divided the Forum of Trajan into two parts. To the south lay an open piazza, the Area Fori. A gently curved perimetric wall, broken by three monumental arches, delimited its southern end; colonnades, with large hemicycles behind, bounded the east and west sides (Frontispiece, Figs. 2, 3, 149A, 149b, 150). At the center, stood the "Equus Traiani," the famous equestrian statue of Trajan.

Visitors to the Forum would normally have entered through the three arches that faced the Forum of Augustus to the south. Although the excavators of 1928-1934 demolished the overlying buildings, they did not excavate the site of the Central Arch, and, like the nineteenth century authors of the several fanciful restorations of the monument, we must still rely on numismatic sources for some idea of its general appearance (Figs. 102, 106a, 110, 111, 114).

The Central Arch appears on the reverses of Trajanic gold and bronze coins (aurei and sestertii). Bearing the legend "FORVM TRAIAN[I]" (to which the sestertii add below "SC", "by decree of the Senate"), they exhibit six distinct variants. Variant I includes the largest number of specimens, all aurei (Figs. 47, 48) but, with minor variations, aurei and sestertii of the six other variants closely resemble these coins.

Until the site is excavated, all interpretation of this evidence is necessarily theoretical, but a comparison of the depictions of the Central Arch on the coins with plans and architectural fragments from the other monuments of the Forum suggest some interesting possibilities. The Central Arch apparently stood on a stylobate or low platform reached by three giallo antico steps. Since the Arch faced the central porch of the Basilica Ulpia and was its exact equivalent on the south side of the Forum, it too must have projected forward into the forum square. Moreover, while nearly all the scholars of the nineteenth century assume that the passage under the fornix (arched opening) divided the stylobate into two parts; the numismatic evidence indicates that the stylobate continued across the fornix, closing it to wheeled traffic and providing the forum square with a continuous raised frame. The north and south sides of the Central Arch were very probably identical, although since the south facade was the only monument of the Forum visible from outside the forum square, the coins must represent that elevation; and, in the shorthand of the diemaker, the elevation on the coins will thus have been a reference to the whole Forum—as the legend "FORVM TRAIAN[I]" on the reverses of all the coins mentioned above seems to indicate.

Further, we may at least speculate on the general dimensions of the monument. Aligned with the central porch of the Basilica Ulpia, the Central Arch and the two smaller lateral arches, mirrored the facade of the Basilica across the forum square (Fig. 149A, 149B). Thus, it is reasonable to suppose that, allowing for the fornix, the Central Arch, having the width of the opposite central porch of the Basilia (plus two additional bays and the adjacent stair) will have been about 31 m long (104 1/2 Roman feet); the central block, without the stair, about 28 1/2 m (97 Roman feet), with a height of 19.905 meters (67 3/4 Roman feet), and it probably had a width of 14.25 meters (48 1/2 Roman feet) (Figs. 149A, 149B, 150). That is, it was about twice as long as wide; and the measurements of the components of the

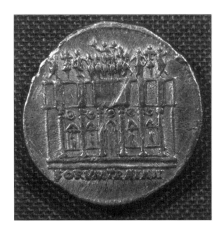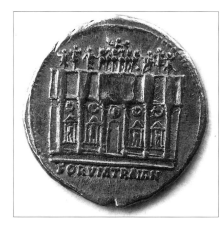

FIGURE 47. *The Central Arch: aureus, reverse.*
J. P. /M.N.R.
FIGURE 48. *Central Arch: aureus, reverse.*
A.N.S.

facade would have duplicated those of the corresponding elements on the porch of the Basilica Ulpia, although to leave space for the fornix, the columns on the Central Arch would have been more closely spaced than those on the Basilica.

Within the framework of these general dimensions, we may now consider the architectural details. All the coins show the columns of the main order with extremely thick bases, about two-thirds the height of the capitals. These features suggest that, like the columns of the lower interior order of the West Library (Figs. 75-77), the order of the Central Arch stood on pedestals. In the Library, similar pedestals are as high as two of the treads of the stair on which they stand; and the Central Arch may have been detailed in the same way. Since the Central Arch, bisecting the Murus Marmoreus (the Marble Wall), occupies a position analogous to that of the central porch of the Basilica, the shafts of its columns, were very likely of giallo antico, like those of the opposite porch, and will also have been cabled and fluted with white marble bases and capitals.

The capitals, seem to have differed from those of the lower orders of the Basilica, however. The cushion and beads clearly visible on several of the capitals on different coins probably indicate a Composite rather than a Corinthian order (Fig. 48), a view confirmed by a late nineteenth century discovery of fragments of a Composite order on the site of the East Lateral Arch. Since the same excavation also uncovered finely detailed modillions, it is likely that these modillions came from the cornice of the entablature, which, therefore, resembled the cornice of the lower exterior order of the Basilica Ulpia.

In each of the center bays, a base molding linked the pilasters behind the freestanding columns visible on the coins and continued around the podium of an aedicula (Fig. 47). This podium had a cornice and carried Corinthian columns and an entablature with a triangular pediment. A statue, probably framed by a recessed rectangular niche, stood inside the aedicula, and in the bay above, an imago clipeata, a portrait bust in a heavy ornamental frame, mirrored the imagines clipeatae in the the attics of the East and West Colonnades (Figs. 54, 61). Centered above the free standing columns, Dacian atlantes divided the attic into seven bays.

Although the details of the statuary on the Central Arch vary somewhat among the representations on coins (Figs. 47- 48), the general interpretation of these figures is reasonably clear. The charioteer in the *seiugis* (six-horse chariot) is surely Trajan portrayed as a victorious general. In his right hand, he raises a staff crowned with a decorative device, perhaps an eagle. A winged victory accompanies the Emperor in the chariot; and we may perhaps imagine that she held a wreath above the Emperor's head. Bearing spears, the two figures restraining the team which pulls the chariot may be Amazons of a type associated with the goddess Roma. The attendants of Dea Roma herself conduct the victorious emperor into the Forum which commemorates his triumph. The ornaments over the second and fourth bays of the Central Arch (reckoning from either side) are clearly trophies; the figures over the outer ressauts are additional female attendants. All this sculpture was probably of gilt bronze.

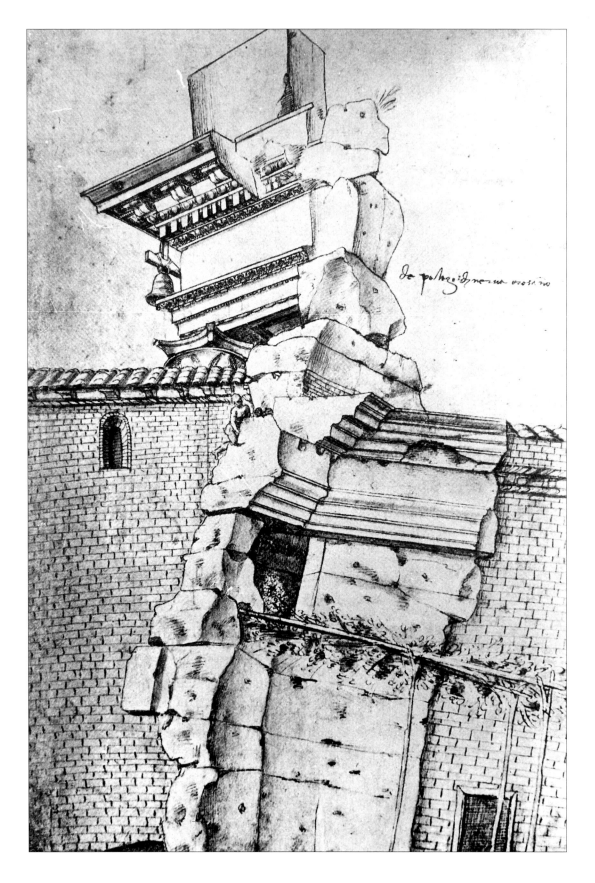

de pa...o ...

FIGURE 49. *View of the south perimetric wall of the Area Fori in the fifteenth century. B.R.*

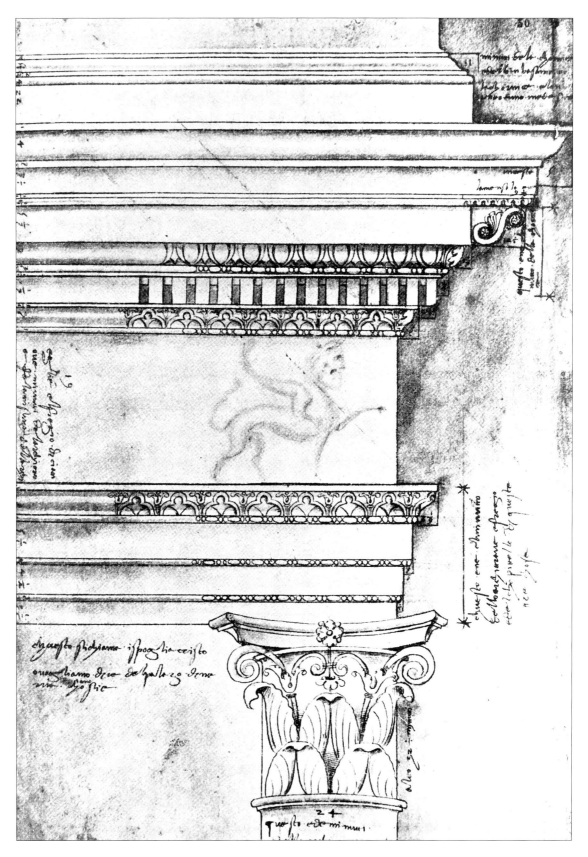

FIGURE 50. *The order and attic base from the south perimetric wall of the Forum of Trajan in the fifteenth century. B.R.*

The excavators of the 1931-32 were surprised to find that the remains of the south perimetric wall of the Forum form a shallow curve (Fig. 149A, 149B). With regard to the original appearance of this wall, the theories of Bartoli have long been accepted. In an important article written over fifty years ago, he argued that the Renaissance drawings which record the antiquities of Spoglia Cristo refer specifically to the area around the church of that name. Later known as St. Mary in Campo Carleo, it stood at the southeast corner of via Alessandrina and via del Grillo (Fig. 13). On the basis of this identification, Bartoli used the most informative drawings (Figs. 49, 50) to reconstruct a Murus Marmoreus with freestanding columns supporting ressauts. The entablature had a frieze of cupids and lion-griffins, part of which is still preserved in the Vatican Museums (Figs. 136-37), and the architectural scheme closely resembled the extant south lateral wall of the neighboring Forum Transitorium.

This article was so persuasive that, even after the excavations of 1928-1934, in his model of the Forum of Trajan, Gismondi (infra pp. 136-37) still shows the wall at the south side of the forum square fronted by columns *en ressaut* (Figs. 3, 4, 6). Unfortunately, the excavators of 1928-34 found no trace of foundations for columns *en ressaut*, and consequently we must now abandon Bartoli's reconstruction of the Murus Marmoreus and assume that the monuments depicted in his drawings stood north of the Basilica Ulpia.

Yet, since we can no longer accept Bartoli's reconstruction of the Murus Marmoreus, we no longer have any sure means of determining its appearance. We can only assume that its features to some extent continued those of the arches. Pilasters perhaps divided the wall into regular bays echoed in the attic above by projecting vertical panels with friezes of acanthus leaf and scroll with birds and insects (Fig. 51), and the marble veneer would probably have been drafted to resemble ashlar masonry.

The Murus Marmoreus (Marble Wall)

Despite its absence from the standard modern plans of the Forum, the East Lateral Arch has long been known. Standing near the Church of St. Mary in Campo Carleo beneath the intersection of the via Alessandrina and the via del Grillo, its excavated remains were too far from the axis of the Forum to have been those of the Central Arch (Figs. 13, 14). Although buried, the East Lateral Arch may have been partially intact until March of 1526, when, although the monument itself was damaged, a large number of historical reliefs came to light in its immediate vicinity (above p. 10). After the demolition of the Church of St. Mary in Campo Carleo in 1862, the foundations of the arch appeared with fragments of its entablature, a Composite order, and a Dacian atlas (above p. 27). The West Lateral Arch has never been excavated, but, in order to balance the East Lateral Arch and render symmetrical the design of the forum, it probably lies under what was, in the nineteenth century, the intersection of the via de' Carbonari and the via Cremona (Figs.13, 14).

Like the opposite lateral porches of the Basilica (Frontispiece, Figs. 149A, 149B, 150), both the Lateral Arches would have projected forward from the face of the Murus Marmoreus, probably to the same distance as the Central Arch; and on each, there would have been two *bigae* (two-horse

The Lateral Arches

chariots), one facing the forum square; the other, the zone outside the Forum. We may also surmise that bronze trophies crowned the ressauts of each Arch; bronze legionary standards (like the ones on the attic of the Basilica Ulpia, Figs. 150, 152) those of the Murus Marmorus.

FIGURE 51. *Anonymous sixteenth-century sketch (by Panvinio?) of a relief from the Marble Wall at the south end of the Forum of Trajan. B.A.V.*

In antiquity, the rectangular forum square south of the Basilica Ulpia was called the Area Fori. Several important features softened and relieved the dazzling white expanse of its white marble pavement. Centered on the lateral porches of the Basilica and on the opposite arches of the Murus Marmoreus were four avenues of trees (Frontispiece, Fig. 149A,149B). At least two life-size equestrian statues and, at the center of the Forum, an enigmatic elongated monument, perhaps for a line of statues, embellished these avenues.

On the central axis of the Forum stood that famous colossal equestrian statue (Frontispiece), the Equus Traiani which, on the occasion of Constantius II's visit to the Forum in A.D. 363 so excited his admiration—and his cupidity (Ammianus Marcellinus 16.10.15-16). Unfortunately, the excavations of 1928-34 did not uncover the site of this monument; and our only sources for it consist, therefore, of a large number of contemporary coins in bronze, silver, and gold.

Four variants appear on obverses bearing the legend: "SPQR OPTIMO PRINCIPI;" and the bronzes add below "SC". In coins of the first variant, Trajan is mounted on a sedately striding horse. On the other coins, the emperor battles one or more fallen Dacians who beg for his mercy. Which of these quite different representations depicts the Equus Traiani? Coins of the last three variants bear the dates of the Trajan's fifth consulship (A.D. 103), the year between the First and Second Dacian Wars. Coins of the first variant, however, seem to be part of a series which commemorated some of the most famous monuments of Trajan's new Forum. Moreoover, like these other coins, first variants date from Trajan's sixth consulship (A.D. 112), the year in which the Forum was dedicated. Thus first variants almost certainly show the Equus Traiani, which must have been the successor of and the answer to the famous supressed equestrian statue of the emperor Domitian in the Roman Forum. Consequently the Equus Traiani, as it appears on first variants, must have been the model for the nearly identically posed horse and rider in the extant equestrian statue of Marcus Aurelius, and both groups clearly reflected the artistic conventions which traditionally governed imperial equestrian portraits.

The Area Fori (Forum Square) and the Equus Traiani

Although the excavations of 1928-34 did not uncover extensive remains of the Murus Marmoreus and the three arches, they did clear the north end of the West Colonnade and all of the East Colonnade and Hemicycle (Figs. 2, 22-24, 27, 52, 53). Part of the exterior rear wall of the West Colonnade was freed—it is still accessible under the Esedra Arborea—and enough of the interior pavement came to light to show that, despite later, non-matching repairs, in design and almost certainly in dimensions, it duplicated that of the East Colonnade (Figs. 32, 149A, 149B).

The East Colonnade and Hemicycle stand on a rectangular concrete platform composed of several clearly defined strata enclosed on all four sides by massive foundations of travertine (in the Colonnade) and peperino (in the Hemicycle) (Fig. 61). These foundations support walls of drafted stone (opus quadratum) one block wide.

The East Colonnade and Hemicycle

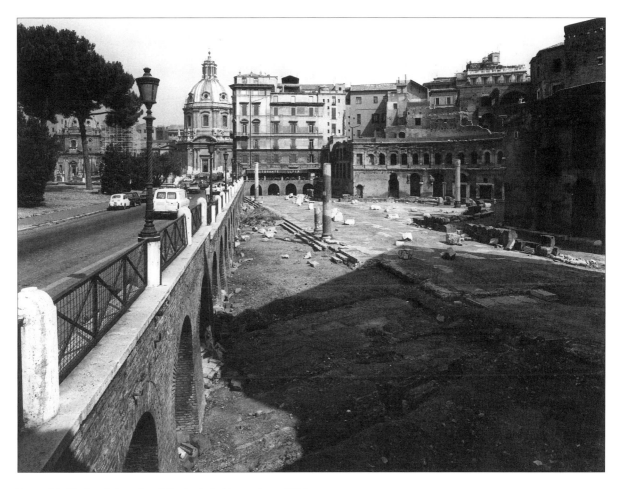

FIGURE 52. *The East Colonnade and Hemicycle, looking northeast. G.R.L.*

Like the exterior facade of the fire-wall behind the Forum of Augustus, the rusticated facade of the Colonnade, would have been crowned, when complete, with a course of plain travertine blocks, one course high, which will have projected slightly beyond the plane of the wall (Fig. 66). The east facades of both the Hemicycle and the Colonnade (a continuous wall) would have concluded with a simple cornice (Figs. 66, 149A, 149B, 150).

Three giallo antico steps led from the forum square to a Corinthian colonnade with cabled, fluted pavonazzetto shafts, white marble capitals and bases and a conventional entablature (Figs. 52, 54, 61). The individual elements, all of which survive, indicate that, on a reduced scale, the attic reproduced that of the Basilica Ulpia. Above each column, a white marble Dacian on a pedestal carried an elaborately decorated cornice (Figs. 30, 59). Between the atlantes, in the bays above the intercolumniations, were imagines clipeatae, larger than life-size portraits of historical personnages set off by circular frames (Figs. 55-58). The cornices on the heads of the Dacians supported an upper cornice (Figs. 60-61) which, crowning and completing the attic, carried (above each Dacian) inscribed pedestals with standards (Figs. 54, 61).

The interior of the Colonnade is a spacious rectangle (Figs. 62, 149A, 149B, 150). Giallo antico borders centered on the columns on all four sides of the building divide the pavement into large squares paved with pavonazzetto (Figs. 62, 149B). On the East wall, flanking the line of piers which screened the East Hemicycle Corinthian pilasters with white marble bases and capitals and cabled, fluted pavonazzetto shafts framed twenty bays (Figs. 2, 52, 62). The profiles of the pilaster bases continued across the bays as a base molding. Like the shafts of the pilasters, the veneer in the bays had a slight curve at the bottom, an apophyge; the entablature of the pilasters was complete, but the order will not have had an attic. A wide north entrance (Figs. 149A, 149B, 150), which framed a single column in antis, a continuation of the Corinthian colonnade along the Facade of the Basilica Ulpia, connected the

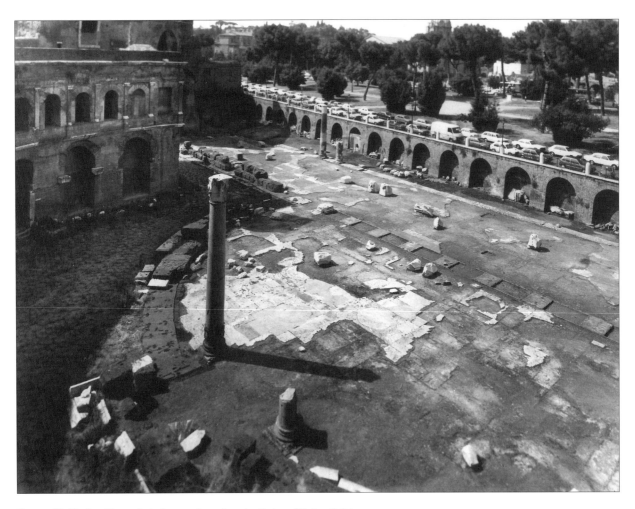

FIGURE 53. *The East Hemicycle, looking southwest from the Markets of Trajan. G.R.L.*

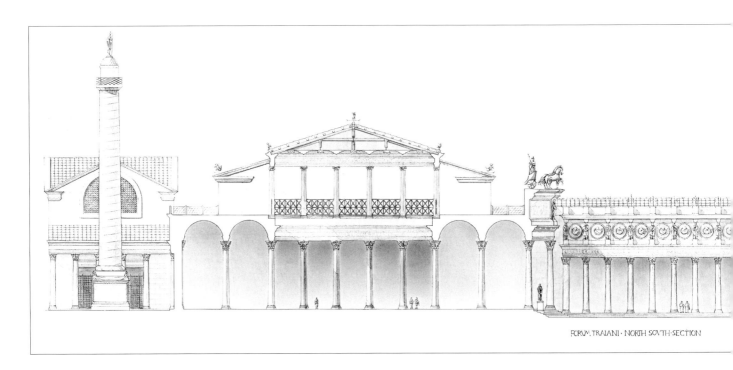

FORVM TRAIANI · NORTH SOVTH · SECTION

Colonnade with the interior of the Basilica, indicating that in conception the East and West Colonnades were simply wings of the Basilica, not independent halls.

Visitors entered the Hemicycle through the screen of piers (Figs. 53, 62). The grid from the floor of the Colonnade continues into the Hemicycle where, however, the marbles in the design of the pavement are reversed with respect to those in the pavement of the Colonnade (Figs. 2, 53, 62, 149B). The walls of the Hemicycle are poorly preserved; and the remains were heavily restored between 1928 and 1932 (Figs. 24, 53). Nonetheless, the numerous architectural fragments unearthed in that period permit a fairly accurate restoration of the building (Figs. 29, 30).

Although the bases of the pilasters project from the surface of the wall slightly more than those of the Colonnade, as in the latter structure, the pavonazzetto shafts will also have been cabled and fluted. As in the Colonnade, between the pilasters, the profiles of the bases continued as a base molding; and the walls above were veneered with colored marbles which, with the polychrome shafts of the pilasters, must have visually echoed the rich colors of the marble pavement below (Figs. 66, 149B).

Positioned above a dado, the niche framed in each bay had a white marble frame and an entablature which incorporated a cornice with modillions. Of the statues which once stood in these niches, a civilian and a general survive (Figs. 64-66). Both figures are 1 1/2 times life-size and were probably attached to the backs of the niches in which they stood. The civilian wears the customary toga draped over the left left shoulder. The general, who closely resembles an almost identical, although better preserved, figure in the Ny Carlsberg Glyptothek, is almost certainly Trajan. In both portraits, the emperor was probably shown bare-headed—although here the head and neck have disappeared—and in each, the emperor wears a cuirass with a military cloak draped over his left shoulder and right forearm. As a contemporary portrait of Trajan found at Ostia indicates, there were probably elaborate sandals on the missing feet of the statue from the Hemicycle.

The last feature of the lower story of the Hemicycle is the rectangular east recess (Figs. 149A, 149B, 150). Little remains of it today, but it probably had a dado veneered with africano rather the giallo antico used for the dado elsewhere in the Hemicycle. The gray granite shafts of the flanking columns (Fig. 53) have the same proportions as those of the columns along the facade; and did not support a second story. Instead, profiling as ressauts over the columns, the entablature will have run around the inside of the recess (Fig. 150).

An arch probably revealed the barrel-vaulted interior of the recess, and the pilasters of the upper order, their shafts cut off below by the rise of the arch, would have continued above the arch. Thus, on the level of the second

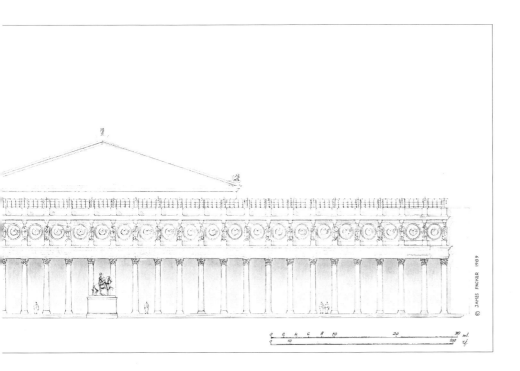

FIGURE 54. *The Forum of Trajan: restored north-south section and elevation: looking east, showing (right to left): the facade of the East Colonnade and Hemicycle, a north-south section through the Basilica Ulpia, the west facade of the East Library, the portico around the Column of Trajan, the Column of Trajan. S.G.*

63

FIGURE 55. *The East Colonnade, attic facade: the frame from an ornamental shield* (imago clipeata). *B.B.*

FIGURE 56. *The East Colonnade, attic facade: head of Nerva from an ornamental shield. G.R.L.*

story, a pilaster would have marked the central axis of the Hemicycle. Inside the recess, there would have been a colossal statue, and sockets in the shafts of the columns, intended for hooks or for some other means of supporting chains, show that this area was physically separated from the rest of the Hemicycle.

Considerable evidence exists for a second story (Figs. 66, 150). The walls of the Hemicycle are thicker than those of the Colonnade, suggesting a heavier roof; and there are abundant architectural fragments from the upper order of pilasters: several bases and sections of the connecting base molding, parts of cabled, fluted giallo antico shafts, and the remains of two white marble Corinthian capitals. As in the West Library, the pilasters probably stood on a podium carved from the same block as the cornice of the order below. The base, shaft, and capital are all approximately three-fourths the size of the corresponding components of the first order (cf. Vitruvius 5.1.3). The entablature may have been undecorated, and the order was set into a veneer the same width as that in the bays below.

Of the roofs over the Colonnade and Hemicycle nothing remains. For the Colonnade, however, the socket in best preserved of the surviving blocks of the upper attic suggests a timber truss roof of the kind probably used in the Basilica Ulpia and in the later fourth-century basilica of St. Paul's Outside-the-Walls, and this roof probably supported a stuccoed false vault (Figs. 62, 63, 150). For the Hemicycle also, certain points are clear. The fine marble pavement and the lack of drains within the walls indicate a roof. Yet, although the walls are more robust than those of the Colonnade, they are significantly narrrower than the wall of the rotunda in the Pantheon. Thus, the wall of the Hemicycle, unlike that of the Pantheon, could never have supported a dome with a central oculus. Moreover, since the widths of the plinths in the line of piers which separated the Hemicycle from the Colonnade (Figs. 53, 62) equalled that of the semicircular east facade of the Hemicycle (although the wall above the piers would have been somewhat narrower than the east wall), these piers must have supported the same weight as the walls—probably the pediment of a conical roof with wooden trusses (Fig. 150). Consequently, in order to light this roofed space without a skylight, in the upper story, windows (with plain frames) must have replaced the niches below.

Finally, from the internal decoration of the Colonnade or Hemicycle, three large-scale modillions survive (Fig. 29). The widths of their tenons shows that they would have stood in either the Colonnade or the Hemicycle. If these modillions were thus built into the dadoes of the Colonnade or the Hemicycle, they would have interrupted the base moldings. Yet, until the excavation of the West Colonnade and Hemicycle provides further evidence, we can only speculate on the original positions of all such architectural elements.

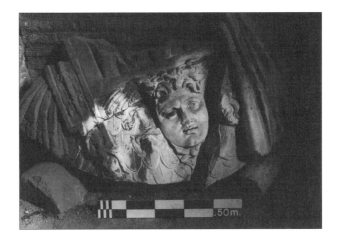

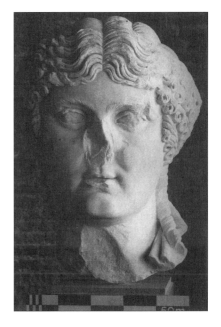

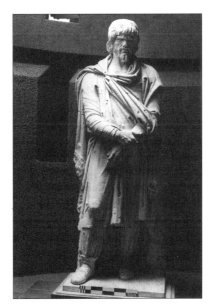

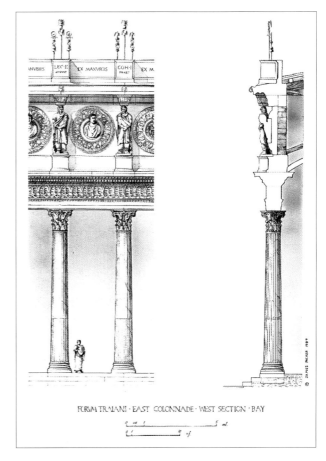

FORVM TRAIANI · EAST COLONNADE · WEST SECTION · BAY

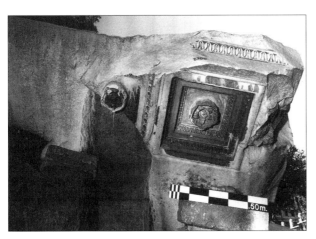

FIGURE 57 (upper left). *The East Colonnade, attic facade: a marble bust from a portrait in an ornamental shield. G.R.L.*

FIGURE 58 (upper right). *The East Colonnade, attic facade: head of Agrippina the Younger from an ornamental shield. G.R.L.*

FIGURE 59 (center left). *Dacian atlas: a Severan copy of a Trajanic original in the Vatican Museums G.R.L.*

FIGURE 60 (lower left). *The East (or West) Colonnade: upper cornice, front and soffit with coffer. G.R.L.*

FIGURE 61 (lower right). *The East Colonnade, the west facade: restored bay, elevation and section. S.G.*

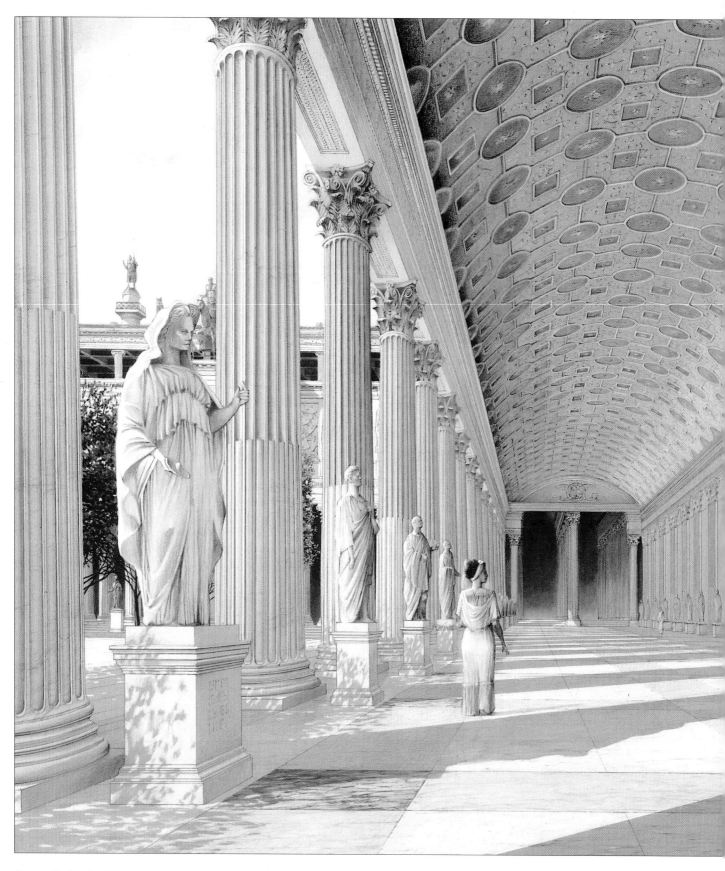

FIGURE 62. *The East Colonnade: restored interior, looking northeast into the East Hemicycle.* G.G.

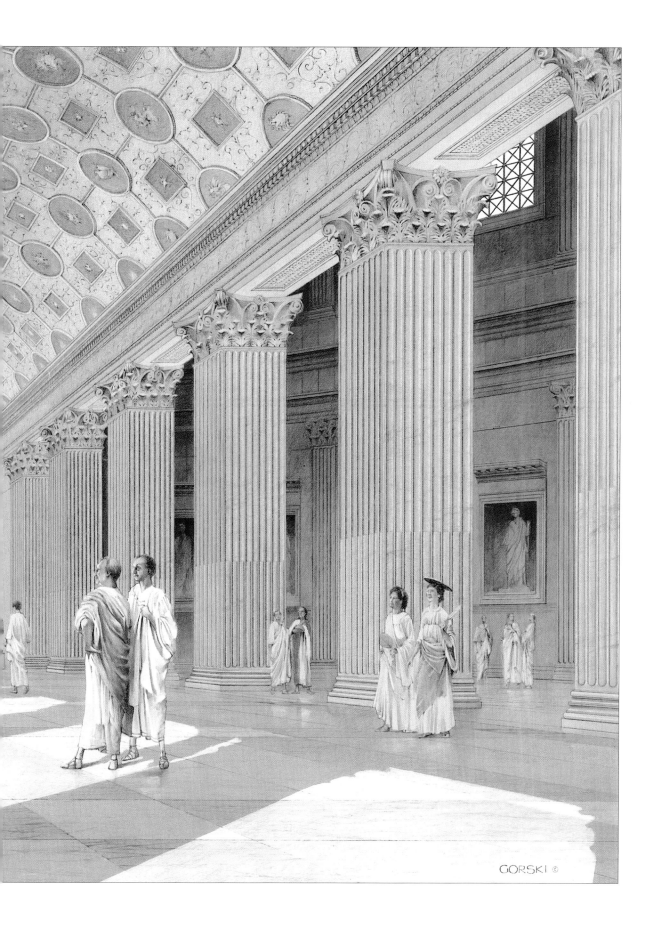

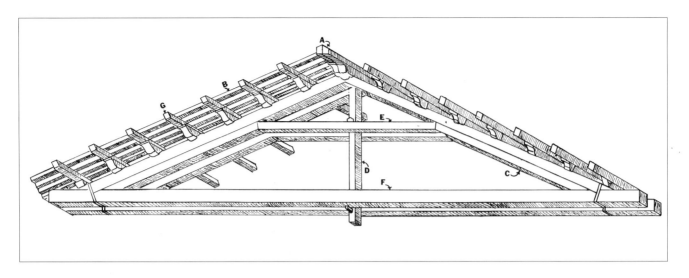

FIGURE 63. *Roof truss of Old St. Paul's Outside-the-Walls before 1823: A. ridge pole, B. batten, C. principal rafter, D. king post, E. collar beam, F. tie-beam, G. purlin. Sakur.*

FIGURE 64. *The East Hemicycle: statue of an emperor (Trajan?). G.R.L.*

FIGURE 65. *The East Hemicycle: statue of a togate figure. G.R.L.*

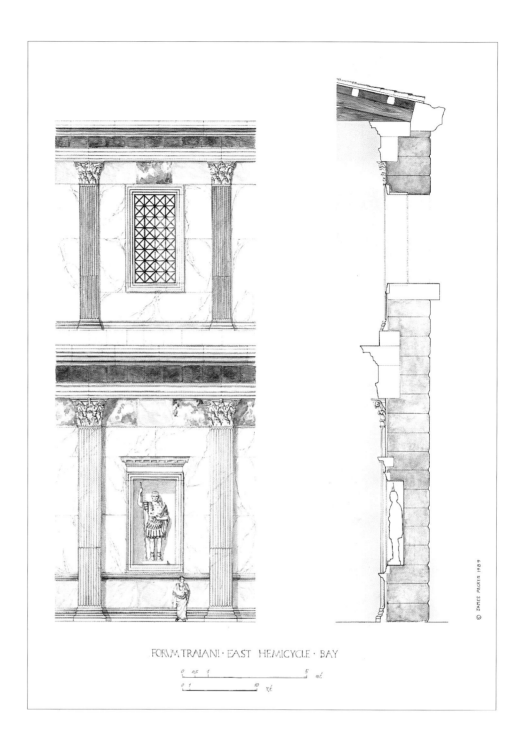

FORVM TRAIANI · EAST HEMICYCLE · BAY

FIGURE 66. *The East Hemicycle: a restored interior bay, elevation and section. S.G.*

© JAMES PACKER 1989

Chapter Four

The Monuments North
of the Basilica Ulpia

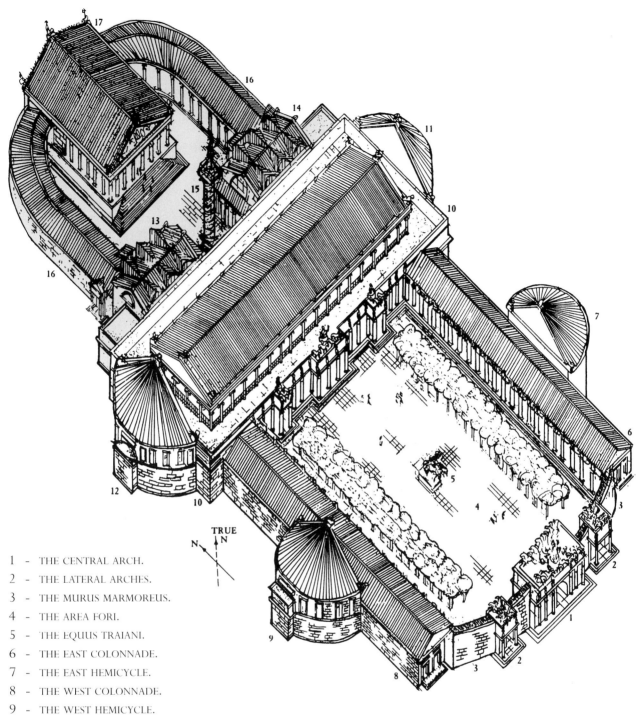

1 – THE CENTRAL ARCH.

2 – THE LATERAL ARCHES.

3 – THE MURUS MARMOREUS.

4 – THE AREA FORI.

5 – THE EQUUS TRAIANI.

6 – THE EAST COLONNADE.

7 – THE EAST HEMICYCLE.

8 – THE WEST COLONNADE.

9 – THE WEST HEMICYCLE.

10 – THE BASILICA ULPIA.

11 – THE BASILICA ULPIA, EAST APSE, THE "ATRIUM LIBERTATIS".

12 – THE BASILICA ULPIA, WEST APSE.

13 – THE WEST "GREEK" LIBRARY.

14 – THE EAST "LATIN" LIBRARY.

15 – THE COLUMN OF TRAJAN.

16 – THE COLONNADES OF THE TEMENOS OF THE TEMPLE OF TRAJAN.

17 – THE TEMPLE OF TRAJAN?

THE FORUM OF TRAJAN
Color indicates the areas discussed in this chapter

North of the Basilica Ulpia, two symmetrical Libraries flanked the small rectangular peristyle which framed the Column of Trajan. To the north, in its own colonnaded precinct, rose the grandiose Temple of the Deified Trajan (Figs. 3, 5-6, 149A, 149B).

The Peristyle Around the Column of Trajan

Denuded of its original architectural context, the Column of Trajan today rises over 40 meters to dominate a site on which the adjacent structures are all but leveled (Figs. 1-3). Originally, however, the Column stood in a narrow rectangular Corinthian peristyle 25 meters x 20.20 meters (85 x 58 3/4 Roman feet) which allowed clear views of only the monumental base (Figs. 3, 4, 6, 68). Rectangular slabs of white marble paved this peristyle, and the colonnade stood on a low stylobate one step high. The reconstruction of this order is based on surviving fragments of an entablature of approximately the same size as that of the East Colonnade. The bases and capitals were probably of white marble; the shafts, of pavonazzetto. With variations, the entablature of the peristyle matched the proportions of the entablatures of the Colonnades on the forum square. The exterior frieze included griffins, candelabra, and vases (Figs. 67, 69,70); the interior frieze had sphinxes (with candelabra and vases?). This entablature supported a coffered ceiling and a timber roof (Fig. 75). At the south end of the peristyle, engaged half-columns probably continued the order across the north facade of the Basilica Ulpia. The attic, which masked the vault over the adjacent aisle of the Basilica, will have been the location of the so-called Great Frieze of Trajan (Fig. 54). The interior of the peristyle was paved with six rows of alternating rectangular slabs of pavonazzetto and giallo antico that, in size and materials, were identical to those in the lateral aisles of the Basilica Ulpia (Fig. 149B).

The north side of the peristyle passed through two phases. Initially, the colonnade had a north branch, closed behind by wall of peperino blocks; and a central door, on axis with the Column, led north out of the court to the site of the Temple of Trajan. During the second phase, six of the eight columns of the north branch were removed (five of the travertine foundations remain in situ). The peperino wall was demolished, and the pavement in the court around the Column was extended into the Temenos of the Temple of Trajan. These changes fully integrated the court and the Column with the precinct of the new Temple to the north.

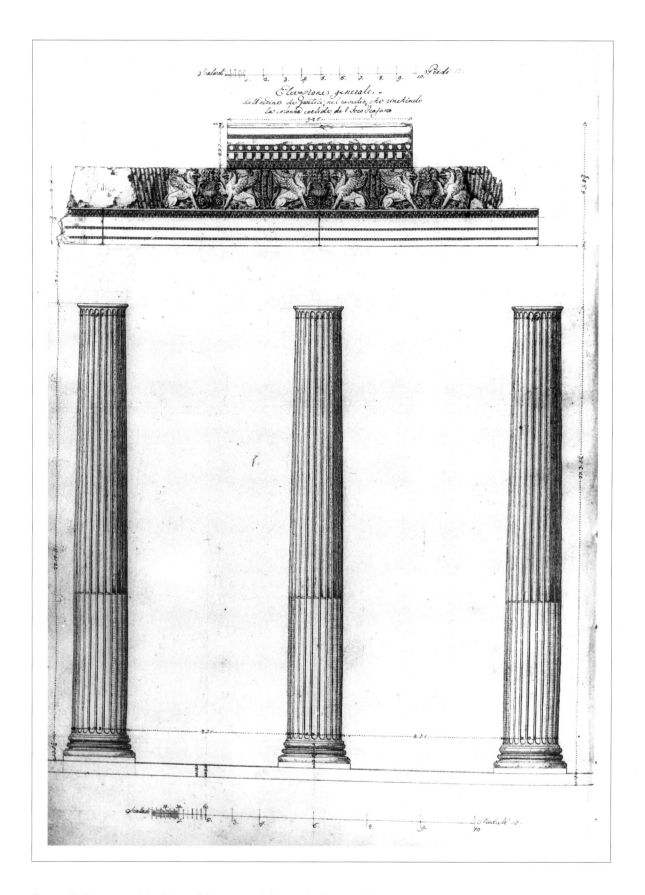

FIGURE 67. *Portico around the Column of Trajan, restored elevation. De Romanis. B.S.*

As the sole surviving monument in the Forum, the famous Column of
Trajan has been has been much discussed (Figs 1-3, 9-12, 16-17, 54, 68,
149A, 149B). A travertine foundation supports the pedestal, which was ori-
ginally set in an square enclosure (with sides of 8.52 meters or 29 Roman
feet) delimited by a perforated marble screen. Twenty-nine blocks of Luna
marble are used in the monument. Eight make up the pedestal and plinth of
the base; nineteen blocks are used for the rest of the Column (including the
torus of the base and the capital; two, the post-antique finial.

The pedestal has the usual divisions: base, die, and cornice. On its sides,
friezes of artfully piled captured weapons depict the armaments of the con-
quered Dacians and their allies, the Roxolani. The entrance on the south
side of the pedestal was originally fitted with two bronze doors that opened
inward. Above, two winged victories present a rectangular dedicatory tablet
which reads:

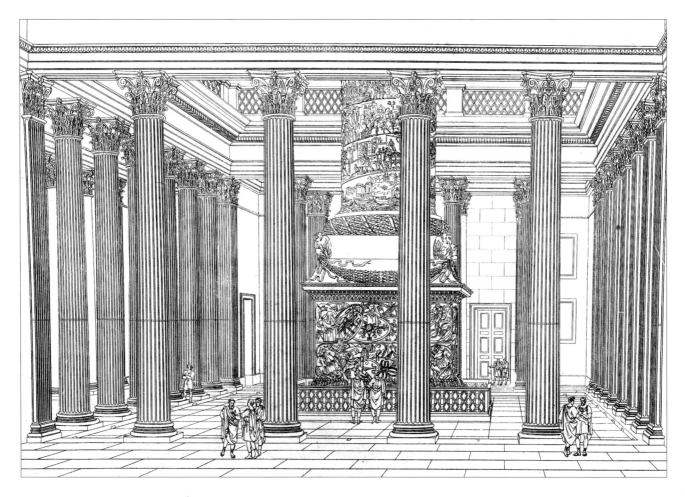

FIGURE 68. *Portico around the Column of Trajan: restored interior. Uggeri.*

SENATVS ▾POPVLVSQVE ▾ROMANVS
IMP ▾CAESARI ▾DIVI ▾NERVAE ▾F ▾NERVAE
TRAIANO ▾AVG ▾GERM ▾DACICO ▾PONTIF
MAXIMO ▾TRIB ▾POT ▾XVII ▾IMP ▾VI ▾COS ▾VI ▾P ▾P
ADDECLARANDVM ▾QVANTAE ▾ALTITVDINIS
MONS ▾ET ▾LOCVS ▾TAN[tis ▾oper]IBVS ▾SIT ▾EGESTVS

(The Senate and Roman People [dedicate this column] to the emperor Caesar,
son of the deified Nerva, Nerva Trajan, Augustus, Germanicus, Dacicus,
Pontifex Maximus with tribunician power for the seventeenth time,
commander-in-chief for the sixth time, consul for the sixth time,
father of his country in order to declare how deep were the rock
and earth excavated for these great works.

Swags of oak-leaves bound with fluttering ribbons decorate the frieze over the crisply cut cornice (Fig. 9). Two of the original four eagles at the corners of the plinth above are badly preserved.

In the interior of the pedestal are three small chambers (Fig. 149A, 149B). In the first, a vestibule, the plain walls and ceiling meet at sharply cut 90 degree angles. The doorways to the other two rooms duplicate the size and finish of the external entrance. Reached by a single step, the east door leads to a narrow landing, the first tread of a stair. The west door opens into a narrow corridor largely occupied by a late eighteenth-century fill of concrete and brick which extends into the third chamber to the north. Although lacking a frame the entrance to that chamber, like those in the vestibule, was originally equipped with double doors of bronze or wood.

Decorated with only a plain cornice, this rectangular third room was Trajan's sepulcher. Subdued light, filtering through a window with splayed reveals, illuminates the position of a low platform on which the burial urns of Trajan and his wife, Plotina, once rested. Although this platform has completely disappeared, roughly picked areas on the floor and north wall provide its dimensions (0.745 meters x 1.154 meters, 2 ½ X 4 Roman feet) and show that it was cut from the same marble as the pedestal itself and ran the length of the room.

The Column is Tuscan. The torus is enriched with laurel leaves—a reference to the victorious campaigns depicted on the shaft—and despite its size, the shaft exhibits the same ratio of diameter to height as appears elsewhere in the Forum. At the top, twenty-four flutes emerge above the continuous scroll which winds around the shaft. The astragal is enriched with bead-and-reel, two beads-and-reels corresponding to one of the flutes below. A necking groove divides the top of the shaft from an echinus embellished with egg-and-dart. The twenty-four eggs respond to the number of flutes below; the intentionally blunted tips of the darts contrast markedly with the sharp points of the darts in the ovolo of the cornice on the pedestal.

Conceived as a giant scroll, the continuous frieze, if unrolled, would be 200 meters long. It depicts Trajan's Dacian Wars (A.D. 101-102, 105). Carved on the completed shaft, these scenes, which may have been brightly colored, probably illustrated the Emperor's own commentary on his campaigns, a book once housed in the adjacent Libraries. As the hero of these wars, Trajan himself appears in the 155 separate scenes no less than 60 times. The artist(s), however, avoided representations of war (only 18 scenes depict battles), preferring instead to render a day-by-day account of the campaigns, the lands in which they took place, and the chief characteristics of the Roman soldiers and their adversaries.

The 185 steps which wind around the cylindrical central core inside the shaft are worn, but the walls and ceiling of the stairwell, meeting at sharp, accurate right angles, still preserve their fine, smoothly picked finish. Light reaches the stair through forty windows with splayed reveals: a vertical row of 10 is situated above each side of the pedestal. On top of the Column, the stair ends at a door which opens to the east onto a platform on the abacus. Higher but narrower than the doors inside the pedestal, this door has a frame which dulplicates the frames of those below.

The statue base above the abacus repeats the profile of the base for a statue of Trajan which the excavators of the nineteenth century reerected next to the east porch of the Basilica Ulpia (pp. 26, 146-47). The cornice and the fascia above are original, but the present finial dates from 1588, when Domenico Fontana set up the existing statue of St. Peter where the long vanished colossus of Trajan had once stood. Unfortunately, contemporary ancient coins do not precisely render the ancient finial, showing the statue of Trajan on what appears to be a rectangular pedestal. This, however, represents a combination of the statue base and the original bronze railing that enclosed the top of the abacus. Medieval and Renaissance drawings depict a cylinder topped by a segmental sphere, a design confir-

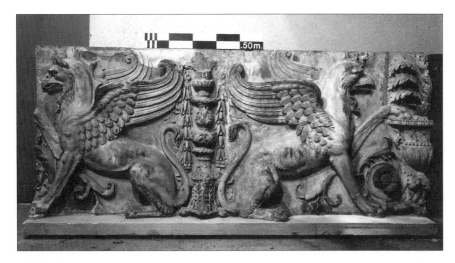

FIGURE 69. *Portico around the Column of Trajan: Griffin-and-candelabra frieze. M.L.*

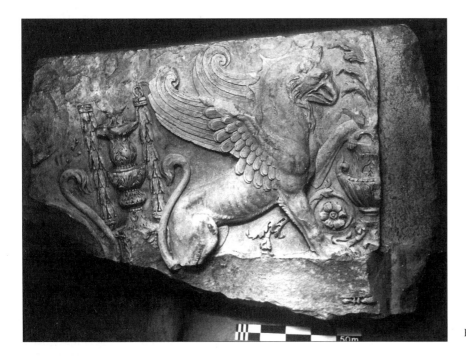

FIGURE 70. *Griffin-and-candelabra frieze. P./B.*

med by early plans of Rome. Of stone or concrete, this sphere may have been protected by "scales" executed in thin sheets of gilded bronze.

On this sphere, the bronze feet of a statue were discovered in the sixteenth century. Excavations at the base of the pedestal also recovered the head of the statue (supra p. 14). Although the head subsequently disappeared, its height is recorded in a seventeenth century source, and we may thus estimate the height of the whole statue at about 4 meters (a little more than 13 ½ Roman feet). Representations on Trajanic bronze, silver, and gold coins show that this bare-headed figure wearing a cuirass faced south and, inclining slightly towards its right side, held a spear in its left hand. A draped cloak partially concealed its extended right arm, and the right hand held an orb surmounted by a winged victory. The details probably closely resembled those on the statue of the emperor found in the East Hemicycle (Fig. 64).

FIGURE 71. *The East Library: south podium. G.R.L.*

Observing the tradition established by earlier imperial libraries, the Biblio-theca Ulpia (the Ulpian Library) was divided into Greek and Latin collec-tions that were housed in the two buildings that faced one another across the peristyle around the Column of Trajan (Figs. 3, 4, 6, 149A, 149B). Fa-mous in antiquity, this Library also included archival materials—the edicts of the emperors and praetors, decrees of the Senate—and rare books like Caesar's autobiography and Trajan's commentaries on the Dacian Wars. To use the collection, a reader would have asked the *procurator bibliothecarum* for the permission of the *praefectus urbi*.

Completely excavated in the early 1930s (Figs. 38, 43-45), the West Library proved to be a sizeable rectangular hall 20.10 meters wide, 27.10 meters long, with an interior 14.69 meters high (about 68 ½ x 90 x 50 Roman feet) (Figs. 75-78, 149A, 149B). A columnar screen at the east end admitted the visitor to an interior framed by a two-story Corinthian colon-nade interrupted on the west side of the room by a tabernacle, also of two stories. On both floors, the columns framed *armaria*, niches for books.

The first order stood on a stepped podium broken on the west side by a rectangular recess flanked by projections of the podium. These sustained the columns of the aedicula, which probably supported a triangular pedi-ment and framed colossal statues, perhaps of Trajan and Minerva (Figs. 75-78).

Separated by a low plinth, the nearly identical lower and upper Corinthian orders had fluted shafts and differed only with respect to bases and friezes (Figs. 72-78). On both floors, base moldings connected the corresponding pilasters. The entablature of the lower order continued along the east side of the room above two columns *in antis* intermediate in height between the columns of the lower interior order and those of the portico

FIGURE 72. *The West Library (under the Esedra Arborea): the south side looking east. G.R.L.*

around the Column of Trajan (Fig. 76). Bronze screens between these columns restricted access to the Library, and, on the outer side of this entrance, the entablature (an extension of the entablature of the lower interior order) must have projected out over and concluded above the responding pilasters of fluted white marble. In the interior along the east wall, pilasters would have replaced the columns of the upper order.

On the north, south, and west walls (Figs. 44-45, 75-77), the columns of the lower order bracketed rectangular armaria. Their simple frames probably carried a full entablature of which the cornices were smaller versions of the one on the pedestal of the Column of Trajan. Repeated on the upper floor, these armaria could have housed over ten thousand scrolls, and indeed, without such second-story niches, the storage space in the Libraries would have been halved. Since, however, there is no evidence for any connection between this upper floor and the stair in the Basilica behind the Library, a second smaller stair, possibly in the unexcavated zone at the northwest corner of the Library, would have been the means of access to these upper niches (Figs. 149A, 149B).

The brick-faced walls supported a high groin vault. Located at the east and west ends of the room and under the cross-vaults, semi-circular "thermal" windows would have provided readers all day long with a good indirect light that would never have reached the interiors of the armaria to damage the papyrus rolls stored inside (Figs. 75-78).

Externally the walls must have been concealed with stucco finished to resemble ashlar masonry. Internally the walls and podiums were sheathed with veneers of pavonazzetto, the same marble used for the shafts of the columns of both orders. The column bases, base moldings, capitals, niche frames and cornices were of white marble. The giallo antico shafts of the two-story aedicula at the east end of the room accented and emphasized the importance of this projecting pavilion. Giallo antico also perhaps alternated with slabs of pavonazzetto in upper zones aligned with the capitals of both orders, and in the rich if somber pavement, narrow giallo antico borders separated rectangles of gray Egyptian granite, and a gray granite border outlined the sides of the chamber (Figs. 78, 149B).

FIGURE 73. *The West Library: the lower interior order: base and shaft fragment. G.R.L.*

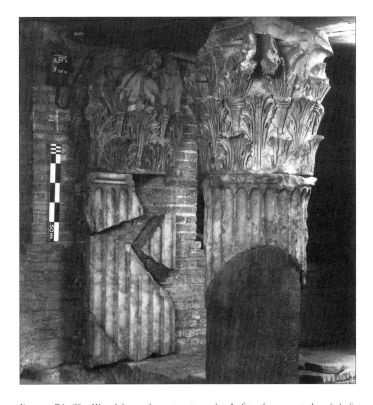

FIGURE 74. *The West Library: lower interior order.* Left: *pilaster capital and shaft fragments;* right: *capital and shaft fragment. G.R.L.*

For the colonnades that enclosed the Temple of Trajan, still largely interred like the Temple itself (Figs. 1-3, 5, 6), we have only the reports of the excavators of the Temple in the eighteenth and early twentieth centuries. - Uncovered in the first investigation, the dedicatory inscription, reads:

e]X ▾S ▾C ▾DIV[is Tr]IANO ▾PARTHICO ▾ET ▾[Plotinae
im]P CAES[ar di]VI ▾TRAIANI ▾PARTHICI F DIVI N[ervae
nepos Traia]NVS ▾HADRIANVS ▾AVG ▾PONT ▾M[ax
trib pot...] COS ▾III ▾PARENTIBVS ▾SVI[s]

The Emperor Trajan Hadrian Augustus, son of the deified Trajan Parthicus, grandson of the deified Nerva, Pontifex Maximus with Tribunician Power, Consul for the third time, by decree of the Senate [dedicates this temple] to his deified parents, Trajan Parthicus and Plotina

In 1902-1904, a second, more scientific excavation, on the present site of the General Insurance of Venice Building, cleared the street behind the West Colonnade of the temple precinct and a part of its perimetric wall, showing that the north end of the colonnade curved east toward the cella of the Temple. Elevations of the south facades on the Trajanic bronze coins (Fig. 81), the fragmentary plan on the Forma Urbis (Fig. 130), and elements from the entablature also help to reconstruct the ancient appearance of these colonnades.

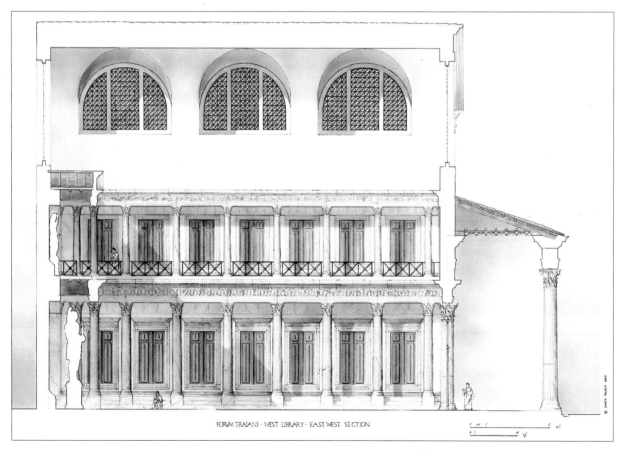

FORVM TRAIANI · WEST LIBRARY · EAST WEST SECTION

FIGURE 75. *The West Library: restored east-west section looking north. S.G.*

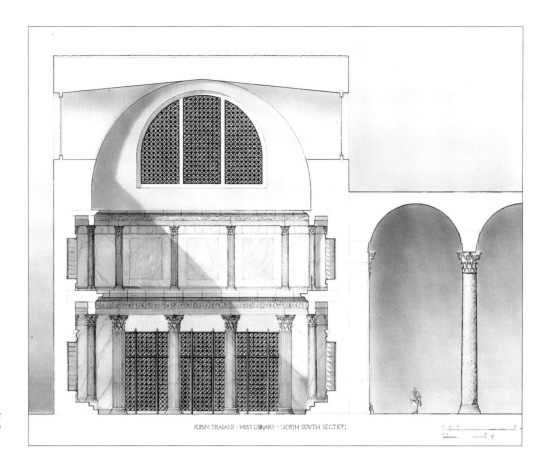

FIGURE 76. *The West Library: restored north-south section looking east. S.G.*

FORVM TRAIANI · WEST LIBRARY · NORTH SOVTH SECTION

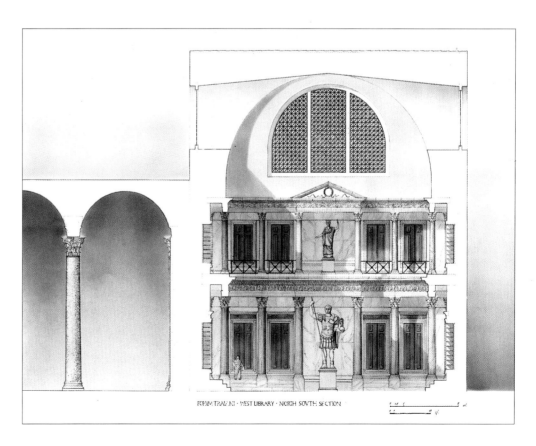

FIGURE 77. *The West Library: restored north-south section looking west. S.G.*

FORVM TRAIANI · WEST LIBRARY · NORTH SOVTH SECTION

General views appear on the coins (Fig. 81). In each colonnade, a low, stepped podium supports a Corinthian order and, at the short ends of the building, there are undecorated (?) pediments with acroteria. No fragments of the architrave survive, but one fragment was apparently known in the late nineteenth century. The frieze was decorated with a serially repeated "scene" that combined cupids, vases, and winged lion-griffins (Figs. 79-80), and a fragment of the massive cornice survives.

If the colonnades ended at decorative arches on either side of the Temple, as in the Forum of Augustus, they would have thereby defined the temenos, thus constituting a richly decorated, visually satisfying frame for the sacred area at the north end of the Forum (Figs. 3, 6).

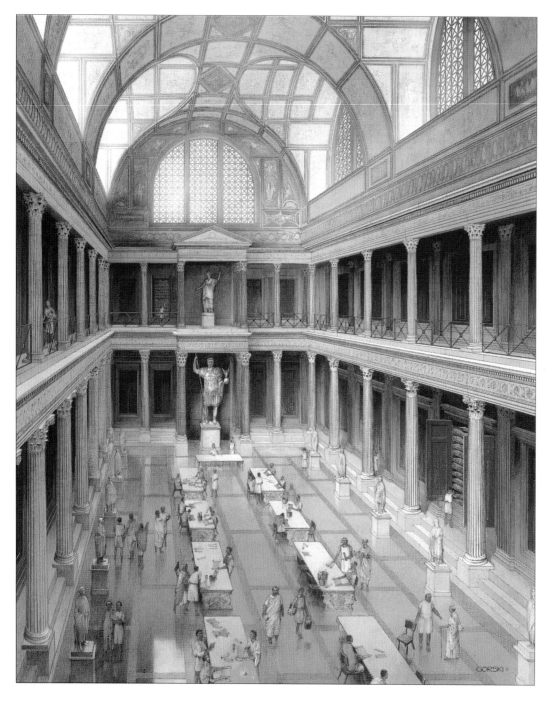

FIGURE 78. *The West Library: interior, restored, looking northwest. G.G.*

The Temple of the Deified Trajan

Although planned as an integral part of the Forum, the Temple of the Deified Trajan was not dedicated until the third decade of the second century (Figs. 3, 5. 6). The structure extends under the present Valentini Palace (Figs. 1, 2), which is now divided between the offices of the Provincial Administration of Rome and the Quaestura. It has never been excavated and thus, to get a general idea of its ancient appearance, we must rely on the random discoveries of earlier excavators.

Since the surviving fragments of the Corinthian columns of the porch belong to a very large order virtually the same size as that of the Temple of Mars Ultor in the Forum of Augustus (Figs. 3-4), it is not unreasonable to suppose that the Temple of Mars served as a model for the Temple of Trajan. Thus, standing on a high podium reached, like that of the Temple of Mars Ultor, by an impressive stairway, the Temple of Trajan was probably octastyle and pseudo-dipteral. The width of this facade (approximately 124 $^1/_2$+ Roman feet) was about the same as the distance between the foundations of the front walls of the two libraries.

If the Temple of Trajan did generally reproduce the lines of the Temple of Mars Ultor, the length of the lateral colonnades will have equalled that of the portico on the facade. Allowing space for an interior apse for the cult statue, the entire building could have had a length of 51 meters (about 173 $^1/_2$ Roman feet) and on the north and south facades a height of approximately 31.887 meters (about 108 $^1/_2$ Roman feet).

In order to flesh out this bare mathematical construct, we must return to the few surviving architectural fragments and to the numismatic evidence (Fig 81). Like the single excavated capital, the bases of the pronaos were probably of white marble. Of the shafts themselves, we have only two fragments, both of the gray granite from Mons Claudianus in Egypt, the same stone used for the shafts of the interior colonnades in the Basilica Ulpia. Only greater size distinguishes the two surviving gray granite shafts from those of the lower interior order of the Basilica Ulpia. The labor involved in erecting such enormous masses of stone was considerable. Even though one or two spares remained in the stone yards in case a shaft developed a fatal flaw, minor breaks that occurred during construction, probably after the shaft had already been erected, were repaired on the spot by inserting a new section (infra p. 168). The extant capital from the order of the porch also required several repairs (infra pp. 169-170).

Although no actual fragments of the architrave/frieze are presently visible, we may reconstruct their proportions from the other surviving elements of the order. The architrave probably had the three fasciae typical of the other buildings in the Forum but, owing to its larger size, its moldings will have been more elaborately decorated than those of smaller architraves. Like the frieze of the colonnades of the Temenos (Figs. 79, 80), that of the Temple would have included figures. On a larger scale, the cornice of the Temple resembled that of the surrounding precinct.

Despite minor differences, the coins preserve the appearance of the facade and the flanking colonnades (Figs. 3, 5-6, 81). The high front stair emphasizes the imposing Corinthian order, flanked on either side by a statue on a pedestal. A space between the fourth and fifth columns frames the cult statue, a seated male figure. He raises his right arm and rests his left arm on his lap. His upper torso is bare, the lower is draped. His right hand may

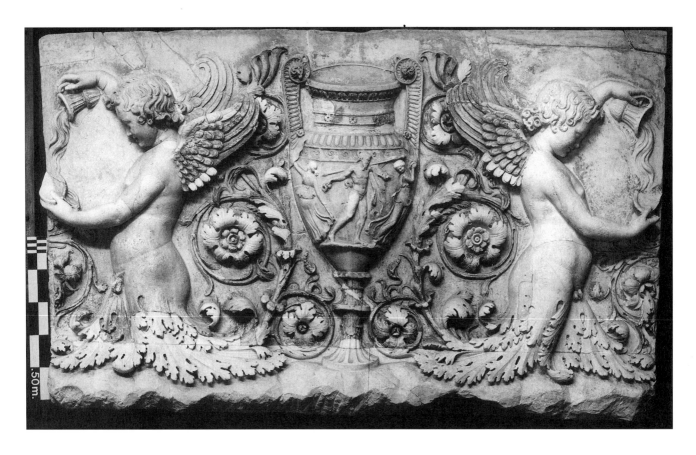

FIGURE 79. *The Temple of Trajan, temenos colonnade: architrave/frieze fragment now in the Vatican Museums. G.R.L.*

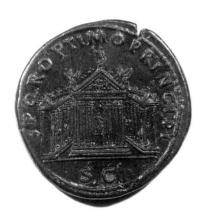

FIGURE 81. *The Temple of Trajan: sestertius, reverse.*
J.P./.M.N.R.

have held a scepter; his extended left hand, a winged victory. The two beaded lines above the columns suggest a richly decorated entablature; and the seated central figure in the pediment above (Trajan?), is flanked by two reclining figures, perhaps the Danube and the Tigris or Euphrates. To fill out the frieze, there would have been space on either side of central figure for at least two others, and one may have been Plotina, possibly with the attributes of Vesta. The standing figure that surmounts the apex of the pediment (Trajan?) resembles the cult statue inside and the central figure in the pediment below. Turned toward the sides of the Temple, the winged victories at the corners of the pediment hold eagles; and elaborate acroteria crown the raking cornice between the statues.

84

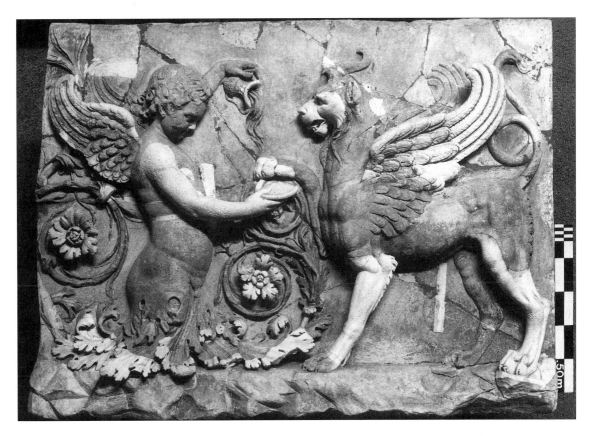

FIGURE 80. *The Temple of Trajan, temenos colonnade: architrave/frieze fragment now in the Vatican Museums. G.R.L.*

Several fragments discovered in the court of the Valentini Palace probably belong to the interior of the Temple. These fragments show that two superimposed orders of cabled and fluted columns must have divided the interior into a nave and two narrow aisles. The lower order had shafts of pavonazzetto and stood directly on the floor of the cella. Resting on the cornice of the lower order, the columns of the upper order, which had shafts of giallo antico, supported ressaults. Deep sockets cut into the backs of the returns would have supported the beams of the roof. As in the Temple of Mars Ultor, a shallow apse, the width of the nave with a depth 1/4 its length will have framed the cult statue.

Part II
Restoring the Basilica Ulpia
Chapter Five

Essays of Reconstruction in the
Nineteenth and Twentieth Centuries

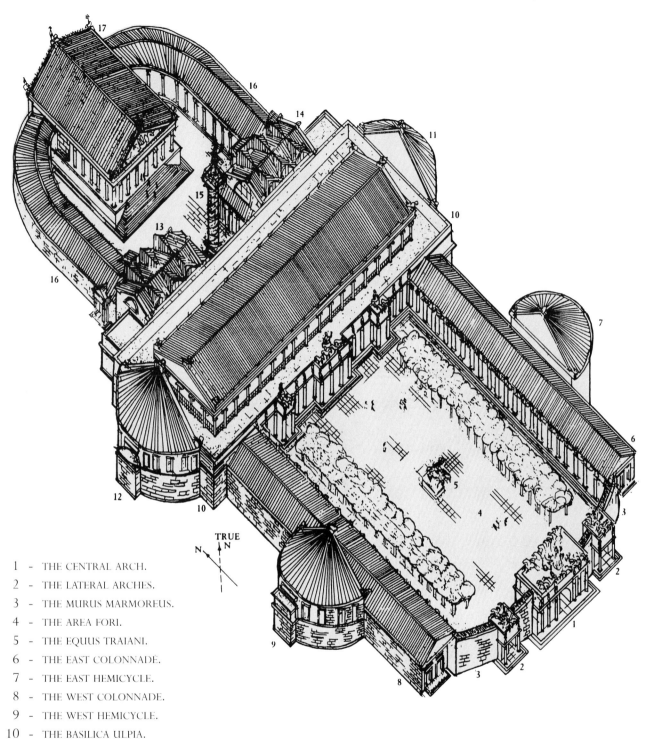

1 — THE CENTRAL ARCH.

2 — THE LATERAL ARCHES.

3 — THE MURUS MARMOREUS.

4 — THE AREA FORI.

5 — THE EQUUS TRAIANI.

6 — THE EAST COLONNADE.

7 — THE EAST HEMICYCLE.

8 — THE WEST COLONNADE.

9 — THE WEST HEMICYCLE.

10 — THE BASILICA ULPIA.

11 — THE BASILICA ULPIA, EAST APSE, THE "ATRIUM LIBERTATIS".

12 — THE BASILICA ULPIA, WEST APSE.

13 — THE WEST "GREEK" LIBRARY.

14 — THE EAST "LATIN" LIBRARY.

15 — THE COLUMN OF TRAJAN.

16 — THE COLONNADES OF THE TEMENOS OF THE TEMPLE OF TRAJAN.

17 — THE TEMPLE OF TRAJAN?

TRUE
N

THE FORUM OF TRAJAN
Color indicates the areas discussed in this chapter

The splendid architectural fragments disclosed by the French Excavations of 1811-1814 immediately interested contemporary architects and archaeologists; Jean Baptiste Cicéron Lesueur, a young French architect, was the first to produce a detailed monograph on the site. Observing and measuring the excavated area carefully, he made three small excavations in 1824 (supra p. 26). For the raw materials for his theoretical restoration of the building, he used his excavations, Vitruvius' description of a basilica (5.1.4), and a contemporary view of the Basilica Ulpia on a Roman coin in the collection of the Bibliothèque Nationale (Fig. 131).

Chosen from the relatively large number available, a few architectural fragments are the prototypes for Lesueur's first and second interior orders and the colonnades of the three porches on his closed south facade (Figs. 82-85). Since he is convinced that the Basilica Ulpia had been a proto-Christian basilica, analogous to St. Paul's-Outside-the-Walls, he postulates a grand entrance to the east opposite a single west apse (Figs. 82-84).

A clerestory on the second floor lights the interior, and a high parapet (Vitruvius' "pluteus") separates the lower and upper colonnades (Figs. 84, 85). Located on the slope of the Capitoline Hill, the domed apse freely varies the plan on the Forma Urbis (Figs. 82-85, 130); and while Lesueur

Jean Baptiste Cicéron Lesueur

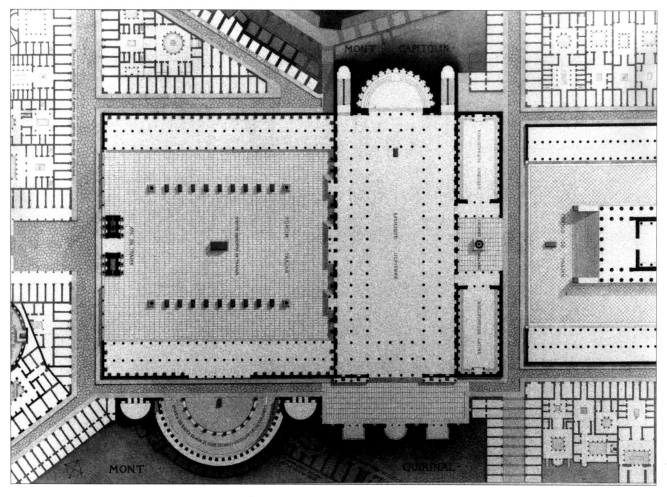

FIGURE 82. *The Forum of Trajan: restored plan. Lesueur. B.É.B.A.*

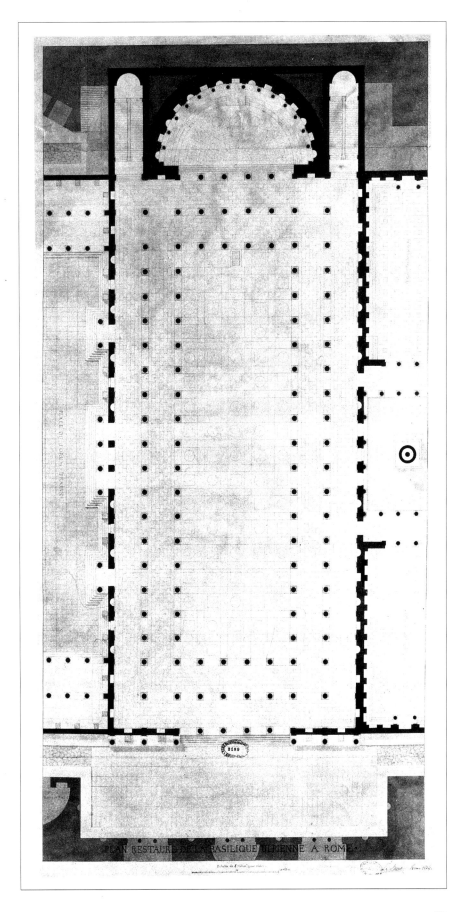

FIGURE 83. *The Basilica Ulpia: restored plan.*
Lesueur. B.É.B.A.

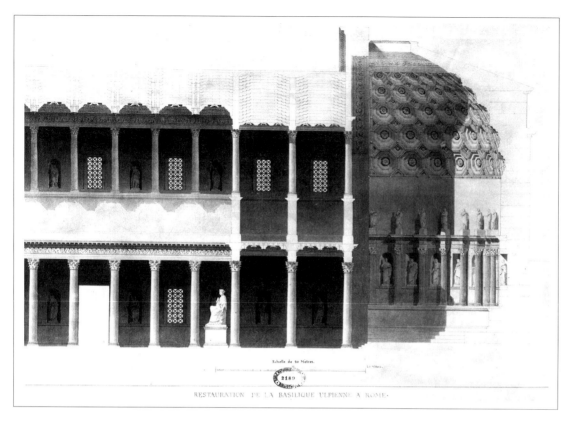

FIGURE 84. *The Basilica Ulpia: east-west section looking south. Lesueur. B.É.B.A.*

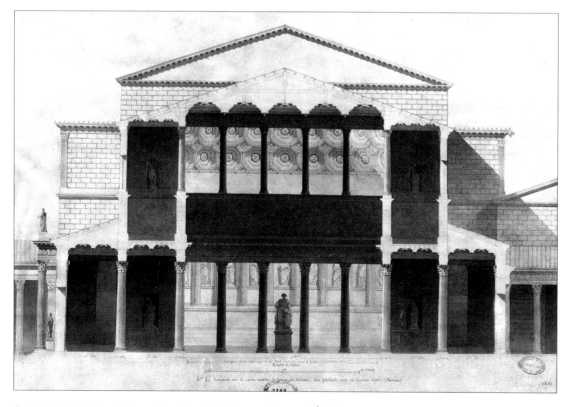

FIGURE 85. *The Basilica Ulpia: north-south section looking west. Lesueur. B.É.B.A.*

recognizes the importance of the south elevation of the building on the sestertius in the Cabinet des Médailles (Fig. 131), he makes no real use of that coin.

Moreover, his general conception of the Forum is remarkably clumsy. He apparently saw it as a series of rectangles (Fig. 82): a triumphal arch at the entrance to the Forum, the forum square, the side colonnades, the interior of the Basilica Ulpia, the forecourt in front of the east entrance to the Basilica, the East and West Libraries, the peristyle around the Column of Trajan, and the precinct of Trajan's Temple. Only two semicircles relieve the monotony of his restoration: the "the ancient structures known as the Baths of Aemilius Paullus"; that is, the west facade of the Markets of Trajan and the apse of the Basilica. Both, however, are largely separated from the rest of the complex: a street divides the west facade of the Markets from the East Colonnade, and the West Colonnade would have hidden much of the apse from a viewer in the forum square.

Worse still, each section is virtually independent of the others. Two bays wider than the central porch of the Basilica Ulpia, his triumphal arch bears no relationship to the closed facade of the Basilica opposite that effectively isolates the interior of that building from the Forum (Figs. 82-85). Then too, since Lesueur gives the Basilica Ulpia two major facades at right angles to one another, his plan is asymmetrical.

Angelo Uggeri

A student work, Lesueur's monograph on the Basilica Ulpia disappeared into the honorable obscurity of the archives of the École des Beaux-Arts in Paris from which it did not emerge for over a half-century. The first published study of the Basilica was, therefore, that of Angelo Uggeri, an energetic and successful architect and antiquary in late eighteenth and early nineteenth century Rome. Uggeri's interest in the monument awakened during the French excavations of 1811-1814. He sketched the work in progress and a few years after its conclusion published descriptions of some of the discoveries. Finally, after noting the results of Lesueur's excavations of 1823 and inspecting the discoveries of 1830, he issued his own monograph on the Basilica Ulpia.

Preoccupied with other affairs, he apparently worked in some haste, and his conception of the south elevation evolved through several stages (Figs. 86, 89, 90). In all of them, his closed facade has several entrances. An elaborate, flat triumphal arch flanked by a high entablature frames the central door, and the side entrances (excluding those that lead from the Basilica into the side colonnades around the Forum) are equally ornate (Figs. 89, 90). A clerestory lights a nave framed, like that of Lesueur, by two superimposed orders separated by a pluteus. Two domed apses close the ends of the building (Fig. 87).

With respect to his general plan of the Forum, Uggeri changes his mind. At first, he envisioned the forum square with double colonnades that masked rows of shops. At the south end of the Forum, a triumphal arch stood between two grandiose buildings, colonnaded front and back, whose sole purpose is to provide space for "merchants" and "salons for entertainment". In order to move the shops far enough forward to allow space for the known rooms of the Markets of Trajan (which seem to have been originally forgotten), he subsequently renders the lateral colonnades as single (Fig. 86). Since this drawing shows only the Basilica Ulpia and its immediate surroundings, we shall never know what repercussions this change would have had on his conception of the rest of the Forum.

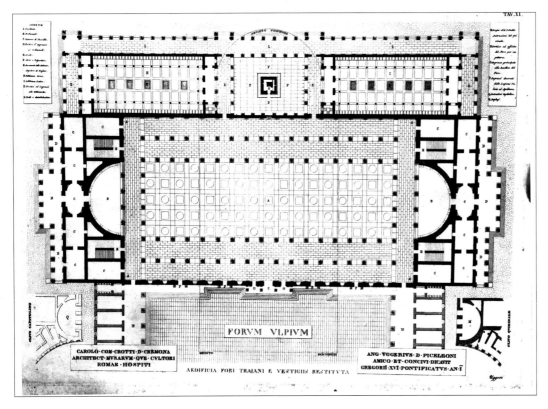

FIGURE 86. *The Basilica Ulpia: restored plan. Uggeri.*

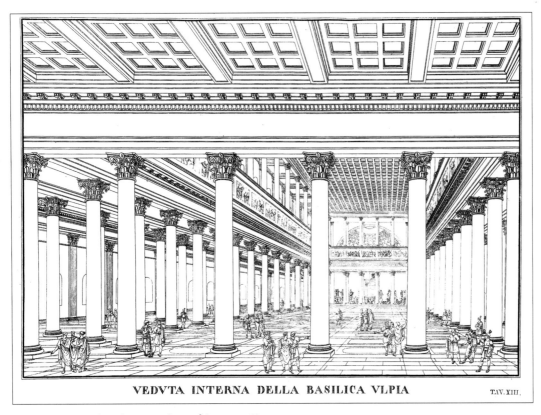

FIGURE 87. *The Basilica Ulpia: restored view of the interior. Uggeri.*

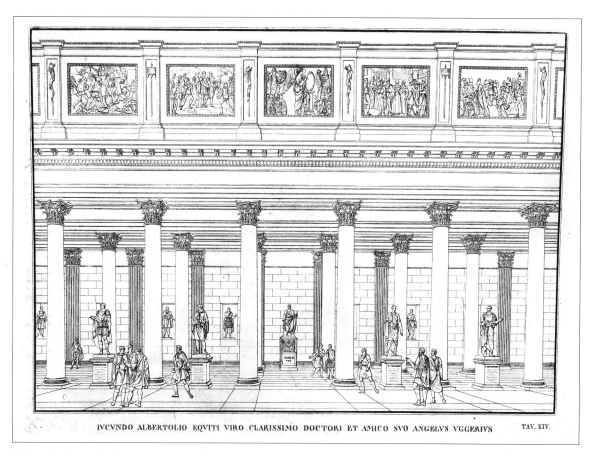

FIGURE 88. *The Basilica Ulpia: restored view of the interior, looking into the side aisles from the nave. Uggeri.*

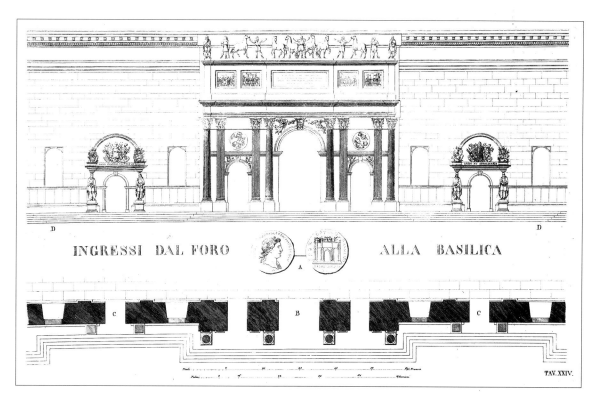

FIGURE 89. *The Basilica Ulpia: restored view of the south façade. Uggeri.*

93

As the first scholar to publish on the Forum of Trajan, Uggeri breaks new ground by emphasizing the arch-aeological evidence and providing measured renderings of the architectural elements, both those found in 1811-14 and those that came to light during the next two decades. Moreover, he emphasizes the necessity for close study of the numismatic evidence—even if he himself did not look very carefully at the individual coins; and just a few years after the excavations of 1811-1814, he advocates comparing the physical remains with that fragment of the Forma Urbis that shows the nave of the Basilica Ulpia (Fig. 130).

Nonetheless, Uggeri's interest in the reconstruction of the Basilica of St. Paul's Outside-the-Walls and various social obligations distracted him from leisurely study and revision, and his final book is not so much a unified exposition as the notes and drawings of a work-in-progress. Then too, despite his emphasis on the ancient evidence, he really uses these materials only as inspirations for handsome drawings. Hence his views of the interiors and rear elevations of the apses are entirely imaginary; even in cases where he bases his drawings on architectural elements—as in the two renderings of the south (Forum) facade—the results are little short of fantastic (Figs. 89, 90). Yet, whatever the occasionally extravagant character of Uggeri's individual views, his conception of the entire Forum is simplistic: a series of contiguous rectangles (Fig. 86). The first narrow one includes the triumphal arch with its flanking buildings; the next, a wider unit, takes in the forum square and its flanking colonnades. The third, equal in size to the second, encloses the Basilica and its dependencies. The fourth, one-third narrower than the second and third, comprises the two Libraries and the peristyle around the Column of Trajan, The fifth, the Temple of Trajan, at right angles to all the others, equals the width of the nave and aisles of the Basilica, and the cella of the Temple is as wide as the nave and inner aisles of the Basilica.

Excluding the apses of the Basilica, this is an uneventful design of straight lines and endless regular colonnades. Turning its back on the Markets of Trajan and the responding structure on the slopes of the Capitoline Hill, it buries the ancient plan in the overly facile solutions of early nineteenth-century Neo-classicism. Consequently, despite the dutiful applause of Uggeri's friends in the Roman Pontifical Academy of Archeology, other students of the Forum of Trajan justly neglected his work—even as they adopted its methodology.

RESTAVRO DELLA DECORAZIONE DELLA LEGIONE VALERIA

FIGURE 90. *The Basilica Ulpia: the south facade, restored section and bay. Uggeri.*

Prosper-Mathieu Morey

Two years after the publication of Uggeri's monograph, Prosper-Mathieu Morey, another young winner of the Grand Prix de Rome, made the Basilica Ulpia the subject of a third restoration study, a far more sophisticated attempt to comprehend the Basilica and Forum in terms of the ancient evidence (Figs. 91-94). In an essay on his restoration, Morey frequently cites the Forma Urbis (Fig. 130) and numismatic representations both of the facade of the Basilica Ulpia (Figs. 131-32) and the triumphal arch at the entry to the Forum; and his drawings demonstrate that he had carefully studied these sources. In addition, he spent much time on the site. He did some limited excavation (supra p. 27) and measured and drew a large number of fragments, producing a plan of the site as it was in his day.

Like Uggeri's Basilica Ulpia, Morey's had a closed facade with three porches (Figs. 91-93). In a high attic above, Dacian atlantes stand on a base that

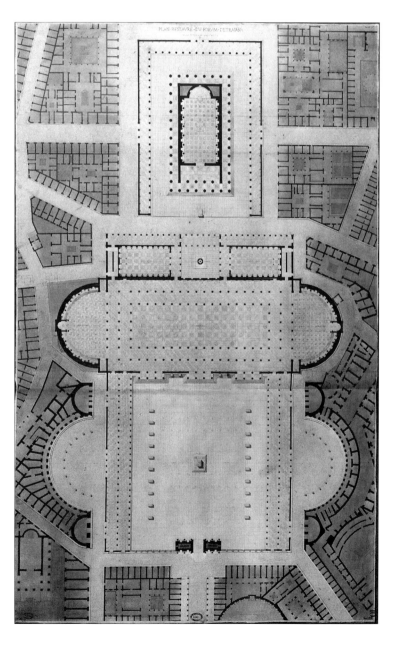

FIGURE 91. *The Forum of Trajan: restored plan. Morey. B.É.B.A.*

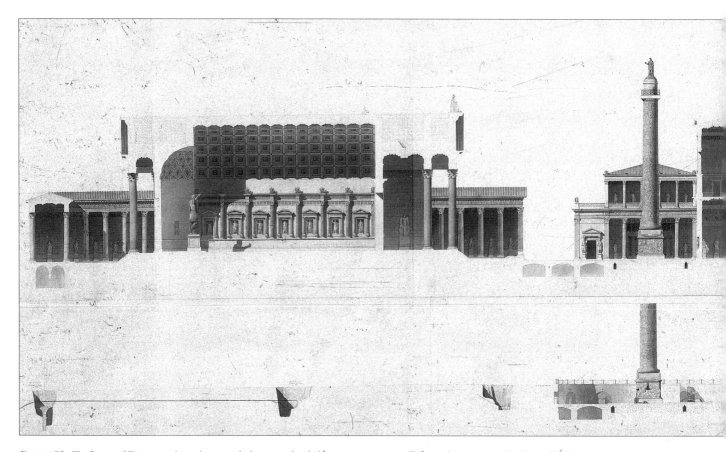

FIGURE 92. *The Forum of Trajan: north-south section, looking east, detail.* Above: *reconstruction.* Below: *the ruins in 1835. Morey. B.É.B.A.*

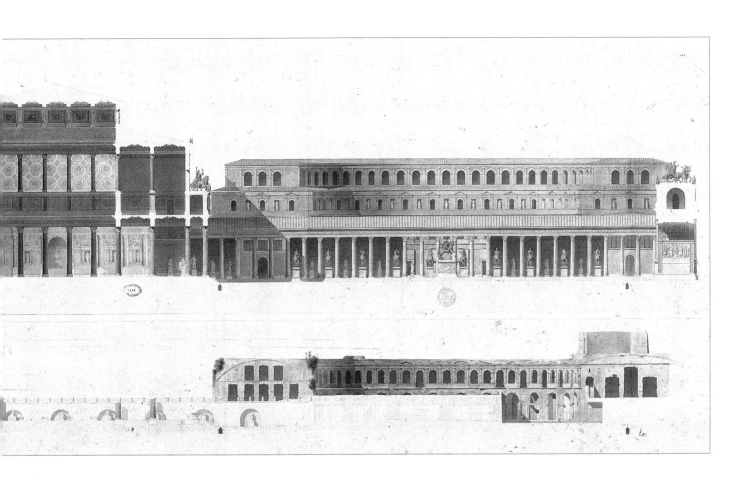

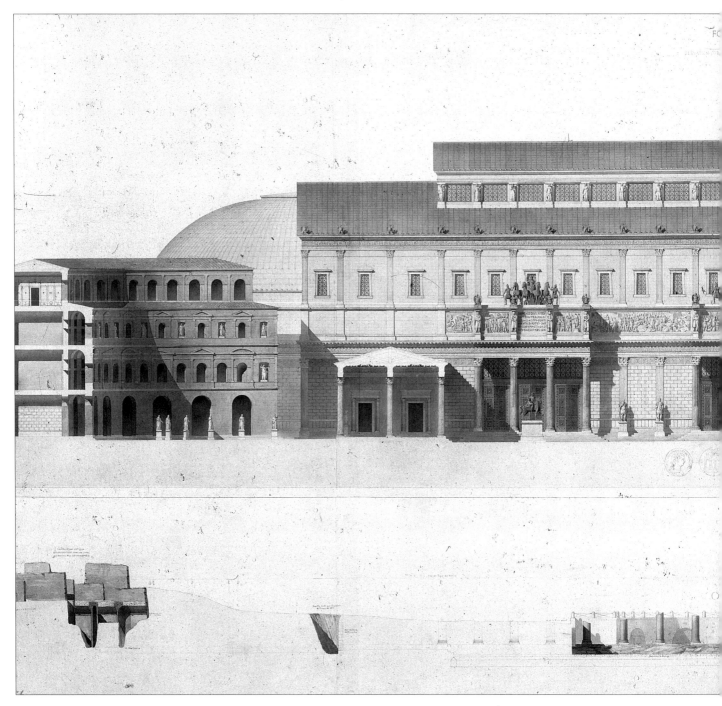

FIGURE 93. *The Basilica Ulpia, south facade:* Above: *reconstruction.* Below: *section of the same area in 1835. Morey. B.É.B.A.*

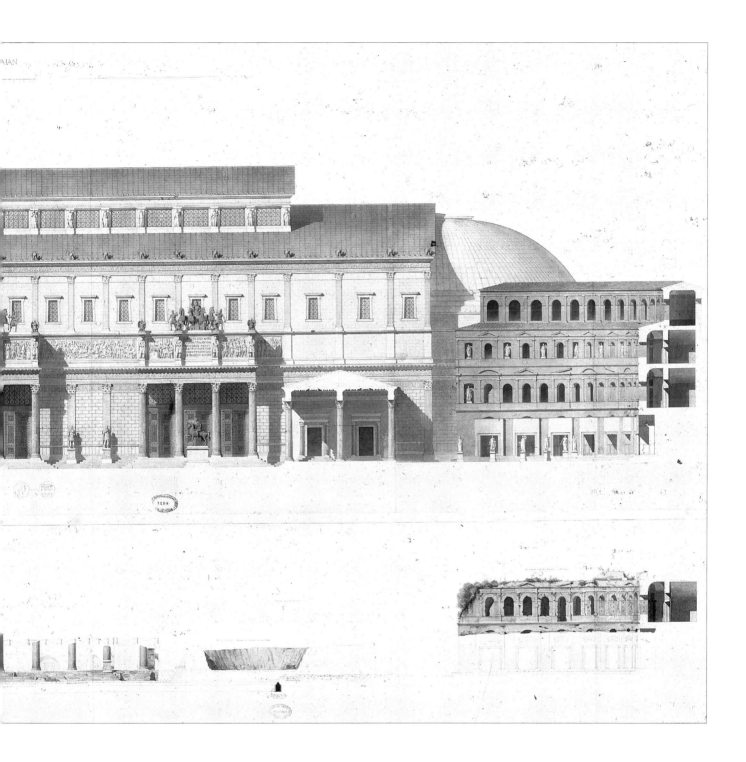

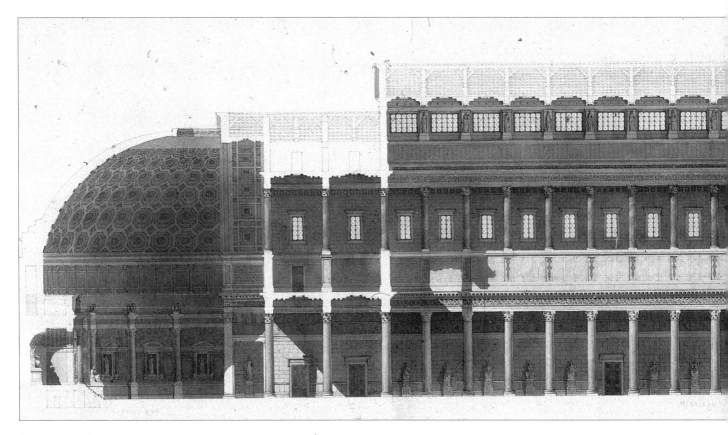

FIGURE 94. *The Basilica Ulpia: east-west section, looking north. Morey. B.É.B.A.*

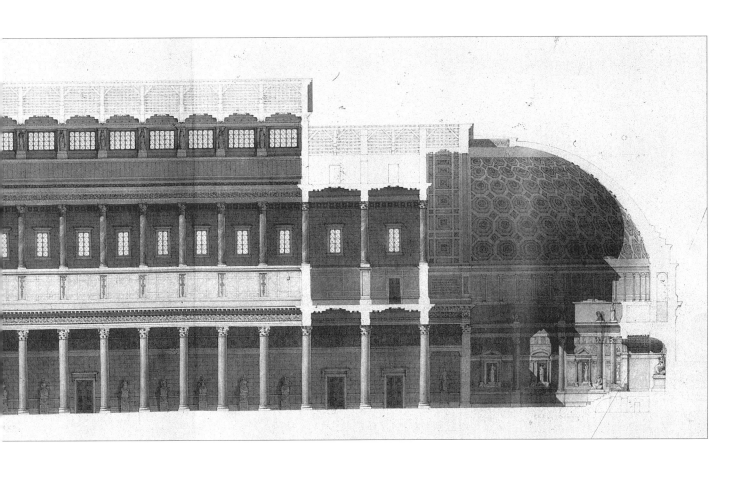

continues on the facades of the porches (Fig. 93). In the bays between the statues, a fascia on the cornice is decorated with inscriptions commemorating the legions that had participated in the Dacian Wars, and triumphal chariots crown the porches.

Second story windows and a third-floor clerestory light the interior, and a high Vitruvian pluteus separates the upper and lower orders (Figs. 92-94). Timber-trusses, masked below by coffered ceilings, roof the nave and aisles, and at the short ends of the building rectangular wings, or "intermediate blocks" screen the two apses (each with a central tribunal) from the nave. Despite a cool reception from a contemporary critic, its skillful use of the ancient evidence marks this restoration as a real contribution to the study of the Basilica Ulpia and its setting. Morey is the first to realize that the lower exterior order had a high attic and to identify its architectural elements correctly. Moreover, his treatment of the sculpture on the porches closely follows representations on contemporary coins (Figs. 92-93, 131-32). For the interior of the nave (Fig. 94), however, he simply repeats Lesueur's suggestions (Figs. 84-85) and derives the first and second orders from elements on the site; the pluteus, from Vitruvius. Like Lesueur, however, he does not include a measured drawing of the columns of the second order, and thus fails to provide future scholars with a means of verifying his evidence.

His conception of the apses, however, advances far beyond that of Lesueur (Figs. 91, 93-94). He accepts Uggeri's suggestion that the Basilica Ulpia had two apses not the single one of the early Christian basilica (Figs. 86, 91); and, although he follows Lesueur in taking the form and decoration of of the dome and the details of its order from the Basilica of Maxentius/Constantine (Figs. 84, 94), he combines these architectural loans with a plan derived from the Forma Urbis (Fig. 130), to create an archaeologically and stylistically plausible design.

Finally, Morey's conception of the entire Forum (Fig. 91) is more unified and sophisticated than Lesueur's—although even here he owes his predecessor a considerable debt. Like Lesueur, he conceives the Forum as open on the south side and flanked laterally by one-story double colonnades (Figs. 91-93). His triumphal arch, however, corresponds with reasonable fidelity to representations on sestertii and aurei (Figs. 47-48); and he realizes that the semicircular west facade of the Markets of Trajan and the responding structure on the slopes of the opposite Capitoline Hill mirrored and continued the curves of the apses of the Basilica Ulpia (Fig. 91). Consequently, his plan of the Forum shows a rhythmic unity sadly lacking in Lesueur's corresponding drawing (Fig. 82).

Fjodor Richter

Four years after Morey finished his restoration, Fjodor Richter published another monograph on the Forum of Trajan. On the closed south (Forum) facade of Richter's Basilica, the chief features are three four-columned porches (Figs. 95, 98). Statues of Dacian prisoners divide the attics (continued in the bays between the porches) into four bays, and the triumphal statuary on the porches is partially imaginary. A single grand entrance on axis with the Column of Trajan distinguishes the north facade (Figs. 95, 99).

The interior closely follows Morey's drawings (Figs. 95-97). Light enters from second-story windows and a clerestory on the third floor; and the columns of the upper order stand on a Vitruvian pluteus. Concealed by the coffered ceiling over the nave, the timber-truss roof is a somewhat higher version of Morey's design, and, at the ends of the building the apses, entered from the nave by an "intermediate Block" roofed with a high barrel vault, are domed and coffered. Both Morey and Richter thus conceive the Basilica Ulpia as a three-story building with a clerestory over the nave and two identical semi-domed, opposed apses (Figs. 94, 97) Richter must have seen Morey's preliminary or final drawings in Rome or else the two had talked, and in consequence their designs embody mutually agreed upon concepts. In any case, of the two, Richter approached his subject carelessly, frequent-

ly ignoring or inadequately comprehending the true character of the archaeological record. Thus, the lateral colonnades of Richter's Forum are on the same level as those of the Basilica's first order and equal them in size (Figs. 95, 96, 98), while Morey correctly shows shorter columns on a lower stylobate (Figs. 92, 93). In the attic on the south facade of the Basilica Ulpia, Richter follows Morey in locating statues of Dacian prisoners above the columns of the lateral porches. Yet, where Morey correctly uses the statues to support the elaborate cornices still preserved in the Forum (Fig. 93), Richter perversely sets the same cornices atop caryatids in the interiors of the Libraries (Fig. 99).

Like Morey's nave (Figs. 92, 94), Richter's (Fig. 96-97) combines the existing elements of the first interior and exterior orders with precepts taken from Vitruvius. Although both men assume that the cipollino columns of the second order (Fig. 148) are 3/4 the size of the gray granite ones of the first (Figs. 133-34), they disagree on the pluteus. Realizing that, if Vitruvius were followed literally, the pluteus would be enormously high, each rejects Vitruvius. Morey, however, sensibly makes the pluteus the same height as the attic on the facade (Fig. 92); Richter, for no discernable reason, conceives it as substantially lower (Fig. 96).

In the apses, Richter adopts Morey's views completely, although again his details vary, sometimes merely for the sake of producing an "original" restoration, and, while Richter closes off his intermediate blocks, Morey, relying on the Forma Urbis (Fig. 130), leaves them open (Figs. 91, 95). And finally, if Richter defies the evidence on the site to introduce into the north facade a single grand portal on axis with and facing the Column of Trajan (Figs. 95, 99), Morey, observing the existing remains, shows two entrances leading from the Basilica Ulpia into the colonnades in front of the Libraries (Figs. 91, 94).

For all its great merit, Morey's work was nonetheless consigned to the relative obscurity of the files of the École des Beaux-Arts while Richter's monograph, published shortly after its completion, served as one of the models for the second of Luigi Canina's two theoretical restorations of the Basilica Ulpia.

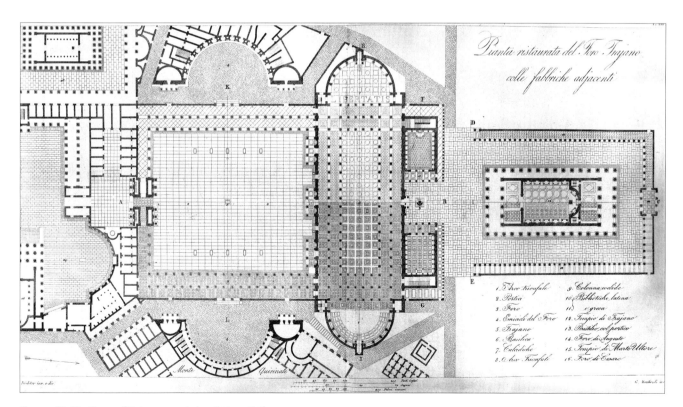

FIGURE 95. *The Forum of Trajan: restored plan. Richter-Grifi.*

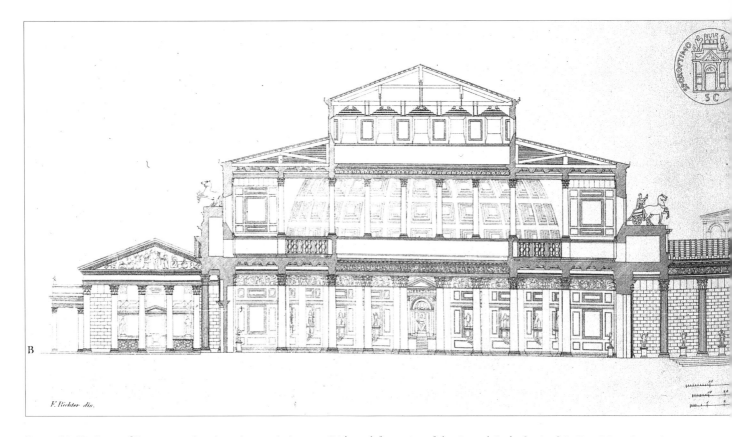

FIGURE 96. *The Forum of Trajan, restored north-south section looking east.* Right to left: section of the Central Arch, *facade of the East Colonnade, north-south section of the Basilica Ulpia, facade of the East Library. Richter-Grifi.*

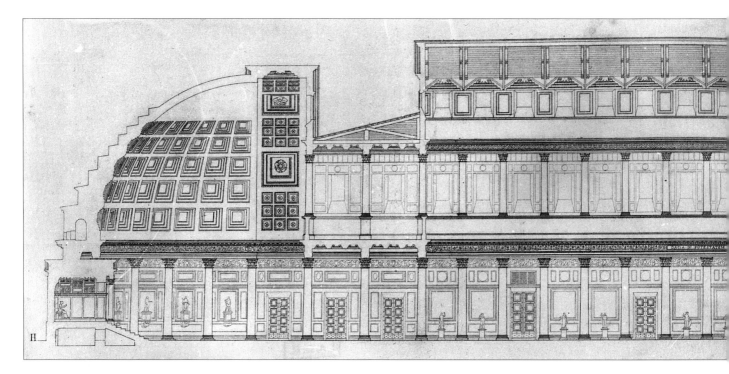

FIGURE 97. *The Basilica Ulpia: east-west section. Richter-Grifi.*

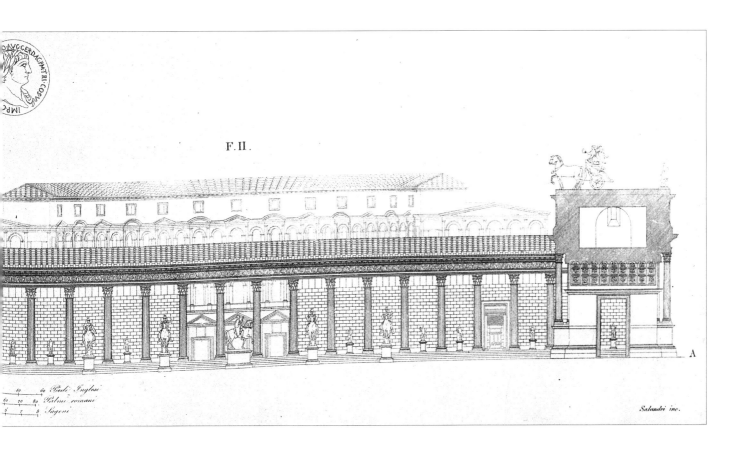

F.II.

A

Salandri inc.

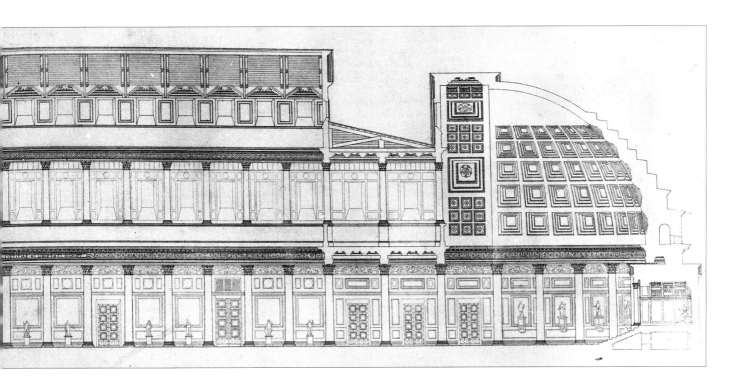

105

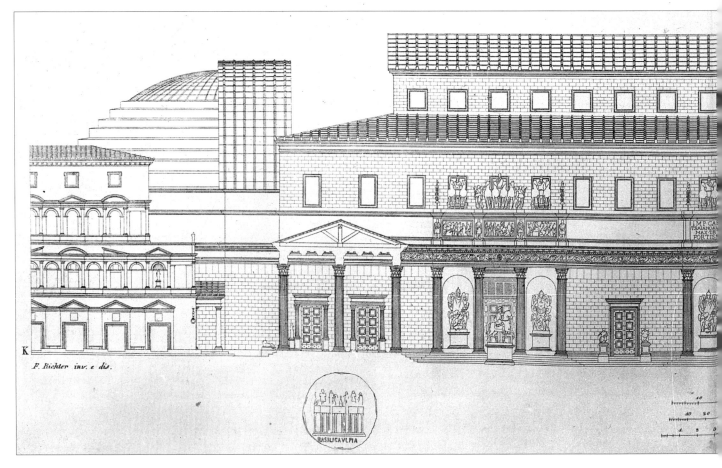

FIGURE 98. *The Basilica Ulpia: south facade; the East and West Colonnades: east-west sections. Richter-Grifi.*

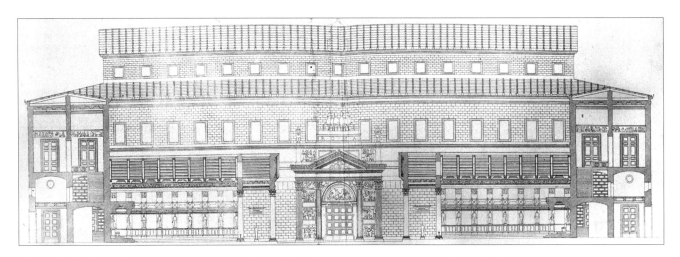

FIGURE 99. *The Basilica Ulpia: restored north facade; the East and West Libraries: restored east-west sections. Richter-Grifi.*

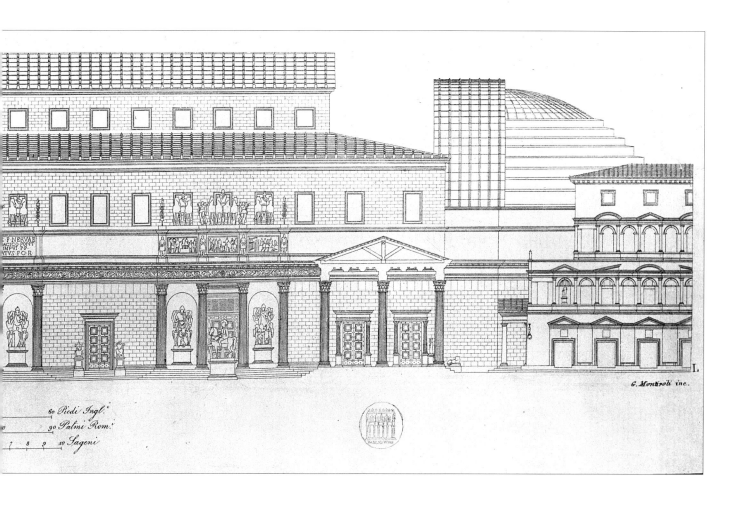

60 Piedi Ingl.

90 Palmi Rom.

10 Sageni

Canina's first restoration of the Basilica, executed by 1833-1834, was the least successful (Figs. 100, 101). Three four-columned porches with unfluted Corinthian columns dominate his closed south (Forum) facade. In the openings behind the porches, columns *in antis* screen the interior. Windows on the second story and a clerestory light the interior, and coffered ceilings, their designs unrelated to those of the marble pavements below, roof the nave and aisles. The colonnades that divide the nave from the side aisles support a pluteus and the columns of the upper order.

An "intermediate block", a separate wing between the nave and the apse, has its own wooden roof, and while Canina never really worked out the details of the two apses, they also have slightly lower gabled timber roofs of approximately the same height as those above the second-story colonnade that flanks the nave. Following the Forma Urbis (Fig. 130), Canina bisects each apse with a temple-like tribunal, framed on either side by five bays marked off by columns at the ends of short partitions.

Completed nearly twenty years after his first efforts, Canina's second restoration, perhaps discussed at various times with Uggeri, Morey, and Richter, is far more sophisticated (Figs. 18, 102-109). Although the general facade of the building is the same (Figs. 102-103A), there are some extemely important changes. The lateral porches now have two columns apiece, and on their high attics, Dacian atlantes frame the bays. Fluted pilasters divide the four recesses between the porches into four bays, and pedestals in front of each pilaster support seated figures.

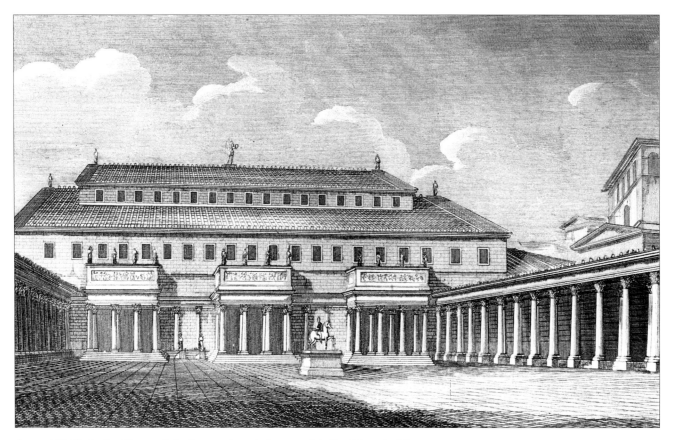

FIGURE 100. *The Basilica Ulpia, south facade: restored view, looking toward the East Colonnade. C.I.*

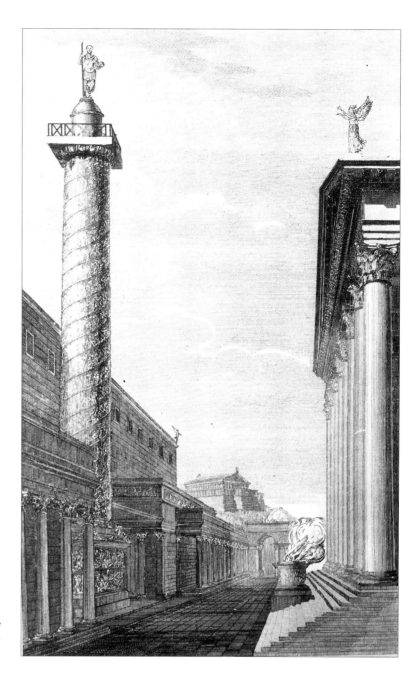

FIGURE 101. *The north facade of the Basilica Ulpia, the Column of Trajan, and the facade of the Temple of Trajan, looking west. C.I.*

Like Morey and Richter, Canina uses second-story windows and a clerestory to light the interior of his Basilica (Figs. 103A, 104-106). The dimension of the lower interior order are identical to those of the exterior order, but the interior columns have shafts of gray Egyptian granite; the columns on the facade, shafts of fluted giallo antico (Figs. 18, 103A, 104-106). The interior columns support the upper order on a Vitruvian pluteus, and coffered ceilings in the nave and aisles conceal the timber-truss roof. The two apses have central temple-like tribunals and masonry semidomes (Figs. 102-106).

In comparison with its immediate predecessors, the works of Lesueur and Uggeri, even Canina's first restoration represents a considerable advance (Figs. 100-101). Lesueur's "Christian" basilica has an entrance to the east and an apse to the west (Figs. 82-84). Uggeri recognizes two apses, but relying entirely on his imagination he supposes that, in proportion to the rest of the building, they are relatively small (Figs. 86, 87). Canina's great contribution is his emphasis on the correct interpretation of the fragments of the Forma Urbis, both the extant fragments

and the relevant drawing of a lost fragment today among the Latin Manuscripts of the Vatican Library (Figs. 102, 130). Thus his plan of the apses repeats that of the Forma Urbis, but he perhaps indicates that, in elevation, these apses would have had timber-truss roofs (Fig. 100).

His assumption that the south porches had free-standing columns is a great improvement over Uggeri, although, since he was apparently not acquainted with Lesueur's plan of the Basilica and the flanking Colonnades (Fig. 83), he shows the three south porches of equal width and does not continue the south stair past the ends of the porches. Moreover, without any attempt to examine existing evidence from the East Colonnade, he designs orders for the Colonnades in the Forum that equal in height those of the side porches of the Basilica Ulpia (Fig.

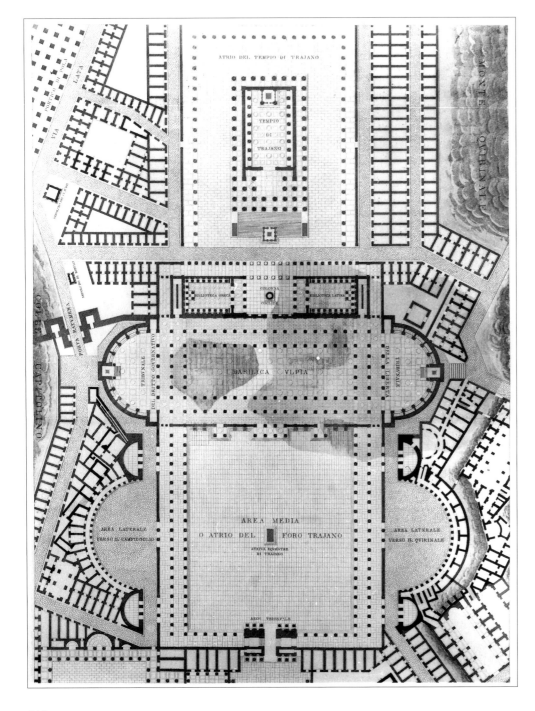

FIGURE 102. *The Forum of Trajan: restored plan superimposed over fragments of the* Forma Urbis. *C.E.*

100). Supposing that the Colonnades had a stylobate only one step high, he sets their columns on low pedestals, an arrangement more common in late antiquity than in the reign of Trajan.

Above the entablature of the porches of the Basilica, his elevations are entirely conjectural (Fig. 100). The attics of the porches are not composed of recognizable fragments from the site, and the walls of the upper stories are rendered in plain ashlar masonry with cornices marking the tops of the attic, the second story, and the clerestory. Unlike the attempts of Lesueur and Uggeri, however, Canina's Basilica Ulpia relates clearly to the rest of the Forum. The triumphal arch at the entrance to the complex mirrors the opposite main porch of the Basilica (Fig. 100); by their identical proportions, the lateral colonnades are closely connected with the Basilica Ulpia; and the semicircular facades of the Markets of Trajan and the responding building on the slopes of the Capitoline Hill anticipate and reflect the apses of the Basilica.

In general conception, Canina's second restoration, completed after 1849, clearly utilizes the work of Richter and, through Richter, of Morey (Figs. 18, 102-09). Like Richter, Canina now connects the stairways of the colonnades and the Basilica Ulpia, erroneously assuming that the podia of all three buildings had been of equal height (Figs. 103A-104). The fact that the orders of the Colonnades had been lower than that of the Basilica had long been forgotten. Yet, after his excavation of 1849, Canina knew that the lateral porches had only two columns apiece, and he reconstructs the attics of the porches correctly (Fig. 18). Above the porches, his facade has not changed substantially from his first restoration (Figs. 18, 103A-105, 107).

For the interior of the Basilica Ulpia, Canina again owes much to Richter (Figs. 95-97, 102, 103B-106, 108), and the high domes of his apses adhere to what had by now become a traditional pattern (Fig. 103A, 104-106). In order to cover the larger spaces suggested by the plan on the Forma Urbis, Morey had greatly (enlarged the small dome of Lesueur's apse, and Richter took over the concept of these large domes, transmitting it directly to Canina (Figs. 84, 94, 97, 106). Following Richter rather than Lesueur and Morey, Canina assumes that the coffers of the domes were identical to the coffers in the Pantheon (Figs. 103A-106). With monumental modillions suspended from the walls, the bays below resemble those of Richter. And finally, with Richter, Canina assumes that a grand entrance, centered on the axis of the Column of Trajan, led from the north side of the Basilica into the peristyle around the Column (Figs. 102, 106).

Only in the connection between the apses and the central section of the building did Canina abandon Richter (Figs. 97, 106). Modeled on Richter's interior, two-story colonnades divide Canina's nave from his apses and intermediate blocks. Following Morey, Richter roofs these wings with enormous concrete barrel vaults that rise slightly above the level of the domes of the apses. Canina retains these vaults, but, unlike Richter, does not articulate them on the facades of the building, concealing them instead under extensions of the roof over the nave (Figs. 103A, 106). The vaults are the height of the apses, and the skylights of the apses rise slightly above them.

Although the general concepts behind Canina's second restoration are thus not original—or even, indeed, entirely faithful to the archaeological evidence— they are attractively rendered in handsome plates that not only caught the imaginations of contemporaries but also even occasionally reappear today. Part of the reason for this continuing popularity lies in the comparatively large press runs of Canina's works. Lesueur and Morey remained initially unpublished; the works of Richter and Uggeri immediately became rare books, scarcely obtainable outside of a few libraries in Rome. On his own presses, however, Canina produced sufficient copies of his works to distribute these books widely throughout Europe and the United States. In consequence, throughout the nineteenth and early twentieth centuries, Canina's second restoration became the standard reference for all later students of the Basilica Ulpia.

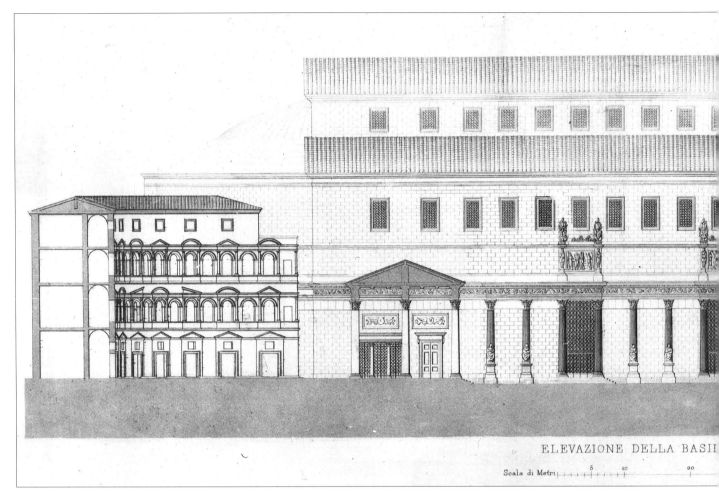

ELEVAZIONE DELLA BASII

Scala di Metri 5 10 20

FIGURE 103A. *The Basilica Ulpia: the restored south facade; the East and West Colonnades, sections. C.E.*

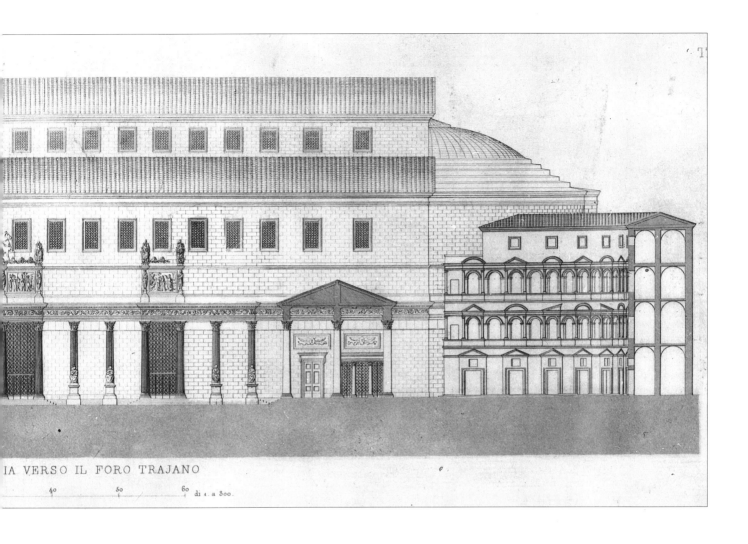

IA VERSO IL FORO TRAJANO

40 50 60 di 1. a 300.

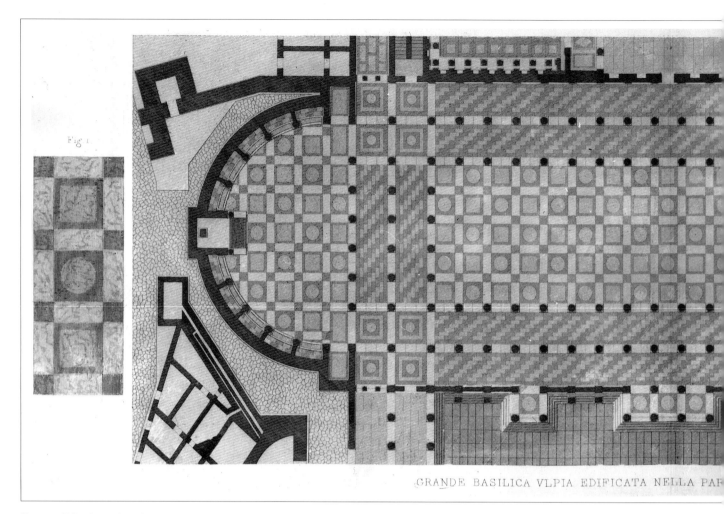

FIGURE 103B. *The Basilica Ulpia: restored plan showing the marble pavement. C.E.*

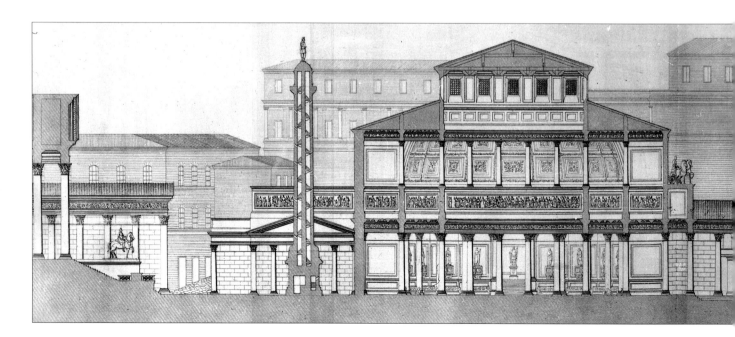

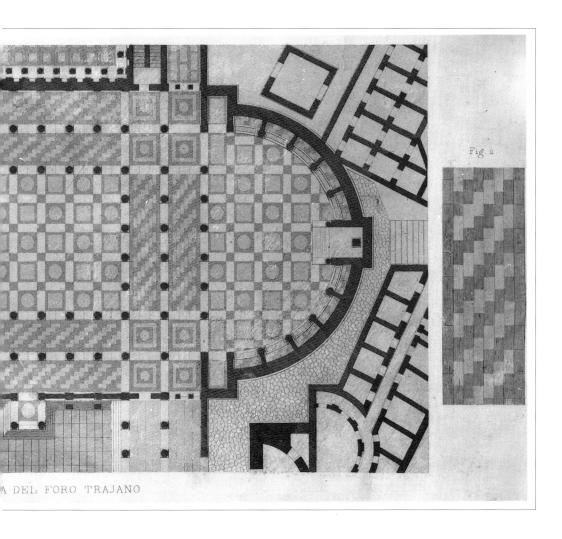

A DEL FORO TRAJANO

Fig. 2

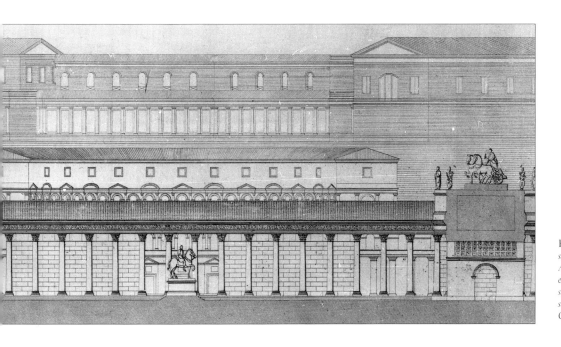

FIGURE 104. *The Forum of Trajan, section. Right to left: the Central Arch, section; the East Colonnade, elevation; the Basilica Ulpia, north-south section; the Column of Trajan, section; the East Library, facade. C.E.*

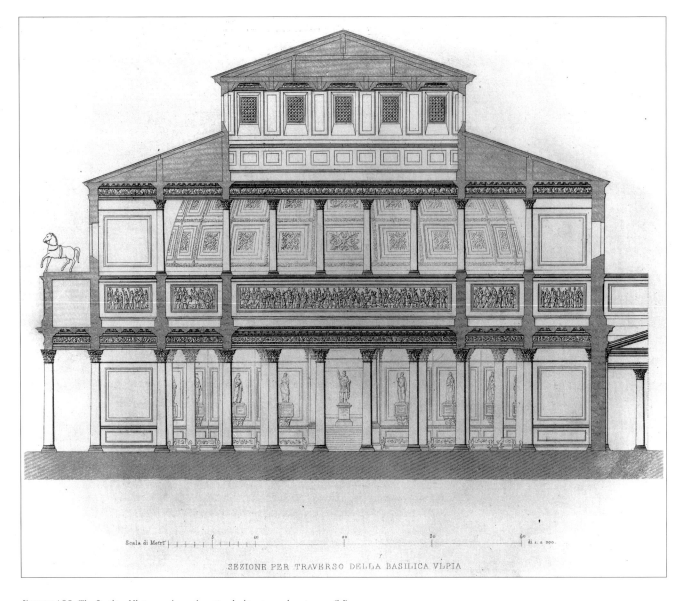

Scala di Metri | di 1 a 200.
5 10 20 30 40

SEZIONE PER TRAVERSO DELLA BASILICA VLPIA

FIGURE 105. *The Basilica Ulpia: north-south section looking toward west apse. C.E.*

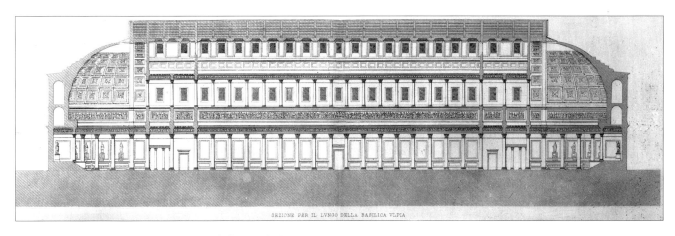

FIGURE 106. *The Basilica Ulpia: east-west section looking north. C.E.*

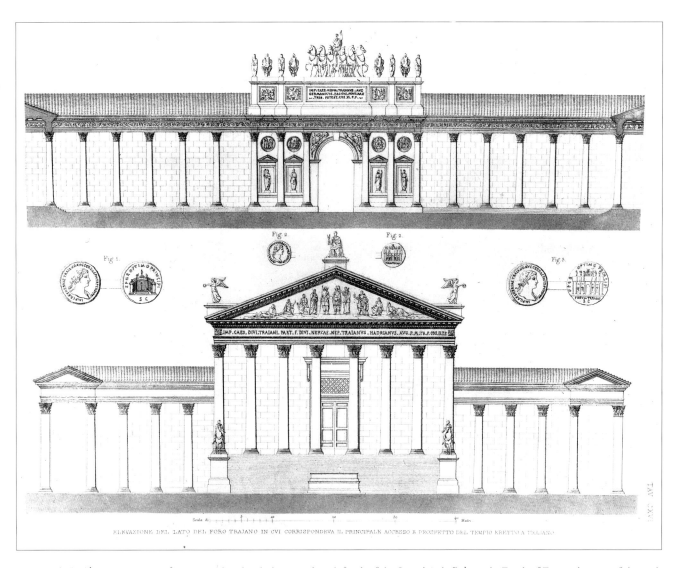

FIGURE 106A. Above: *The Forum of Trajan: south end with the restored north façade of the Central Arch.* Below: *the Temple of Trajan: elevations of the south façade and temenos colonnades. C.E.*

117

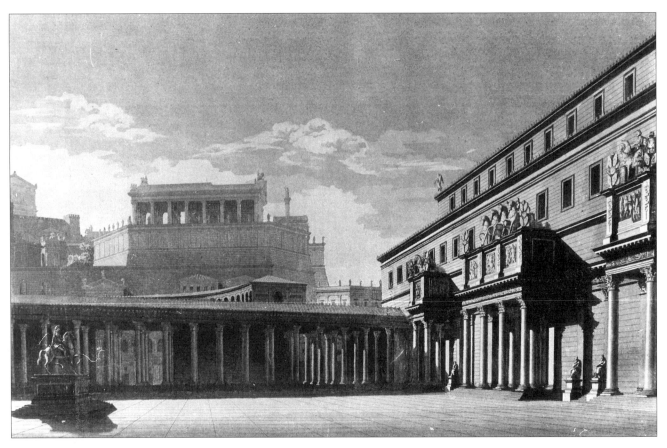

FIGURE 107. *The Forum of Trajan: restored view looking northwest toward the Capitoline Hill. C.E.*

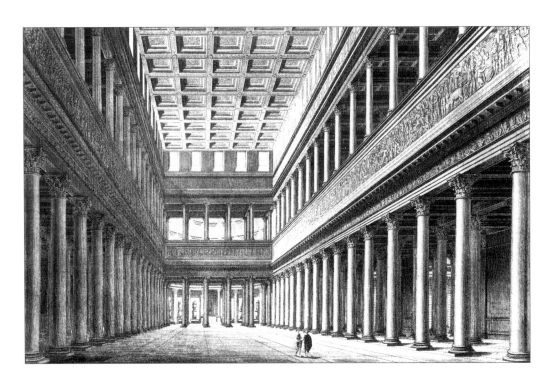

FIGURE 108. *The Basilica Ulpia: restored view of the interior looking southeast. C.E.*

118

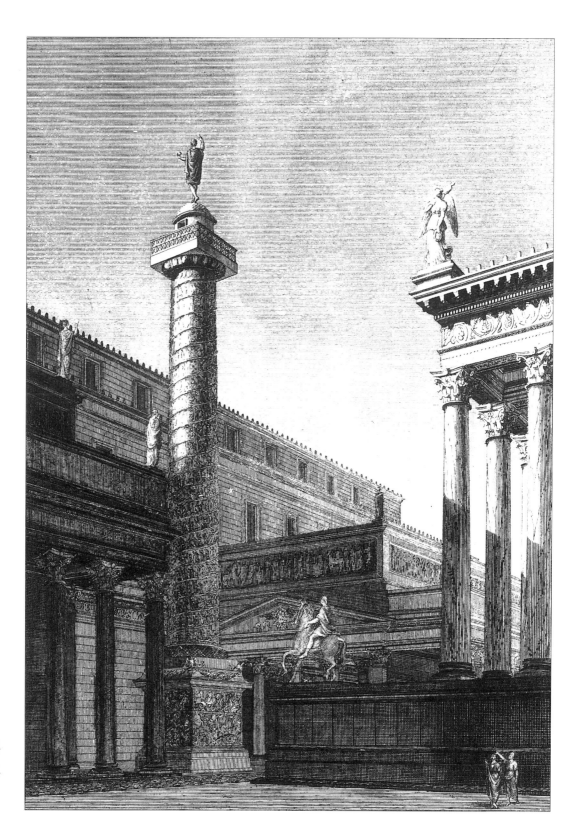

FIGURE 109. *Area around the Column of Trajan after construction of the Temple of Trajan, looking west. C.E.*

Julien Guadet was the last of the students of architecture at the École des Beaux-Arts at the Villa Medici to undertake a major theoretical restoration of the Basilica Ulpia. since the Basilica Ulpia had been so extensively studied by 1867, most recently by the formidable Canina, Guadet approached his subject reverently with an accuracy and an attention to detail unknown to his predecessors.

He made several small excavations (supra pp. 28-29) and measured the site exhaustively, presenting the results in several drawings (Figs. 13, 19). Measuring and sketching the major surviving architectural fragments, the young architect reproduced them in delicately executed, scaled pen-and-wash drawings that included measurements.

Combining this meticulous preparation with a close study of earlier students, the Forma Urbis, and representations of the monuments of the Forum on Trajanic coins, Guadet embarks on his own restoration. His plan (Fig. 110) is essentially that of Canina (Fig. 103B), more archaeologically correct in some points, greatly elaborated in others.

Guadet correctly proportions his Basilica Ulpia with respect to the Colonnades on either side of the forum square (Figs. 110-12, 114), and after much thought, he rejects the views of all earlier students, giving the Basilica's south facade colonnades on the first two floors and a clerestory on the third (Figs. 111-13, 115-16). The rest of the south facade is based on Canina's drawings, but on the north facade, since Guadet had examined the site more carefully than Canina, he correctly replaces Cannina's single grand entrance, aligned with the Column of Trajan, by two smaller doors that open into the peristyle in front of the East and West Libraries (Figs. 103B, 110).

Guadet's interior resembles those of his predecessors, but with some important differences (Figs. 111, 113, 116-17) . Flanking the nave, the columns of the lower order have shafts of gray granite; those between the aisles, of giallo antico and pavonazzetto, and the aisles are barrel vaulted. On the by now traditional Vitruvian pluteus, the cipollino columns of the second order support an open, elaborately decorated timber-truss roof sheathed over the aisles and nave with thin metal plates. At the east and west ends of the building, the domed apses are visible through grandiose triumphal arches that rise above bridges carried by the columns of the lower order (Figs. 117-18). The plan of each apse (Fig. 110), a central tribunal bracketed on either side by five bays, follows the Forma Urbis (Fig. 130), but the rest of Guadet's elaborately realized decorations in these wings is largely imaginary (Figs. 112, 113, 116-118).

Like the work of Morey, Guadet's restoration was exhibited in Rome in the Villa Medici and in Paris at the École. Until very recently, however, with the exception of a few published plates dismissed by a later scholar as "[an] academic exercise...," it had fallen into an undeserved obscurity. Nonetheless, this essay marks a considerable advance in the study of the Basilica Ulpia. With respect both to levels and elevations, Guadet relates the Basilica correctly to the East and West Colonnades; and he realizes that all three buildings shared a continuous stair (Fig. 110-11). He is the first (and last) to suggest that the Basilica had communicated freely with the forum square through a colonnaded two-story facade (Figs. 112, 115) . And, for the appearance of the attic of the first order, he correctly accepts the evidence of Canina's excavations of 1849 (Figs. 18). As for the interior of the

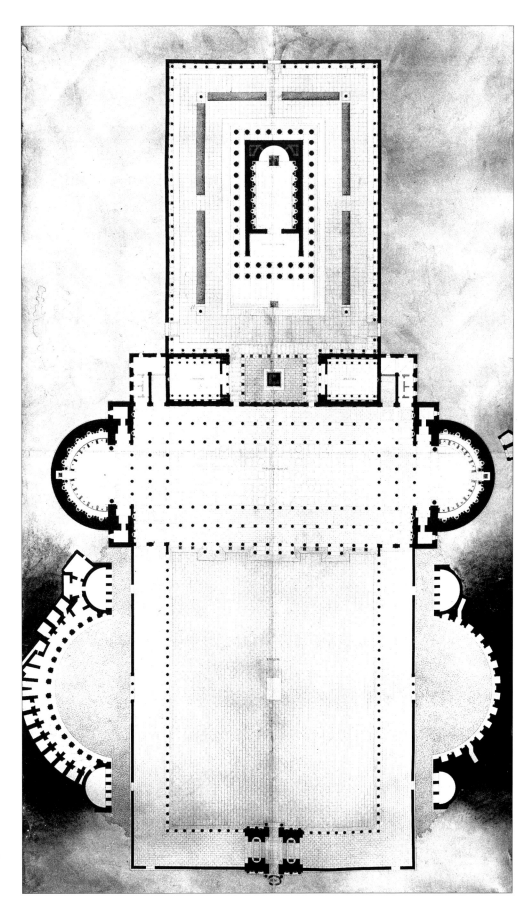

FIGURE 110. *The Forum of Trajan: restored plan. Guadet. B.E.B.A.*

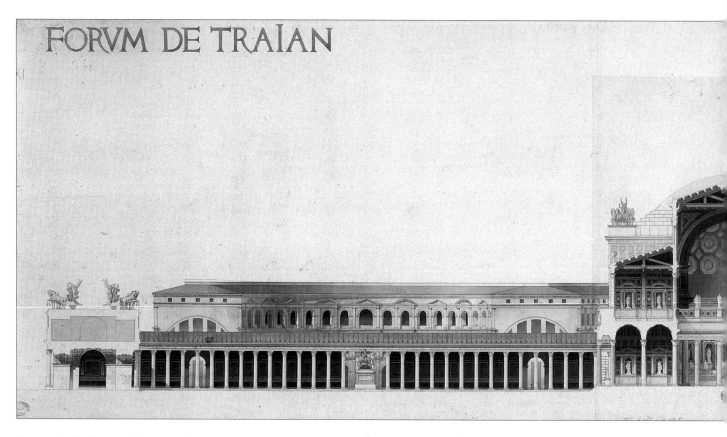

FIGURE 111. *The Forum of Trajan: restored north-south section looking west. Guadet. B.É.B.A.*

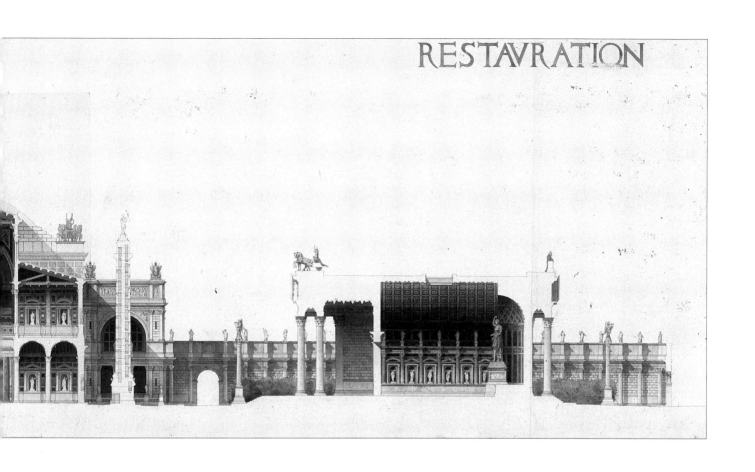

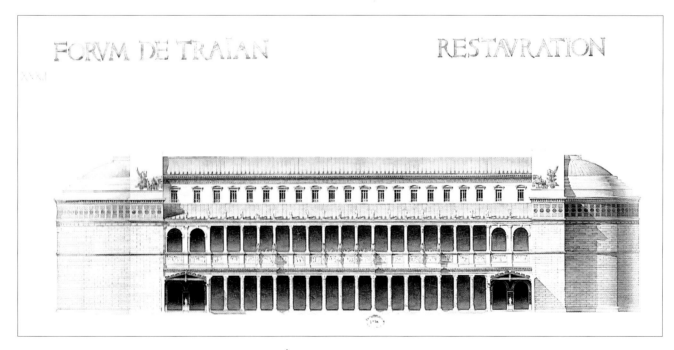

FIGURE 112. *The Basilica Ulpia: restored south facade. Guadet. B.É.B.A.*

FORVM DE TRAIAN

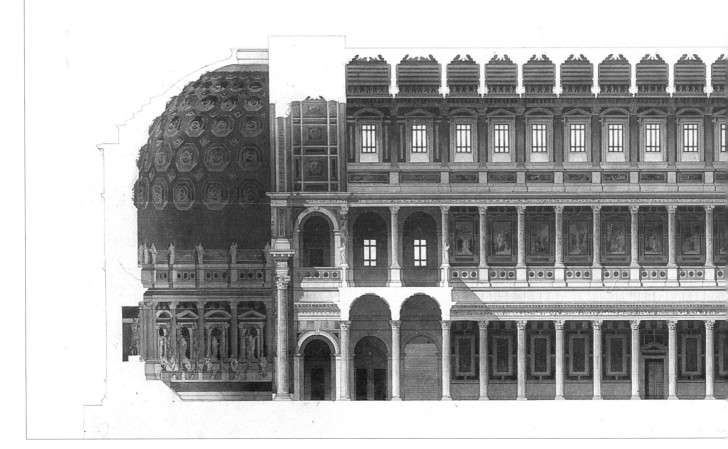

FIGURE 113. *The Basilica Ulpia: restored east-west section looking north. Guadet. B.É.B.A.*

RESTAVRATION

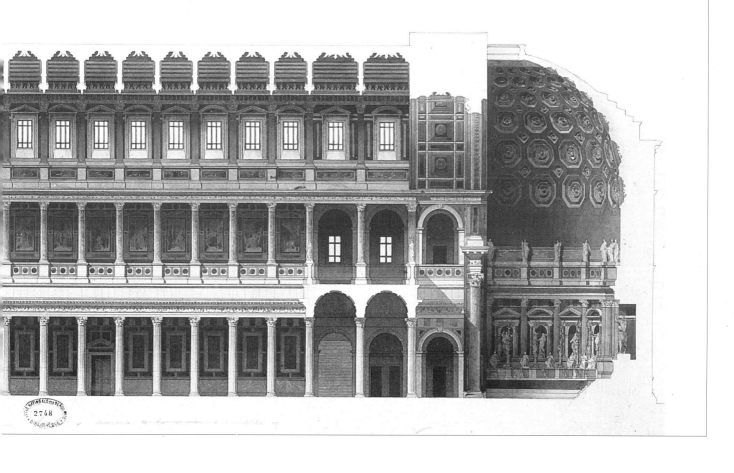

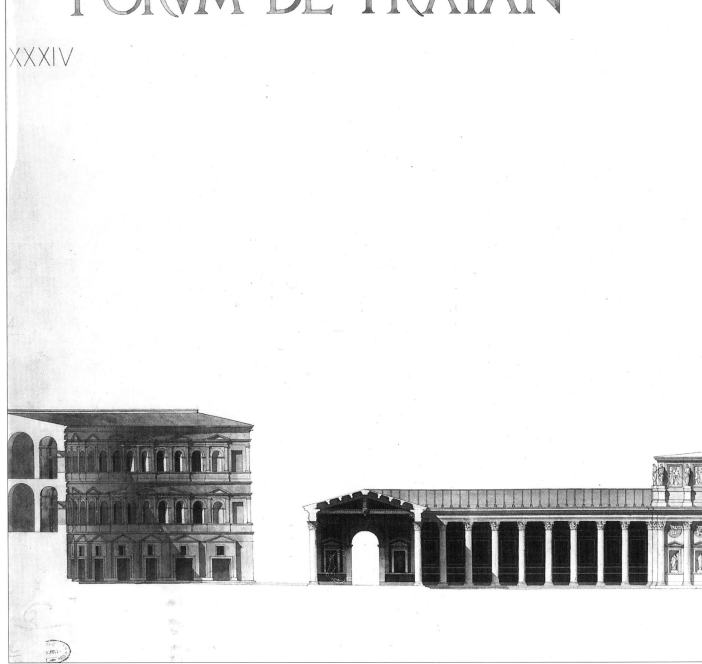

FIGURE 114. *The Forum of Trajan: restored east-west section, looking south to the Central Arch and South Colonnade. Guadet. B.É.B.A.*

RESTAVRATION

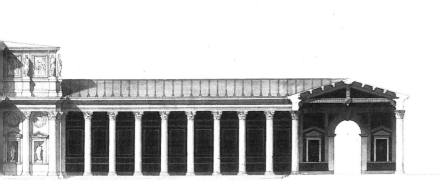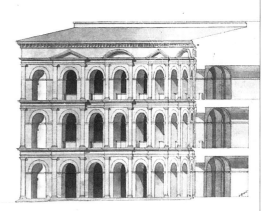

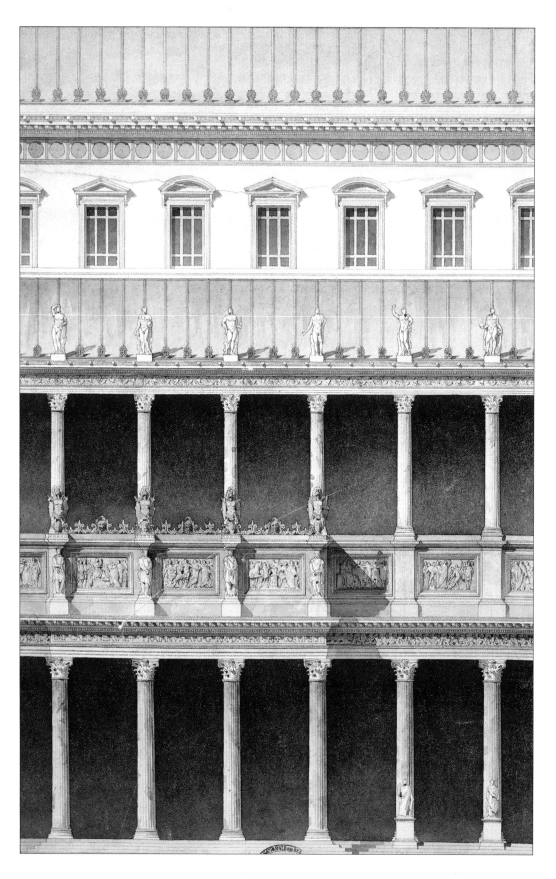

FIGURE 115. *The Basilica Ulpia, south facade: restored elevation of the central porch and several adjacent bays. Guadet. B.É.B.A.*

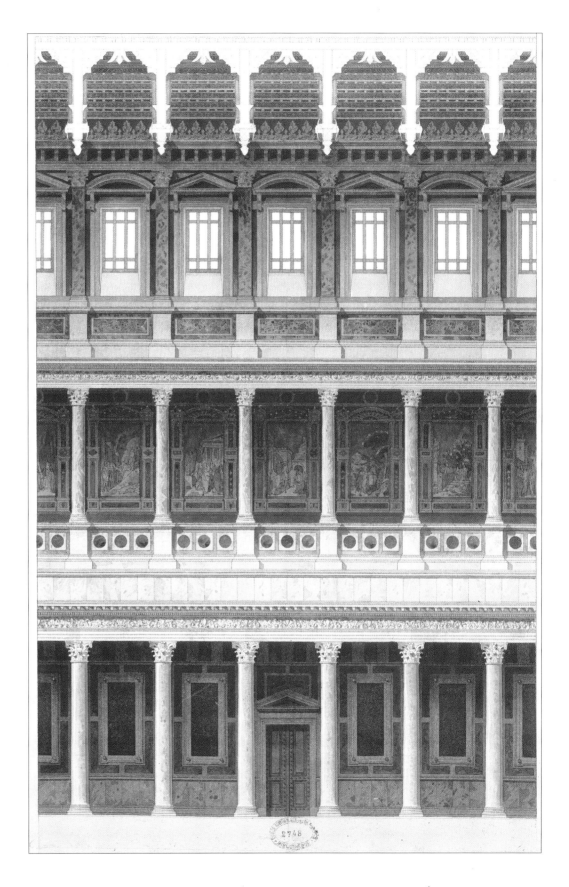

FIGURE 116. *The Basilica Ulpia: restored elevation of several interior bays, looking north. Guadet. B.É.B.A.*

building, the vaults over his aisles have been strikingly confirmed by the discovery of substantial remains of the vaults themselves in the excavations of 1928-34 (Figs. 37, 117). His two north doors in the porticoes around the Column of Trajan (Figs. 110, 116) are in accordance with evidence still on the site.

Some of the other features of his restoration are not so successful, however. He fails to look at the numismatic evidence (Figs. 131-32) carefully enough to discern the quadriga on the central porch—a feature noted earlier by Richter and Canina (Figs. 98, 107); and the grandiose quadrigas with which he crowns the inner corners of his intermediate blocks are completely imaginary (Figs. 111, 117). Moreover, for the design of his open timber-truss roofs, he is perhaps over-ready to rely on evidence from early Christian basilicas (Figs. 111, 113, 116, 117). The plans of his apses only distantly echo the design of the Forma Urbis (Figs. 110, 130) and, in elevation (Figs. 112-13, 117-18), these wings are only elaborate variants of the work of all his predecessors, from Lesueur to Canina (Figs. 84, 94, 97, 106, 113). Finally, in his general plan of the entire Forum, Guadet simply reproduces the broad features of Canina's work, with a few minor variations (Figs. 102, 110).

Yet, despite these problems, Guadet uses sound methodology. He excavated at various crucial spots on the site and exhaustively measured the excavated area and many of its significant architectural elements (thereby gaining a

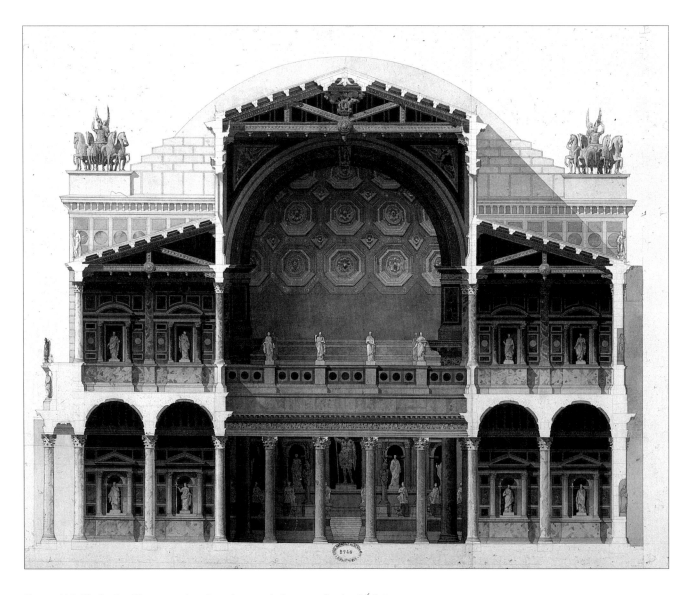

FIGURE 117. *The Basilica Ulpia: restored north-south section, looking west. Guadet. B.É.B.A.*

130

detailed knowledge of each piece). He reviewed the ancient evidence: literary sources, the Forma Urbis, the numismatic portraits; and he did not neglect the work of earlier students of the Forum whose efforts to solve the same problems with which he was confronted often proved extremely helpful. Consequently, if, like other students of architecture at the École des Beaux-Arts, he was sometimes more interested in executing a convincing and impressive set of plans and elevations than in establishing an archaeologically correct rendering of the Basilica and its setting, he has, all the same, marked off the chief approaches to a clear understanding of the problems posed by the remains of the Basilica and the Forum—approaches that no future student of these monuments can afford to neglect.

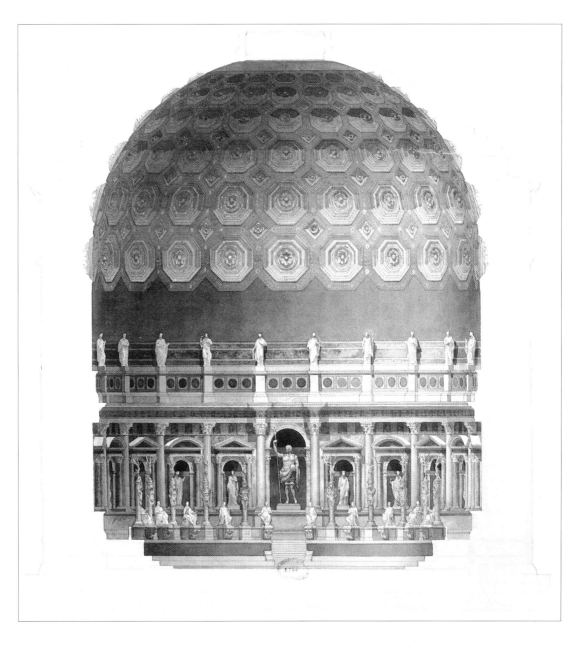

FIGURE 118. *The Basilica Ulpia: restored interior of an apse. Guadet B.É.B.A.*

If the restorations of Lesueur, Morey, Richter, Canina, and Guadet are coherent wholes assembled from detailed studies of the physical remains and other surviving evidence, their immediate successor, the work of Giuseppe Gatteschi, is an odd combination of disparate elements. Part of Gatteschi's collection of restored views of imperial Rome, this "restoration" consists of five plates that, while handsomely executed, are in reality only hasty compilations from the works of Guadet and Canina (Figs. 119-123).

In the first of Gatteschi's views of the Basilica Ulpia (Fig. 119), the south side has an open facade with two superimposed colonnades: the lower is Ionic without an attic; the upper Corinthian. A clerestory runs along the third floor, and the roof of the West Colonnade is a flat terrace connected by an arch with the colonnades on the second story of the Basilica. At the west end of the building, the roof of the intermediate block is an enormous barrel vault, and the apse is domed.

The second view of the facade draws more heavily from Canina than Guadet (Figs. 18, 107, 120). A continuous wall closes off the Basilica from the Forum. The columns of the porches are fluted—although not cabled—and are presumably of giallo antico. On the lower floor, Corinthian pilasters frame windows in the bays between the porches. In the attic above these bays Tuscan pilasters on high plinths bracket imagines clipeatae (replaced in the side bay of the central porch by a large relief). On the attics of the porches, four Dacian atlantes support a cornice with rosettes. Corinthian pilasters frame windows in the bays between the porches. The second story appears to repeat the first.

Gatteschi also provides two other views of the exterior. On the west facade, the slightly projecting center of the building, that corresponds to

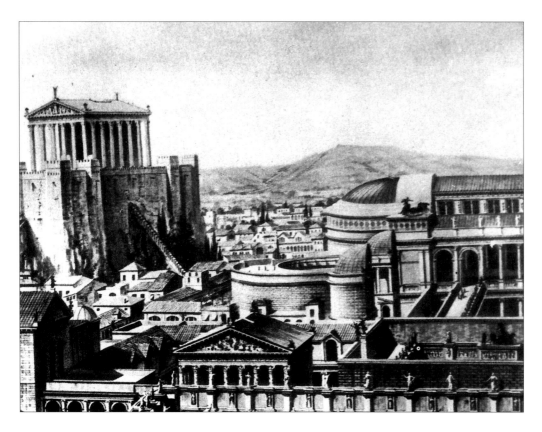

FIGURE 119. *The Forum of Trajan: restored view of the west side, looking north. Gatteschi.*

132

FIGURE 120. *The Forum of Trajan: restored view, looking east.* Left: *south facade of the Basilica Ulpia Gatteschi. F.U.*

FIGURE 121. *The Temple and the Column of Trajan, the East and West Libraries, the north facade of the Basilica Ulpia: restored view looking looking southeast. Gatteschi.*

133

FIGURE 122. *The Basilica Ulpia: restored view of the west facade. Gatteschi. F.U.*

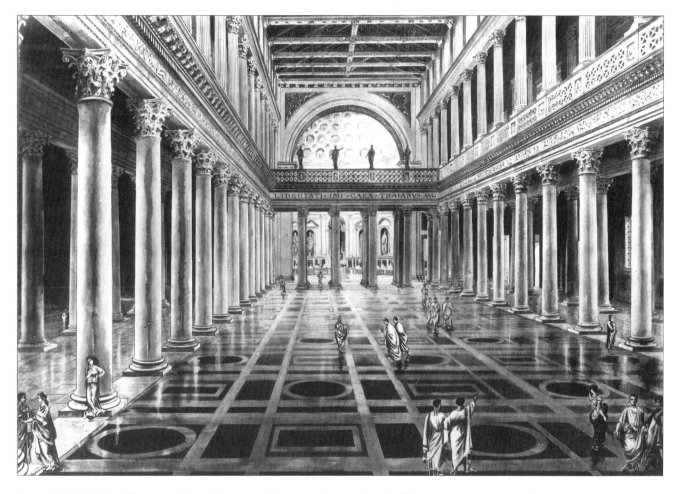

FIGURE 123. *The Basilica Ulpia: restored view of the interior, looking toward an apse. Gatteschi F.U.*

the internal nave, rises three stories to a high pediment (Fig. 122). Above the main entrance is an enormous thermal window. The lateral wings correspond to the aisles of the interior, their half-pediments giving this elevation a curiously Palladian look. A related view of the north facade (Fig. 121) shows that the projecting central wing on the west facade is the end of the clerestory: a row of square windows aligned with the second-story windows below.

The interior owes much to Guadet (Figs. 117, 123). The gray granite columns of the first order carry a frieze of cupids and winged lion-griffins; and the pluteus above consists of pedestals linked by a marble parapet. The columns of the second order are fluted, and following Guadet, at the east end of the building, Gatteschi suppresses the columns of the second order to create a bridge that partially screens the grandiose triumphal arch that frames the semi-dome of the apse.

Executed by various artists at different times, Gatteschi's "restorations" made little contribution to the serious study of the Forum of Trajan. At best they represented a popularization of the work of previous scholars; at worst they diluted their originals with idiosyncratic, imaginary details. Yet, because these renderings were not entirely false and because they conveyed information in a readily accessible fashion, they became extremely popular and have been frequently reproduced, even in the period after the Second World War.

After the large-scale excavations of 1928-34, Italo Gismondi was the first to undertake a new restoration of the Forum of Trajan. Since he had been the official architect of the excavations, he was uniquely qualified to produce an authoritative study of the monument, and, in fact, he made no less than three restorations of the Forum of Trajan. Unfortunately, the drawings for the first (1933), made for the model of Constantinian Rome now in the Museum of Roman Civilization in Rome (Figs. 4-6), have disappeared. Owing to the outbreak of the Second World War, the drawings for the second (1939-1940) were never completed (Fig. 124); and those for the third (1973) have vanished. Consequently, for a rough idea of Gismondi's conception of the Basilica Ulpia, we must rely chiefly on the model of Rome, supplementing it with several of the drawings of 1939-1940.

On the model (Figs. 4-6), a stair of six steps along the arcaded south facade of the Basilica Ulpia continues along the facades of the East East and West Colonnades. Dacian atlantes divide the customary high attic above the first order of the Basilica into bays, and the top of the attic is a high parapet that screens the terrace above the outer aisles and porches, and on the first story of the north facade are pilasters.

Clerestories on the second and third floors light the interior. The lateral aisles are vaulted, and the backs of the columns of the second order, set on plinths above the cornice of the first order, are partially sunken into the vaults, which are masked by marble screens between the columns. Rising for some distance above the tops of the vaults, these screens form the pluteus. Roofed by conical timber trusses, the apses are lighted by second-story windows (Figs. 4, 6).

Gismondi's restoration of the Basilica Ulpia is an intelligent attempt to integrate the results of earlier research with the discoveries of the new excavations of the 1930s. In the light of the excavations of Lesueur and Morey, his rendering of the south stair and its relationship to the stairways of the lateral Colonnades in the Forum is correct; and his belief in an open facade shows both sensitivity to the archaeological evidence and an acquaintance with the work of Guadet. Yet, in his great haste to finish the drawings for the city model, he neglected much of the ancient evidence.

On the facade of the Basilica, the Forma Urbis firmly shows a colonnade— not an arcade (Fig. 130); and Gismondi's omission of the statuary on the porches (the result of the small scale of the model) leads him into a further problem. His supposition that in the bays between the porches the facade of the attic becomes a high parapet for the terrace behind is probably correct, but, in order to provide platforms for the statuary depicted on the coins (Figs. 131-32) , the roofs of the porches must have been above the cornice of the attic. Moreover, all the ancient coins that depict the facade of the Basilica clearly show an Ionic colonnade (not a clerestory) as the second story and none indicate a third-floor clerestory above the nave.

On the north facade of the model (Fig. 6), Gismondi's pilasters, which continue the order of the peristyle around the Column of Trajan, generally accord with the surviving evidence. And although, with respect to the apses, Gismondi's ideas appear extremely sensible, he omits the intermediate block between the apses and the nave, a feature plainly visible on the Forma Urbis (Fig. 130).

Yet, even with these flaws, Gismondi's restoration of the Basilica Ulpia, produced in a short time under great pressure, is an excellent piece of work. Clearly, given sufficient leisure and further research, Gismondi must certainly have altered his earlier views. Thus the loss of his restoration of 1973 particularly unfortunate.

FIGURE 124. *The Forum of Trajan: schematic restored view, looking northeast to the south façade of the Basilica Ulpia. Gismondi. X. Rip.*

The first scholar to make a complete study of the Basilica Ulpia since the excavations of 1928-34, Carla Maria Amici worked out her restoration in considerable detail (Figs. 125-29). The three porches on the south (Forum) facade, which is closed without pilasters, frame doors. Internally vaulted, these porches have giallo antico columns, and statues of Dacian captives frame bays in the attics. The walls of the second story rise above the colonnade that divides the inner and outer aisles in the interior; and windows and (over the central porch) a door or doors distinguish this floor, that, on all four sides of the building, is roofed by a broad terrace (Figs. 126-27).

Amici's restoration of the interior advances considerably beyond any of its predecessors (Figs. 126, 127, 129). A timber-truss roof spans the nave, which is lighted by a clerestory. On all four sides of the building, the lower order supports a system of shallow barrel vaults that roof the aisles. The columns of the second order stand on a plinth that conceals the rise of the barrel vaults. For Amici, the "intermediate blocks," areas that Morey, Richter, Canina, and Guadet show as rectangular recesses, are solid buttresses (Figs. 94, 95, 97, 98, 102, 103A-B, 106, 110, 112, 113, 125, 127); and a clerestory lights the interior of the apses, which have conical timber-truss roofs. Twelve engaged, fluted columns with shafts of giallo antico divide each apse into twelve bays, six on either side of the central tribunal. With an attic, this order equals the heights both of the lower order in the nave and of the pediment of the central tribunal.

A number of minor inaccuracies mar Amici's restoration (Figs. 125, 126). Her general plan misrepresents the materials of the nave's marble pavement; her rendering of the facade of the building shows the podium

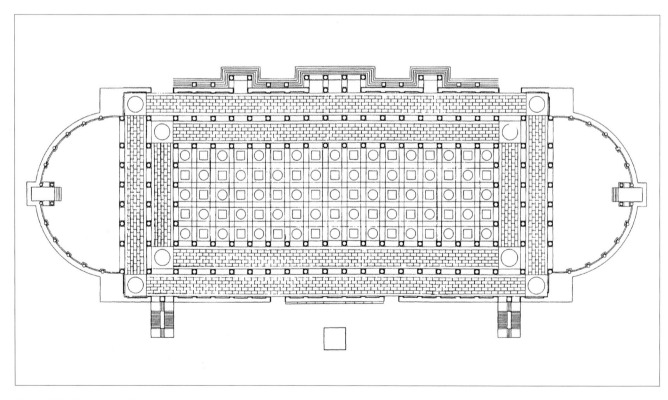

Figure 125. *The Basilica Ulpia: restored plan. Amici.*

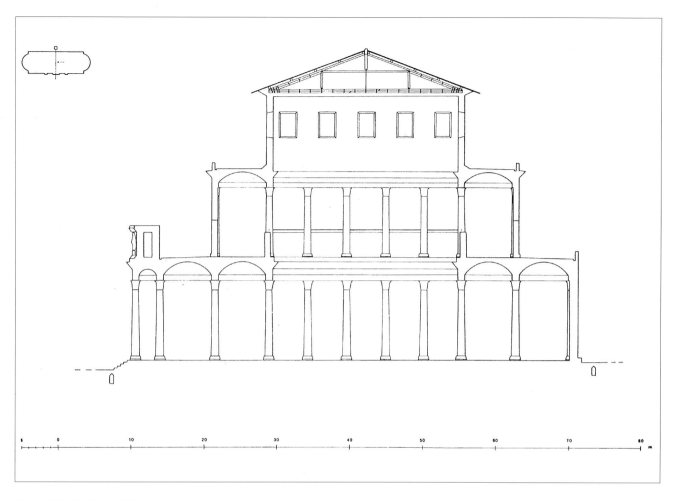

FIGURE 126. *The Basilica Ulpia: restored north-south section, looking west. Amici.*

and the individual treads of the south stair higher than they are (and the number of treads is incorrect); the outer columns of her porches are in the wrong location; and the porches were almost certainly not vaulted. For the attic of her first exterior order, Amici chooses the wrong Dacian atlas; she incorrectly renders the fascia of its cornice; and she erroneously estimates the height of the whole attic. More fundamentally, she neglects evidence on the site (Figs. 133-34), on the Forma Urbis (Fig. 130) and on Trajanic coins (Figs. 131-32) that suggests an open colonnade in place of her closed south facade (Fig. 125).

Amici's lower order is correct, but her shallow vaults, reenforced with tie-rods of iron, are not acceptable. Her treatment of the Basilica's "intermediate blocks" also raises serious problems, and her restoration of the apses is inaccurate in some respects (Figs. 125, 127).

Nonetheless, despite such difficulties, by her detailed study of some of the archaeological materials that resulted from the great excavations of 1928-34, Amici performs an extremely important service. She publishes many new architectural fragments; she presents the first detailed plan of the existing state of the site since those of Angelo Uggeri in 1833; and she analyzes the Basilica's structure in a far more sophisticated fashion than most previous scholars. Consequently, her work henceforth constitutes a necessary point of departure for all future studies of the Forum of Trajan and its monuments.

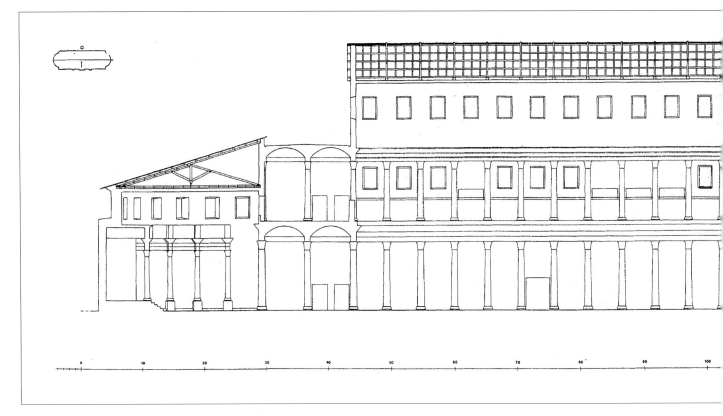

FIGURE 127. *The Basilica Ulpia: restored east-west section, looking north. Amici.*

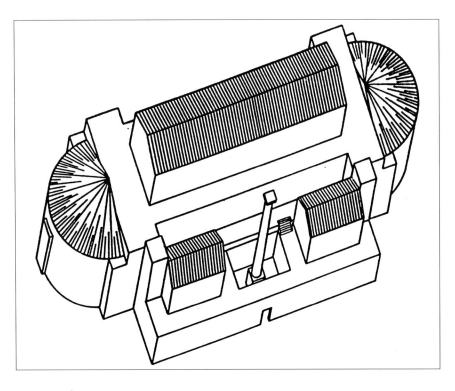

FIGURE 128. *The Basilica Ulpia, the East and West Libraries, peristyle around the Column of Trajan: isometric reconstruction, looking southwest. Amici.*

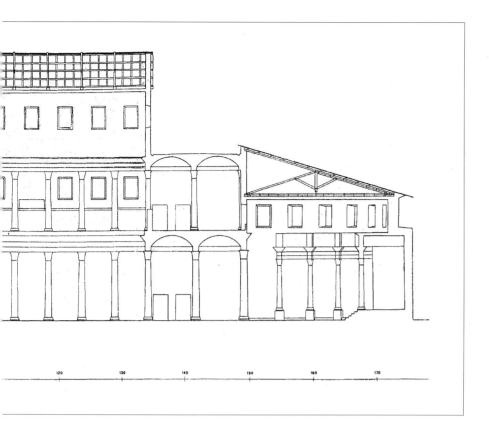

The Restorations of the Nineteenth and Twentieth Centuries: Problems and Proposed Solutions

The excavations and restoration studies of the past one hundred seventy-six years have thus established certain broad conclusions about the Basilica Ulpia that have gradually been commonly accepted. The French excavations of 1811-1814 provided the plan of the central section of the building, the patterns of the pavement, and a large number of architectural fragments (Figs. 15-16). Thus in the next decade, scholars could evaluate these remains in conjunction with evidence from the Forma Urbis (Fig. 130) and from the contemporary Roman coins that portrayed some of the Forum's monuments (Figs. 131-32).

From the French excavations (Fig. 12), it was clear that there were three large entrances on the south facade, but Lesueur could still restore the structure as a Christian church with an apse to the west and a main entrance to the east (Figs. 82-84). Although Lesueur paid lip service to the value of the numismatic evidence, like virtually all his successors, he made no real use of it. His most important contributions were the excavation of the east end of the nave, which established its length, and his identification of the elements of the first order (even though he confused the interior and exterior orders).

Some years afterwards, Uggeri suggested that the building had possessed two apses (Fig. 86), and Canina emphasized that the portrayal of those wings on a plan shown in a sixteenth-century drawing of a vanished frag-

ment of the Forma Urbis should be literally accepted (Figs. 102, 130). Morey was the first to recognize the proper relationship of the elements from the facade of the attic (Fig. 93), and thirteen years later, Canina found actual fragments of the attic of the west porch (Fig. 18). Canina also established that the lateral porches had only two columns apiece (a fact forgotten after Lesueur's excavations of the east porch had been reburied), he used the numismatic evidence to restore the statuary over the central porch (Figs. 18, 107), and, like all scholars of the nineteenth century, he supposed that the columns of the upper interior of the nave had Vitruvian proportions (Figs. 105-06).

From Lesueur on (Figs. 84, 85), all students of the building proposed a timber-truss roof above a nave lit from a clerestory. And, after Morey and Canina, all arranged the interiors of the apses around variations of the plan on the Forma Urbis (Fig. 130), roofing these wings by heavy half-domes lighted by oculi (Figs. 91, 94, 95, 97, 103A, 106, 110, 112-13, 117-18). Yet, if there were a number of commonly agreed upon points, there were also numerous problems. Just how many steps were necessary to climb from the pavement of the forum square to the top of podium of the Basilica? What was the purpose of the stair? Was it purely ornamental (except at the three porches), an elegant lower frame for the elaborately decorated south facade, or was the south facade open? Most restorers assumed that this stair was largely decorative, but Guadet broke with that tradition by proposing an open facade and vaulted interior aisles (Figs. 112, 113, 117), the latter suggestion the result of his study of the back of the block assigned by Lesueur to the exterior lower order. And yet, persuasive as Guadet's arguments were, they were never published, and indeed many of his drawings of the architectural elements on the site have appeared only in the last few years. Twenty-five years after Guadet's death, Gismondi proposed an arcaded facade with pilasters (Fig. 5); more recently , Amici has revived the early nineteenth-century closed facade (Fig. 125).

Another point of disagreement among the restorers was the location of the walls of the second story (Fig. 54). Had they begun immediately above the ornamental cornice of the exterior first order's attic? Were they over the internal colonnade between the inner and outer aisles? Had they been above the colonnade between the nave and the inner aisle? How had the nave and apses been connected on the exterior? Were there intermediate blocks? If so, were they externally visible as the extradoses of colossal barrel vaults? Or, was there a terrace, that, on the level of the second floor, separated the upper stories of the apses from the nave? Did the roof of the nave conceal the intermediate blocks and abut the roofs of the apses?

In the interior of the building, the pattern of much the marble floor in the nave and the aisles had been known since 1811-1814, but since most of the remaining slabs in the nave had disappeared rapidly after their excavation, the materials of the pattern were gradually forgotten. And until 1928-1934, the manner in which the designs of the pavement in the side aisles related to one another at the corners of the building was unknown. Even after that date, the true character of the pattern at these points has never been properly understood.

Then too, the character of the first order remained obscure until 1928-1934. The students of the nineteenth century had suggested that, while the columns between the nave and the inner aisles had shafts of gray

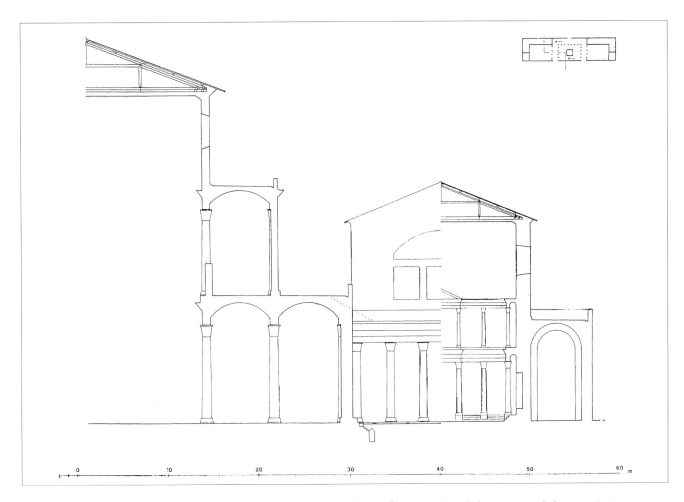

FIGURE 129. *The Basilica Ulpia, the East and West Libraries, peristyle around the Column of Trajan: north-south elevation/section, looking west. Amici.*

Egyptian granite, those of the colonnade between the inner and outer aisles had fluted shafts of pavonazzetto and giallo antico. The work of 1928-1934 proved conclusively, however, that gray granite shafts had been used for all the columns of the interior lower order (Figs. 133-34). Moreover, all the early restorers assumed that, as the dimensions of the columns of the interior and exterior orders were virtually the same, the entablature of the two orders must also have been identical. Not until 1928-1934 were the pieces with friezes of tauroctonous victories securely identified as the architrave/frieze of the lower interior order (Figs. 145-46); and only fifty years later was the cornice of the lower order found to be different from that of the exterior.

Major areas of uncertainty still existed, however. Exactly how did the elevation of the south facade look? Which are the elements of the interior upper order around the nave? How were they used? Had they, as Gismondi has suggested, been partially sunken into the vaults supported by the first order? Or, as Amici has proposed (Figs. 126-27, 129), did they stand on those vaults set into a parapet? Is there any evidence—other than the Forma Urbis—for the existence of the intermediate blocks between the apses and the nave (Fig. 130)? Which of the existing architectural fragments may be assigned to the apses? Finally, are Gismondi and Amici right in supposing that conical timber-truss roofs covered the apses (Figs. 4, 127-28)? Or were the great domes of the earlier restorers more nearly correct (Figs. 84, 93-94, 97-98, 103A, 106, 111-13, 117-18)?

The next chapter discusses these problems.

Chapter Six

A New Restoration
of the Basilica Ulpia

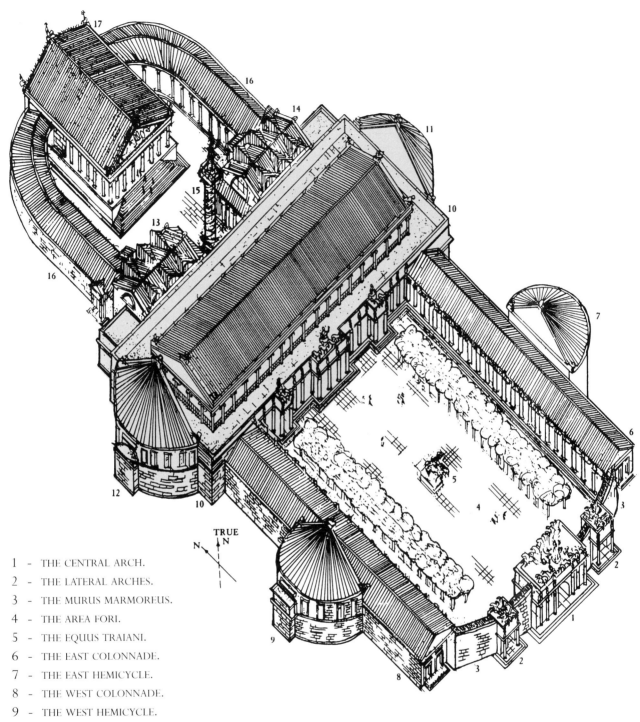

1 - THE CENTRAL ARCH.

2 - THE LATERAL ARCHES.

3 - THE MURUS MARMOREUS.

4 - THE AREA FORI.

5 - THE EQUUS TRAIANI.

6 - THE EAST COLONNADE.

7 - THE EAST HEMICYCLE.

8 - THE WEST COLONNADE.

9 - THE WEST HEMICYCLE.

10 - THE BASILICA ULPIA.

11 - THE BASILICA ULPIA, EAST APSE, THE "ATRIUM LIBERTATIS".

12 - THE BASILICA ULPIA, WEST APSE.

13 - THE WEST "GREEK" LIBRARY.

14 - THE EAST "LATIN" LIBRARY.

15 - THE COLUMN OF TRAJAN.

16 - THE COLONNADES OF THE TEMENOS OF THE TEMPLE OF TRAJAN.

17 - THE TEMPLE OF TRAJAN?

THE FORUM OF TRAJAN

Color indicates the areas discussed in this chapter

Close study of the forma urbis (Fig. 130), of the nummismatic evidence (Figs. 131-32), of archival materials, and of the remains on the site (Figs. 133-38)—now rendered accessible through the Getty Plan and measured drawings and photographs of the architectural elements (supra p. XVII)—suggests a restoration of the Basilica significantly different from those proposed by any of the earlier students of the building discussed in the previous chapter (Frontispiece, Figs. 54, 149A, 149B, 154).

Both the East Colonnade and the Basilica Ulpia stood on concrete podiums, that of the Basilica about twice as high as that of the Colonnade with at least five well-defined strata (Figs. 54, 61, 133, 138, 150, 152). In the Basilica, blocks of peperino replaced the concrete in the intercolumniations, and travertine foundations supported the columns. As in the East Colonnade and along the north facade of the Basilica, a similar row of blocks in the trench between the concrete footing for the south stair and the face of the podium originally sustained the south facade. These three concentric masonry rectangles, the foundations of the north and south facades and the two internal colonnades thus formed a stone framework which strengthened the podium.

In three separate positions, the foundations project forward to outline the remains of porches (Figs. 2, 149A, 149B, 133, 150, 152). With reference to the locations of the reerected columns in the colonnades between nave and the aisles, the central porch is four intercolumniations wide; the lateral ones, two. At the northeast corner of the central porch, parts of three treads of the stair survive (Figs. 133, 138); and a fourth supports the base for a statue of Trajan, reerected by the excavators of 1811-1814 in the bay between the central and the east lateral porches (presumably its original position). Since the lowest tread rests on a fragment of one of the paving slabs of the Area Fori, this pavement was in place (or at least the rows adjacent to the Basilica were) before the steps were installed (Figs. 133, 138).

In each of the four bays between the porches, two white marble pedestals stood on the giallo antico steps, aligned with the two columns behind (Fig. 133, 150, 152). All eight pedestals apparently had the same inscription:

[S P Q R
imp ▾ caesari ▾ divi
nervae ▾ f ▾ nervae
traiano ▾ avgvsto
germanico ▾ dacico
pontif ▾ max ▾ tribvnicia
potest ▾ xvi ▾ imp ▾ vi ▾ cos ▾ vi p p]
OPTIME ▾ DE ▾ REPVBLICA
[m]ERITO ▾ DOMI ▾ FORISQVE

The Senate and the Roman People [dedicate this statue] to the Emperor Caesar Nerva Trajan Augustus Dacicus, son of the deified Nerva, Pontifex Maximus with Tribunician Power for the sixteenth time, Commander-in-Chief for the sixth time, Consul for the sixth time, father of his country who deserves the best from the State at home and abroad

Two large oval sockets in the top show that the pedestal originally supported an over life-size standing statue, probably of gilt bronze.

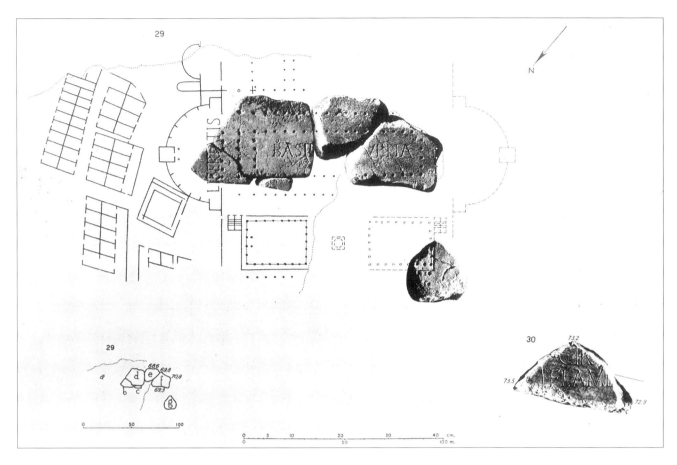

FIGURE 130. *The Basilica Ulpia: plan on the Forma Urbis.* PM.

On the porches, the shafts of the Corinthian columns were of giallo antico, and on the facade behind, the cabled and fluted pavonazzetto shafts of a second Corinthian colonnade duplicated the proportions of the shafts of the porches and of the lower order inside the Basilica (Frontispiece, Figs. 54, 139, 149A, 149B, 150, 152). The neutral purples and whites of the columns on the facade both set off the vivid golden, purple-veined color of the porch columns and visually linked the facade of the Basilica to those of the East and West Colonnades that had colonnades with similar, if smaller, pavonazzetto shafts (Figs. 54, 61).

Of the architrave/frieze blocks which crowned the columns, two major fragments were uncovered in 1811-14 (Fig. 140), and a number of small pieces of the frieze appeared in 1928-1934. In at least some of the bays between the porches, an inscription replaced the usual fasciae, and the soffit panels between the columns were elaborately decorated. The single "scene" of the frieze, florid "S-spirals" of acanthus with rosettes flanking a central vase and framed by two heraldically opposed winged cupids (their legs replaced by acanthus sprays), repeats thirty-four times along the facade (Figs. 140, 150, 152). The cornice which had modillions (Figs. 140-42), supported the profiled base of the attic (Figs. 150, 152). The statues of Dacian prisoners above, their bodies of pavonazzetto, their

147

heads and hands of white marble, about 3 meters or 10 ½ Roman feet high, supported an elaborately decorated cornice with a smooth fascia (Frontispiece, Figs. 54, 143, 150, 152). Rosettes adorned the projections; inscriptions, the returns. The projections of this cornice appeared to rest on the heads of the statues below, but in fact they were cantilevered out from the facade of the attic. On the tops of the blocks, a series of round holes are the bottoms of sockets for the bronze military standards clearly visible on nearly all the coin portraits of the south facade (Figs. 131-32) and specifically mentioned by Aulus Gellius (13.25.1-2), one of our ancient sources. In the porches and the bays between the porches, there were large scale recessed panels (Figs. 131-32), and numerous fragments of the relatively simple frames survive. Piles of weapons identical to those which appear on the pedestal of the Column of Trajan (although in higher relief) decorated these panels, which probably continued along much of the facade (Figs. 144, 150, 152). A large abbreviated cornice completed the attic.

Our only evidence for the triumphal statuary atop the three porches is numismatic (Figs. 131-32), but most of the surviving coins agree on the appearance of these decorations (Frontispiece, Figs. 54, 150, 152). A quadriga

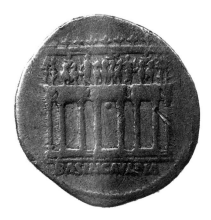

FIGURE 131. *The Basilica Ulpia: aureus, reverse. B.N.*

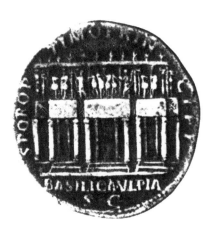

FIGURE 132. *The Basilica Ulpia: sestertius, obverse and reverse. B.L.*

(four-horse chariot) stood on the central porch; a biga (a two-horse chariot), on each of the lateral ones. On the central porch, the horses at the ends of the team faced the corners of the porch; those at the center turned toward one another. The driver, surely Trajan, raised his right arm in a salute. On either side, an attendant in a short dress held a spear. In each biga, the charioteer (one of the Emperor's chief aides?), made the same gesture; and the horses of the team again faced one another. Most of these figures were probably 1 ½ times life-size (although the drivers in the chariots were much larger) and, like the standards along the cornices, were probably of gilt bronze.

Behind the triumphal statuary, nearly all the coins show an Ionic colonnade (Figs. 131-32). This portico probably stood above the Corinthian columns that flanked the nave, and separated the upper part of the nave from the broad terrace over the lateral aisles (Frontispiece, 54, 150-51, 154). Since it enclosed the nave on all four sides, this second-story colonnade, which had shafts of unfluted cipollino (Fig. 148), was a clerestory, admitting light and air to the interior. In back, the bottoms of the shafts were sunken into the supporting vaults (Figs. 54, 151, 153). Set on a plinth, the freestanding fronts of the shafts and of their white marble bases, were clearly visible from the interior of the nave. The entablature was about the size of that of the East Colonnade, and above, all the coins show a series of enigmatic "crosses" with curved arms (Fig. 132). Perhaps best understood as antefixes of a particular type, these symbols may represent gilt bronze eagles (like those suggested by Morey, Fig. 93) or a some other decorative feature connected by a bronze grille (Fig. 152).

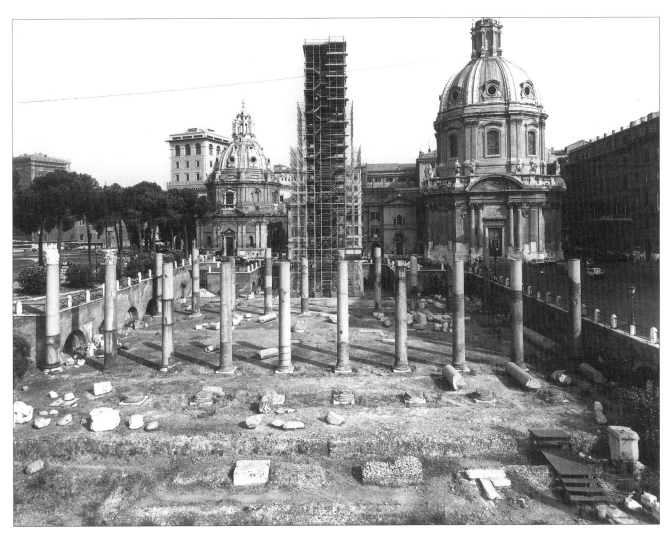

FIGURE 133. *The Basilica Ulpia: the excavated zone, looking north. G.R.L.*

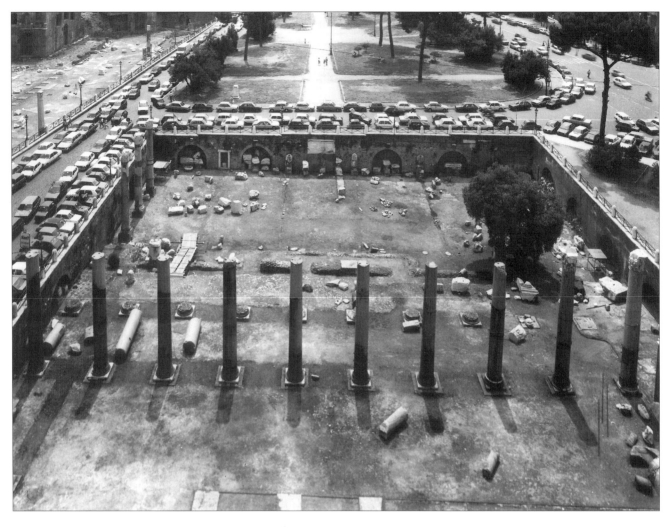

FIGURE 134. *The Basilica Ulpia: excavated zone, looking south from the Column of Trajan, July, 1985. G.R.L.*

FIGURE 135. *The Basilica Ulpia, nave, west end under the Esedra Arborea: south side, looking north. G.R.L.*

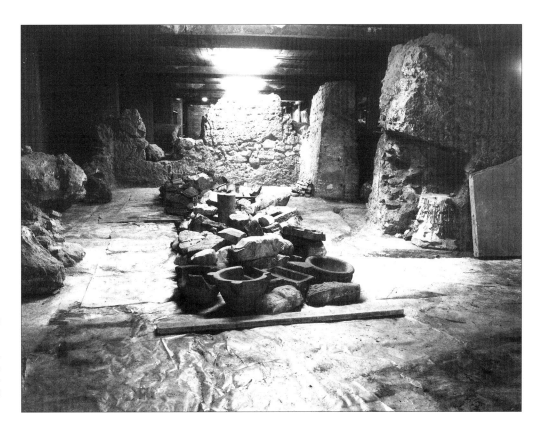

FIGURE 136. *The Basilica Ulpia: the west inner aisle, under the Esedra Arborea, looking north.* Right back-ground: *remains of a post-antique house utilizing the fallen vaults of the Basilica as walls. G.R.L.*

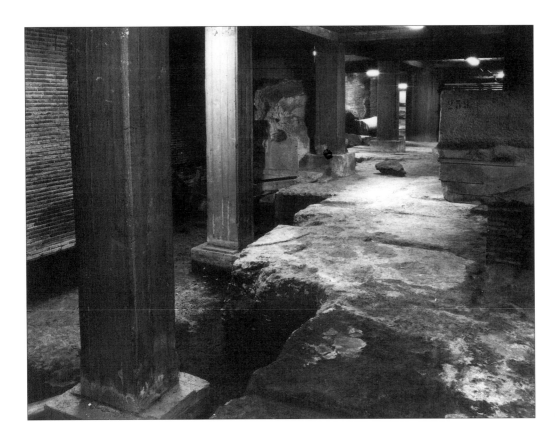

FIGURE 137. *The Basilica Ulpia: the west apse, under the Esedra Arborea, looking southwest. G.R.L.*

FIGURE 138. *The Basilica Ulpia, central porch: extant treads at the northeast corner, looking west. G.R.L.*

The Interior

Walls, Porches, and Aisles

Like the foundations of the colonnade on the facade, the walls of the Basilica Ulpia were of blocks of travertine. As in the East Colonnade, pi-clamps, originally protected by infusions of lead, held these blocks in position. The heights of the blocks in the core of the wall were probably the same as those in the section of wall preserved under the Esedra Arborea, and, their lengths, like those of the blocks in the foundations, would have varied (Figs. 40, 137).

To enter the main wing of the Basilica, a rectangle 117.52 meters x 58.76 meters (400 x 200 Roman feet), the ancient visitor passed either through the portico in the bays between the porches or through one of the porches, which had marble pavements and richly decorated coffered ceilings (Frontispiece, Figs. 149A, 149B, 150). In the north aisle, the pilasters that divided the north wall into bays corresponded to the columns which separated the aisles and the nave (Figs. 133-34, 149A, B). In the bays between the pilasters, the walls were surely veneered (Fig. 151). No trace of this veneer now survives, although we can establish its width, and we should probably assume that, like the flanking pilasters, it was flared at the bottom (apophyge).

The pavement of the aisles is well preserved only in certain sections, chiefly in the north outer aisle under the Esedra Arborea, but from those remains and from the excavation plan of the French excavations in the early-nineteenth century, the original patterns (identical in both aisles) can be restored with complete certainty (Fig. 149B). Africano borders set off the plinths of the adjacent colonnades. At the corners of the building, the borders of the adjoining branches of the outer and inner aisles met at right angles, constituting frames for large giallo antico squares which punctuate the intersections of both aisles. Each of these squares framed a circle with a diameter precisely equal to the distance between the plinths of the surrounding columns.

This design links the pattern of the pavement in the nave with that of the aisles; consequently, the inscribed circles were probably of the same marble as those in the nave—either pavonazzetto or africano. In both aisles, the rest of the pavement is identical: five rows of alternating, rectangular pavonazzetto and giallo antico slabs.

The aisles were barrel-vaulted (Figs. 37, 54, 151-53). Aggregate of pumice supplemented with terra cotta shards lightened these vaults, and their profiles were based on segments of circles. Girdling the building as a double ring, these vaults would have horizontally buttressed the entire structure, solidly supporting the timber-truss roof over the nave and tying together the structure of the nave and lateral aisles with that of the apses. Since there are no indications of coffers in any of the surviving fragments, we should probably assume that the intradoes were decorated with elaborate designs in stucco like those familiar from the somewhat later tombs of the Valerii and the Pancratii on the Via Latina and the Tomb of the Axe on the Via Appia (compare Fig. 62).

The white marble bases of the columns that delimit the nave and the aisles presumably duplicated the bases on the porches and the facade; and the dimensions of the two orders were virtually the same (Figs. 54, 133-34, 152, 153). Yet, the unfluted gray Egyptian granite shafts of the interior lower order contrasted strikingly with the pavonazzetto and giallo antico shafts on the facade. Above white marble capitals identical to those on the facade, the frames of the soffit panels in the architrave repeated the designs of the frames of the soffit panels of the lower exterior order, although the ornamental motifs in the panels themselves differed from those of the exterior order (Fig. 147).

As on the entablature of exterior order, the interior lower order was complete only toward the nave (Figs. 54, 151, 153). On the other side, the zone corresponding to the frieze, which begins immediately above the cymatium of the architrave, is a roughly finished backing for the barrel vaults over the aisles.

In the frieze, a single scene—tauroctonous ("bull-killing") winged victories, kneeling winged victories, and candelabra—was repeated sixty-five times around the nave (Figs. 145, 146, 153). Although the candelabra that framed each scene would have provided rhythmic accents between scenes unrelated to the column centers, these verticals must have served as an effective counterpoint to the driving, insistent regularity of the columns below (Figs. 153, 154). The corresponding cornice resembles the cornice of the lower order on the facade but lacks modillions, an unnecessary feature in the dimmer light of the interior.

The columns that frame the nave enclose a rectangular space which measures 88.14 meters x 24.973 meters (300 x 85 Roman feet). The positions of the columns determine the pattern of the pavement, squares delimited by borders as wide as the plinths of the surrounding columns (Figs. 149B, 154). Within each square, smaller circles and squares alternate. Colored marbles emphasized this simple geometry. The borders between the large squares were of pavonazzetto; the small squares inset at their corners (their sides equal to those of plinths of the columns of the first order) were of giallo antico; and the same material appeared in the large squares. The smaller inscribed circles may have been of africano.

Corrado Ricci, who directed the excavations of the 1930's, correctly concluded that, since the unfluted cipollino shafts he set up next to Pius VII's wall were apparently identical to those described by the excavators of the site in 1813, these were the shafts of the second order (Fig. 148). These shafts belonged to an Ionic colonnade that stood above the gray granite columns which framed the nave and was about three-fourths as large (Frontispiece, Figs. 54, 130-32, 151, 153-54).

Partially set into the concrete vaults below, and raised above the capitals of the first order by a low plinth, these columns were connected by bronze parapets. The frieze consisted of a delicate acanthus-leaf scroll, executed in low relief, and the cornice was plain.

FIGURE 139. *Giallo antico shaft from a porch of the Basilica Ulpia: left side of the altar at the north end of the transept, St. Peter's Basilica, Rome. P./B.*

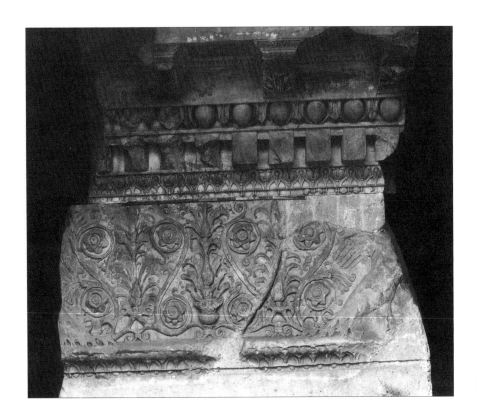

FIGURE 140. *The Basilica Ulpia: combined cornice and architrave/frieze blocks from lower exterior order. D.A.I.R.*

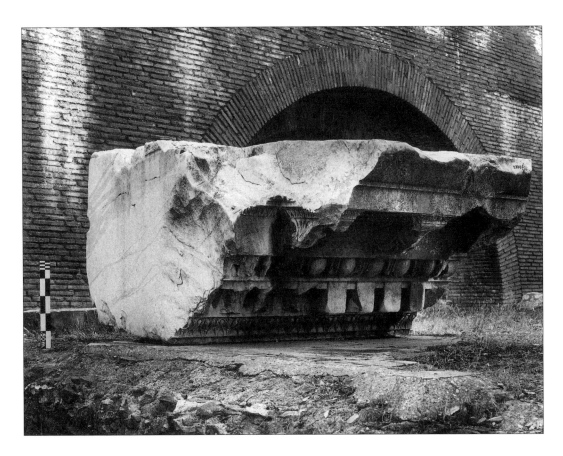

FIGURE 141. *Face and left side of the cornice block in Fig. 140. G.R.L.*

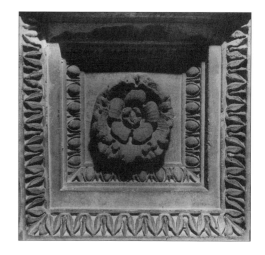

FIGURE 142 . *Soffit panel-with-rosette from the cornice block in Fig. 140. G.R.L.*

FIGURE 143. *Dacian atlas from the Forum of Trajan on the southwest corner of the attic of the Arch of Constantine. P./B.*

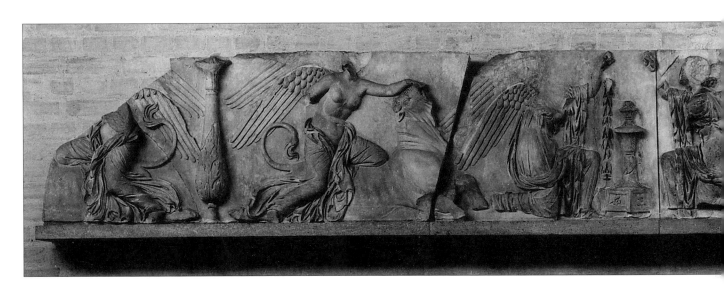

FIGURE 144 (left). *The Basilica Ulpia: fragments from the frieze of weapons on the south attic facade. P./B.*

FIGURE 145 (below). *The Basilica Ulpia: frieze from the lower interior order now in the Glyptothek, Munich. Glyptothek.*

FIGURE 146 (right). *The Basilica Ulpia: architrave/frieze of the lower interior order, fragment found in 1930-31 (see Figs. 31, 39). G.R.L.*

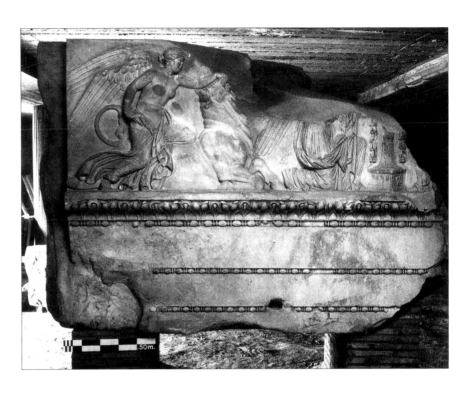

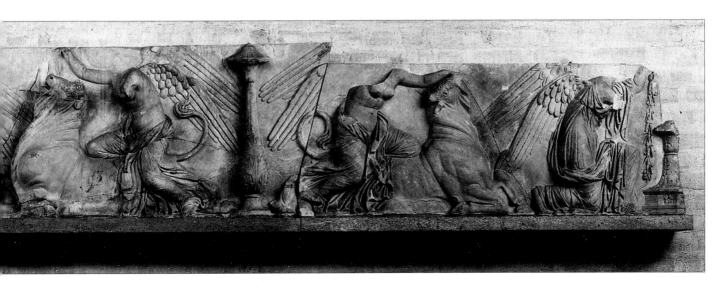

FIGURE 147. *Soffit panel from the architrave/frieze in Fig. 146. G.R.L.*

<div style="text-align:right">

The Roof and Ceiling of the Nave

</div>

The roof and the ceiling above the nave have long since disappeared, but analogies with earlier and better preserved later structures give much information about the probable design of these elements (Figs. 54, 151, 154). Like most Greek and Roman temples, the main wing of the building will have had a gable or saddle roof which, extending over the nave and the inner side aisles, will, in some respects, have resembled the typical example characterized by Vitruvius (4.2.1). Nonetheless, Vitruvius' system presupposes a relatively small building; and thus, while using some of the elements he describes, the roofs of larger structures, like the Temple of Jupiter Optimus Maximus on the Capitoline Hill, required the additional support of prop-and-lintel systems or trusses. Hellenistic architects probably knew both types, and their Roman counterparts were equally well informed.

No large wooden roofs of either type have survived, but the great width of the nave of the Basilica Ulpia (24.973 meters or 85 Roman feet) necessitated the use of a strong, flexible system like that provided by the trusses frequently employed in the early Christian basilicas of Rome. Although the most important, Old St. Peter's Basilica, was destroyed at the beginning of the seventeenth century, a number of similar, nearly contemporary roofs survived. For our purposes, the most significant was that of the basilica of St. Paul's Outside-the-Walls, since, although its design differed slightly from the Basilica Ulpia, this church has long been considered a copy of the Basilica.

In St. Paul's (Pl. 63), trusses pegged to opposite sides of a king-post originally supported the roof, and the same system probably protected the

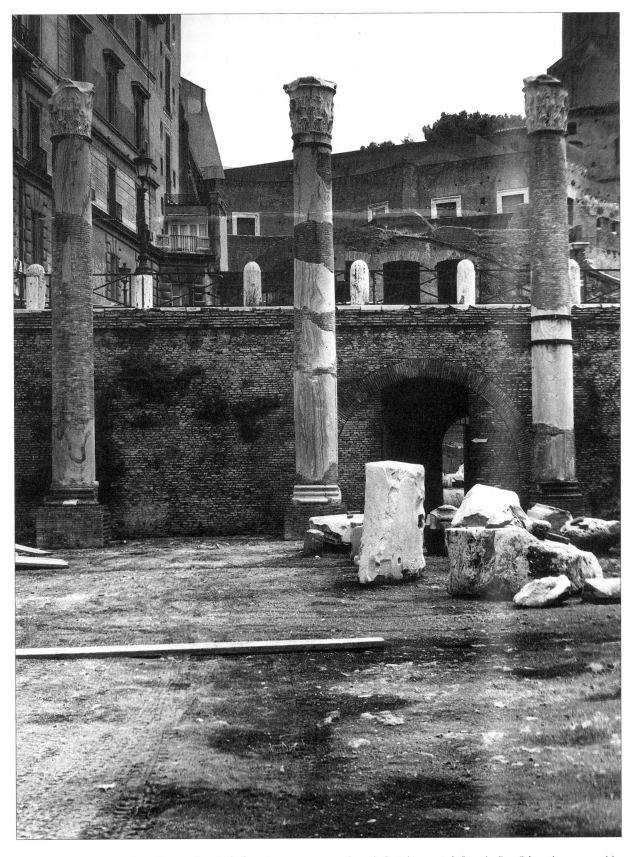

FIGURE 148. *The Basilica Ulpia: three cipollino shafts from the upper interior order with Corinthian capitals from the East Colonnade as reerected by Corrado Ricci in1930-31. P./B.*

nave and inner aisles of the Basilica Ulpia. There, one pair of trusses would have been centered above each of the pairs of columns which bordered the long sides of the nave (Figs. 54, 151). As in the roof of the East Colonnade, however, the tie-beams and the principal and common rafters probably rested in sockets in the blocks of the cornice of the Ionic colonnade on the facade. As in the East colonnade (Fig. 61, 150), these slots will have been somewhat less than half the lengths of the blocks, extending completely through them from top to bottom.

All these beams were presumably either of cedar, like the ninth century trusses of St. Paul's, or of fir, which grew to lengths long enough to fashion the components of each truss from single timbers. The tiles which protected the plank deck probably exhibited standardized Roman dimensions and form, although they may actually have been composed of thin sheets of gilded copper attached to a wooden framework. Considerably lessening the weight on the architectural elements below, a roof of this kind would also have given the Basilica Ulpia an air of suitable magnificence.

As we have seen, antefixes (probably in the form of eagles) concealed the ends of the cover tiles (Fig. 150). From the nave, a coffered ceiling prevented visitors from seeing the woodwork of the roof. Of gilded wood or stucco, its large coffers probably reflected the pattern of squares in the marble floor below (Fig. 154).

The Apses

Only a small part of the west apse was cleared in 1928-34 (Fig. 137). Yet, while not extensive, these remains supply much important information on the plan and elevation of this wing (and, by implication, on those of the identical east apse).

Since the excavators found that the wall of the apse had completely disappeared, leaving only the impressions of the missing blocks in the adjacent concrete podium, determination of the line of the missing wall constitutes a major problem. Close study of the site suggests that the diameter of the apse lay east of the remains of the marble pavement in the apse, running along or west of the west face of the partially intact travertine wall at the northwest corner of the west outer aisle (Figs. 40, 137). Where exactly? Three possible radii have been suggested, but none fits the conditions suggeted by the surviving remains and the Forma Urbis (Figs. 3, 130). Consequently, empirical experimentation at the drawing board suggests that the center of the apse was 4.55 meters (15 ½ Roman feet) west of the wall between the aisle and apse and that the apse had a radius of 22.03 meters (75 Roman feet) with an exterior wall 1.70 meters or 5 ¾ Roman feet thick. Positioned between the surviving remains of the street outside the apse and the interior pavement, this wall would also have related logically to the structural geometry of the nave and aisles (Figs. 149A, 149B). The Forma Urbis shows that there were five bays on either side of the central tribunal in the interior of the identical east apse (Fig. 130), and this plan, in turn, proves the existence of the intermediate block, two opposed rectangular recesses which separated the apse from the west outer aisle. On both sides of the central tribunal in the east apse, the Forma Urbis also records what appear to be short partitions framing the five bays. These were half-columns with fluted shafts of giallo antico (Fig. 151). Above each column, the entablature would have profiled as a ressaut; and, while no fragments of this entablature survive, the heights of its elements probably reproduced the proportions of the entablature of the East Colonnade.

In the bays between the columns of the lower order, a cornice uncovered in the west apse in 1928-34 and now displayed on a pier (part of the modern brick retaining wall) near the place where it was found, suggests that there were niches, probably not framed by tabernacles. As in the East Hemicycle, second story windows probably corresponded to the niches and were bracketed by the half-columns of an upper Corinthian order, three-quarters the height of that below (Fig. 151).

The same size as the flanking giallo antico half-columns that set off the flanking bays, the two columns which framed the central opening of the tribunal were aligned with the middle columns of the colonnade that separated the apse from the outer side aisle (Figs. 149A, 149B). With shafts of polished gray granite, this pair of columns would have contrasted vividly with the fluted, cabled giallo antico shafts of the half-columns which framed the flanking bays and would have subtly alluded to the gray granite columns which flanked the nave. Unlike the recess in the East Hemicycle, the front wall of the tribunal probably carried a low pediment, and the gray granite columns would have supported ressauts. A side door probably gave access to the podium inside the tribunal.

Were the apses roofed? The nineteenth century restorers postulated great semi-domes; and more recently, Gismondi and Amici have suggested semi-conical timber-truss roofs (Figs. 4, 6, 127, 128). As excavated in 1928-34, the remains of the west apse, with its fine marble pavement and the absence of any drains, clearly indicate that the apses were roofed, as earlier scholars had supposed. Yet, this same evidence suggests that the domes so dear to the hearts of the architects of the nineteenth century were only fantasies, and with Gismondi and Amici we should probably assume, therefore, that the apses had conical timber-truss roofs supported by the semi-circular walls and a pediment lower than the roof over the nave (Fig. 151). In both plan and elevation, their size would thus have marked the apses as secondary wings.

Repeating and varying the plans and elevations of the Hemicycles in the Forum, these low, roofed apses linked the Basilica Ulpia closely to the architecture of the buildings to the south (Frontispiece, Figs. 54, 149A, 149B, 150, 151). Similarly, the colonnaded south facade with its three projecting porches, the second-story Ionic clerestory, and the low, timber-truss roof over the nave, set the Basilica firmly in the tradition of earlier state monuments: the Basilica Aemilia, the rear facade of the stage building of Pompey's Theater, and the colonnades and hemicycles of the earlier imperial fora. Yet, while Trajan's Basilica visually commemorated these earlier structures, it utterly surpassed them in size, in close integration into the architecture of the surrounding complex, in grandiose design, and in luxurious materials. This was a building that, while constructed by traditional methods, at once summed up the past and provided a model for the future: "a construction unique under the heavens...never again to be imitated by mortal men" (Ammianus Marcellinus. 16.10.15, trans. by J. C. Rolfe, Loeb Classical Library).

Part III
Conclusions
Chapter Seven

Building Trajan's Forum

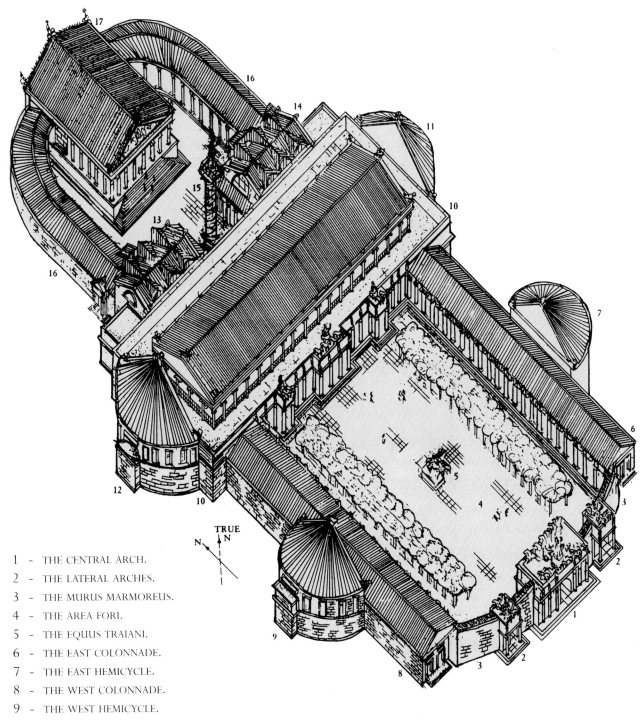

1 – THE CENTRAL ARCH.

2 – THE LATERAL ARCHES.

3 – THE MURUS MARMOREUS.

4 – THE AREA FORI.

5 – THE EQUUS TRAIANI.

6 – THE EAST COLONNADE.

7 – THE EAST HEMICYCLE.

8 – THE WEST COLONNADE.

9 – THE WEST HEMICYCLE.

10 – THE BASILICA ULPIA.

11 – THE BASILICA ULPIA, EAST APSE, THE "ATRIUM LIBERTATIS".

12 – THE BASILICA ULPIA, WEST APSE.

13 – THE WEST "GREEK" LIBRARY.

14 – THE EAST "LATIN" LIBRARY.

15 – THE COLUMN OF TRAJAN.

16 – THE COLONNADES OF THE TEMENOS OF THE TEMPLE OF TRAJAN.

17 – THE TEMPLE OF TRAJAN?

THE FORUM OF TRAJAN
Color indicates the areas discussed in this chapter

Given the elaborate plan of the Forum, there can be little doubt that the design was conceived and elaborated on papyrus. These drawings would have included plans (with colored renderings of the marble pavements and revetments), sections, and elevations. Final details were probably worked out in models of wood, wax, or a combination of these materials. Before or during the completion of the designs, the demolitions necessary to clear the site would have been executed. The well-built, utilitarian, shops (probably with apartments above) along the northwest slope of the Quirinal were taken down. The spur of the Quirinal Hill behind the shops was also cut away to level the site.

An accurate survey preceded actual construction. Executed with the *chorobates* and *groma*, it established levels, aligned a north-south axis with the Temple of Peace, and set cross axes which marked the centers of the Hemicycles behind the East and West Colonnades, those of the facades of the Basilica Ulpia, the Column of Trajan, and the two Libraries.

After excavating the Forum to a depth of several feet below the finished level, workmen poured over the natural rock the even stratum of concrete which supported the pavement of the forum square. The stone foundation blocks would also have been positioned at this time. Cranes hoisted these blocks into position, and the machines employed in the Forum of Trajan were probably much like those described by Vitruvius (10.2.1-10). The simplest consisted of two timbers, their tops bound together. Spread apart, the opposite ends gave this frame the appearance of an inverted V. Two stay-ropes in back held the frame at an angle of forty-five degrees, and a third rope suspended from its top (the Greek *trispaston*) connected two pulleys, one above the other, with a capstan, which, when turned, wound up the rope and raised the block. For heavier loads, the beams of the crane were more massive, and the capstan was a large, hollow wheel that was turned from inside by as many as three men.

At the end of the *trispaston*, an iron forceps was sometimes used to hold the marble blocks. This device had two thin arms. Each was curved at one end with a circular opening at the other. The curved ends fitted into matching sockets on opposite sides of the block, and the arms were held rigid by a rope or chain, suspended from a hook attached to the *trispaston* and inserted in the openings at the ends of the arms. With the *trispaston* slack, the arms were easily placed into the sockets in the sides of the block. With the *trispaston* taut, the arms were wedged tightly into the corresponding sockets, and the stone was easily lifted.

Frequently, the iron forceps was replaced by a lewis: several iron bolts that fit socket(s) cut into the top of the block. Wedge-shaped in section, these sockets usually measured 0.20 X 0.10 meter with depths of 0.15 meter (or more). Small to medium-sized blocks had only one socket; larger blocks had two, one at either end. Once positioned in its socket, the end bolts of the lewis were wedged firmly in place by one or two more additional bolts. Inserted through round sockets in the projecting ends of the bolts,

Foundations

a movable pin locked the bolts into position and connected them to a stirrup, which was attached to the hook at the end of the *trispaston*.

On three sides of the Forum, the podia of the Murus Marmoreus, the Arches, and the Colonnades were the components of a single, continuous structure (Figs. 54, 61, 152). Secured with pi-shaped clamps and protected against rust by a layer of melted lead, the rectangular tufa and travertine blocks which constituted the sides were, in effect, gigantic forms into which workmen poured the interior mass of concrete. In the Basilica Ulpia, the masonry foundations for the colonnades broke up this vast mass of solid concrete. These foundations consist of blocks of peperino between the columns and solid piers composed of travertine blocks which extend at least 4 meters below the marble pavement of the interior (Figs. 26-28, 61, 133-34, 152). In all the podia, the lowest and thickest stratum consists of mortar mixed with broken tiles. Above, the slabs of pavement rest on a layer of bedding mortar mixed with pieces of travertine (and, in the Basilica Ulpia, with fragments of colored marbles).

Walls

When the foundations were in place, the masons assembled the walls of the colonnades from rectangular, partially pre-carved peperino blocks. On these, the projecting centers of the rusticated external faces will have been already finished and the smooth drafts around the joints and the inner side taken down to surfaces just above the final ones. Then, on the top and bottom of each block, masons cut several set-holes for iron pins later inserted and fixed with molten lead. Corresponding sockets in the top of the stone below received the pins, which thus guided the blocks of the next course into place. To attach the blocks to one another firmly, the socket in the lower block was filled with molten lead which, when the upper block and its pins was set in position, was forced out through the shallow channels connected with the sockets. When cool, the lead locked in place the lower half of the pin and subsequently protected it from rust. Although the surviving flows of this lead are often full of air-pockets, these flaws apparently did not weaken the bond between the pin and the surrounding stone. Within each course, two rows of iron pi-clamps set in lead held the blocks in place; the corners of the building were rendered stable by the use of L-shaped blocks. Finally, when the various courses were in position, the masons smoothly finished both the joints that framed the external rustication and the interior faces that would abut the veneer. Although executed in travertine, the north wall of the Basilica was identically finished, but lacked external rustication, since it was evidently veneered on both sides (Fig. 40). Yet, whether of peperino or travertine, these were massive stones.

The walls of the Colonnades and the Basilica would have gone up simultaneously. Although the Basilica was larger than the Colonnades, the facades of all three buildings must have been constructed as a single unit with continuous adjoining foundations. First the masons would have installed the courses of the white marble pavement of the forum square near the podia of the buildings (Figs. 61, 149B, 152). Next, they positioned the rectangular giallo antico blocks of the stair treads. The two lower ones were bedded in concrete; those above fitted into slots cut in the blocks of the travertine foundations (Figs. 26-28, 61). The top treads were blocks as high as the other treads but 0.03 meter wider than the plinths of the columns that rested on them.

Column bases were shaped from white marble blocks, probably just slightly larger than the intended plinths. Then, perhaps before the block left the quarry, the upper part of the base was roughed out into a cylinder wider than the width of the lower torus; and then, using a (wooden?) template as a model, the rest of the moldings were cut from this cylinder. The final finishing took place after base and shaft were installed.

Quarried in Italy or the Greek East to standard lengths and shaped initially by point chisels and then fine picks, the shafts began in the quarries as rough rectangles later cut with even finer picks into cylinders of approximately the final dimensions. These had upper and lower bands from which the cinctures and astragals would later come. At this stage the shaft, monolithic or in drums, would be dragged from the quarry on wooden sleds pulled on rollers to the nearest river or sea for shipment to Rome. The final finish was applied in the Forum. After their bottoms were smoothly finished, the unfluted, monolithic granite and cipollino shafts were set on their bases by a crane. The cincture and perhaps the astragal then probably received their final profiles; and the masons achieved the desired entasis and diminution by simply dropping a plumb-line from the top of the shaft and measuring frequently to it. In some cases, owing either to an internal flaw in the stone or an accident, the end of a nearly completed shaft broke. Yet, the great amount of labor invested in the shaft—both its transportation from the quarries and its working on the site—did not allow discarding it. Instead, the masons first hollowed out the center of the upper end of the defective shaft, leaving a scalloped border about 0.16 meter wide projecting to the original height of the break. Then they cut a new section with an identical, mirror-reversed border. Next they lowered the new section onto the original shaft. Their exactly keyed edges held the pieces firmly together without pins or mortar, and stucco colored with finely ground bits of granite concealed concealed the joint.

Pavonazzetto and giallo antico shafts had two drums divided at a third the total height of the shaft (the top of the cabled section). After their erection, these shafts were carved with a tooth chisel and a flat chisel into a twenty-four-sided polygon—the number of sides equal to that of the fillets on the finished shaft. At the same time, by the method described above, the shaft received its diminution and entasis. Then, after the sides of the polygon had been smoothly finished, the shaft was ready for fluting.

First, around the circumference of the shaft, the masons lightly incised three lines: at the narrowest point (just under the upper cavetto), at the center, and at the bottom. Then they marked 24 equal parts on these lines. Four marks scratched at the top indicated the four faces of the capital, and plumb lines, aligned with these marks, established the centers of the middle fillets on the front and back of the shaft. The same process determined the centers of the sides and the resulting quarters, halved and divided again by three, gave the centers of the 24 flutes at the top and bottom of the shaft. Small circles on these centers subsequently indicated the widths of the flutes. When connected with a straight-edge, these small circles, at the top, middle, and bottom of the shaft, located the guide-lines for cutting the flutes. Next, the workmen removed the marble inside the lines to produce the flutes, semicircular cavities slightly deeper at the bottom of the shaft

than at the top. Lastly, they spent laborious hours applying the final finish, rubbing the stone first with crushed pumice and then with powdered emery.

Capitals

The capitals were roughed out on the ground according to dimensions which, unsuprisingly, adhered only generally to Vitruvius' precepts (Vitruvius 4.1.11-12) (Fig. 74). The sculptor began with a rectangular block of stone, the square ends of which corresponded to the top and bottom of the future capital. On bottom, he lightly scratched in two diameters and two diagonals. Their point of intersection marked the center of the circular bottom (with a diameter the same size as the upper diameter of the column below). These diagonals and diameters divided the base of the capital into eight segments, 45 degrees wide. These segments delimited the centers of the leaves of the lower corona (row of leaves) and the sides of the leaves of the upper corona.

The top of the block was also laid out with diameters and diagonals. Half each diagonal equalled the diameter of the bottom of the capital, and a complete diagonal was thus two diameters long. Using the center of these diagonals, the sculptor inscribed two circles, the larger tangent to the sides of the block. The smaller circle, of the same diameter as that of the supporting column, was inscribed in a square that indicated the load-bearing area of the capital. In order to prevent the weight of the architrave from damaging the delicate edges of the abacus, the sculptor cut the rest of the top down a few millimeters below the level of this square.

The sides of the original block also served as the bottoms of four imaginary equilateral triangles. The apices farthest from the face of the block were the centers of circles from which segments of the circumferances determined the curvatures of the four sides of the abacus. A distance of slightly less than three-fifths diameters from the center established the farthest projection of the lip of the bell. Each leaf included two segments: one diagonal marked its middle; the flanking ones, its sides. From the face of the bell, the leaves of the first corona (row of leaves) projected one-seventh the height of the bell; those of the second corona, about one-sixth. Measured from tops to tips, the heights of the curved ends were respectively one-nineth and somewhat less than one-tenth the height of the bell. Each of the lower leaves was laid out as a square finished at the bottom with a narrow fillet turned up at the sides. The top of the leaf was thicker by 1/3 than the bottom, thus allowing space for cutting the pointed, downwardly curving tip. In order to avoid damaging delicate carving, journeyman sculptors completed all this work on the ground, roughing out the capital, cutting its elements, and smoothing them down into finished forms which lacked the final details.

Lastly, by means of a rope sling or a lewis bolt fixed in the socket in the top, the capital was carefully hoisted into place. Occasionally, however, the tip of an acanthus leaf did break, necessitating repairs. At the top of the damaged leaf, the masons cut a socket. Inserting in it a separate piece of

marble, its back shaped to fit the precut socket, they carved this addition to its final shape and filled the joint between the old and new marble with stucco.

Then, on the scaffolding erected around the column, they completed the final detailing on the now installed capital (Fig. 74). Completely penetrating the leaf, they drilled the sockets that separated the middle sprays from those above and deeply incised the four corresponding lower sockets, flat at the bottom, pointed at the top. They defined the component stalks by seven smoothly finished grooves. Although nearly rectangular in section, these had slightly chamfered corners which softened otherwise hard, artificial outlines. The sculptors gave the contrasting interiors of many of the sprays shallow hollows intended to produce a pliable organic appearance; and, on either side of the central stalk, they cut deeper hollows, which defined the contours of the sprays; to further subdivide these sprays, they added three lower hollows with raking incisions.

Between the lower leaves, they incised narrow spaces (0.05 meter long) which reveal two of the central stalks of the leaves of the second corona. Although their lateral sprays disappear behind those of the first corona, these upper leaves closely resemble those below. The spaces between the leaves of the second corona were reserved for the eight caulicoli. Semi-circular in section, with edges separated by deep, V-shaped grooves, these caulicoli consist of seven contiguous stalks which contrasted sharply with the adjacent leaves.

The buttons were executed in three parts. Above are four oak leaves (of which only the two at the center are fully worked). In the center is a band with two pronounced incisions. At the bottom are four additional bands or leaves. With rectangular sections, slightly chamfered edges, deeply drilled sockets, and hollows between some of the sprays, the buds strongly resemble both the surrounding leaves and the stalks below.

Freeing the backs of the volutes almost completely from the bell, which passed unimpeded behind them, the masons left only small nubs of stone to attach the helices to the capital and to one another (Fig. 74). Emphasized towards the interior by scored lines and flat on top, raised lateral ridges, separated by a U-shaped hollows, outlined the sides of both volutes and helices. The eyes of the delicately thinned helices were drilled completely through. The masons smoothly finished all the exposed surfaces of the bell (although they occasionally forgot some traces of chisel marks) and cut the lip above the projecting beak molding into an elegant, raking fillet.

On each face, they centered the stem of the fleuron above the middle leaf of the upper corona and drilled the spaces between the sprays of the two flanking leaves with their flat down-curved ends. The stem above supported a bud that generated a long, leaved segment that bulged slightly at the bottom and diminished towards the top of the bell. With contiguous drill holes, the masons separated this part of the stem into two equal halves that ended at the fleuron. This was divided into seven sections. Each of the six identical petals framed the circular pistil from which rose a raised, S-shaped style with an enlarged, bulbous lower end.

Entablatures

With the columns in place, assembly of the entablatures began. Their components were usually in two sections, the architrave/friezes and the cornices. The lengths of the architrave/friezes corresponded to the distances between the column-centers; the lengths of the cornices varied. The profiles of both elements had been roughed out on the ground and completed to a smoothly finished state (almost certainly while the block was upside down with reference to its final position), and the soffit panels were probably fully finished.

Before positioning, iron pins, which corresponded to sockets cut in the tops of the capitals below, had been inserted into the bottoms of the architraves. To insure that the architraves sat correctly, lines marking the width of the architrave and the centers of the capitals (the location of the joints between the architrave/frieze blocks) had been incised into the tops of the supporting capitals. The workmen who installed the architraves correctly

aligned these elements as the blocks were lowered onto the capitals. The pins had to fit accurately in their sockets; the ends and sides of the architrave/friezes were precisely aligned within the marks on the tops of the capitals.

Next, using the same techniques of construction, the cornice was positioned on the architrave/frieze, and finally, standing on adjacent scaffolds, specialists in the various types of ornamentation (bead-and-reel, egg-and-dart, etc) completed the decorations, the architrave/friezes first; the cornices last.

Finishing: Marble Revetments and Pavements

In most cases, marble veneers were installed after the cores of the walls were in place. The individual slabs were secured by a heavy bed of mortar, sometimes strengthened by an iron or bronze clamp. Before the mortar was applied, the sharp end of the clamp was driven into the wall and protected with lead. Then, the mortar was troweled into the space between the back of the slab and the wall, and the projecting bent end was inserted into a slot on the upper side of the slab. Pieces of marble projecting from the surface of the wall helped level the slabs. In a few cases, however, as around the niches in the West Library, revetments were positioned during construction of the wall cores. Usually, the slabs were thin, and the lowest ones, which rested on a base molding, were finished with apophyge.

In order to avoid possible damage, pavements were installed after the completion of the building (Figs. 61, 152). Bedded on thick layers of mortar, the individual slabs, which varied considerably in width, were leveled by the use of numerous slate shims, many of which still survive.

Chapter Eight

Concept and Meaning in the Architecture
of the Forum of Trajan

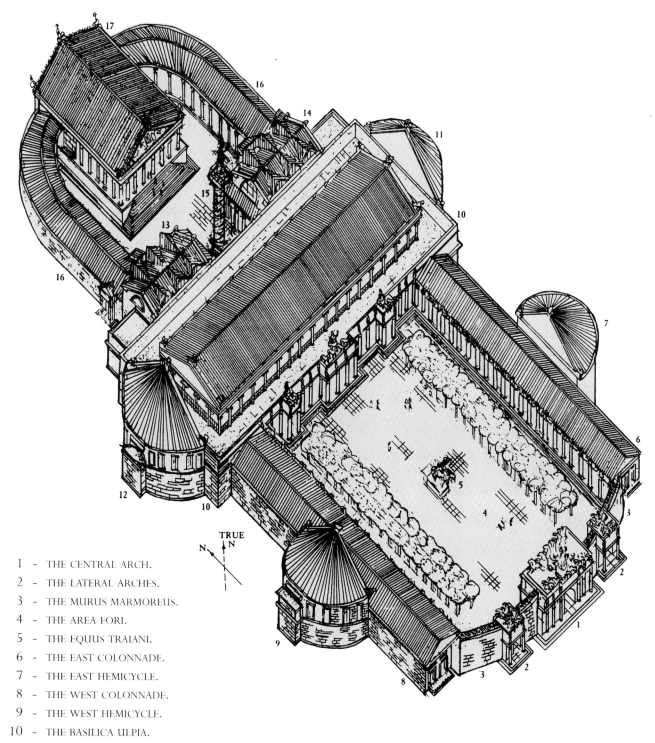

17 — THE TEMPLE OF TRAJAN?
16 — THE COLONNADES OF THE TEMENOS OF THE TEMPLE OF TRAJAN.
16
14
15
13
16
11
10
7
6
12
10
5
4
3
2
1
9
3
2
8

TRUE
N
N

1 — THE CENTRAL ARCH.
2 — THE LATERAL ARCHES.
3 — THE MURUS MARMOREUS.
4 — THE AREA FORI.
5 — THE EQUUS TRAIANI.
6 — THE EAST COLONNADE.
7 — THE EAST HEMICYCLE.
8 — THE WEST COLONNADE.
9 — THE WEST HEMICYCLE.
10 — THE BASILICA ULPIA.
11 — THE BASILICA ULPIA, EAST APSE, THE "ATRIUM LIBERTATIS".
12 — THE BASILICA ULPIA, WEST APSE.
13 — THE WEST "GREEK" LIBRARY.
14 — THE EAST "LATIN" LIBRARY.
15 — THE COLUMN OF TRAJAN.
16 — THE COLONNADES OF THE TEMENOS OF THE TEMPLE OF TRAJAN.
17 — THE TEMPLE OF TRAJAN?

THE FORUM OF TRAJAN
Color indicates the areas discussed in this chapter

As we have seen, the French excavations at the beginning of the nineteenth century revealed much of the general layout of Trajan's Forum, and the excavations of the 1930s provided examples of many of the architectural elements. Thus, for more than a half a century, scholars have characterized the design as a rectangular, axially symmetrical, frontally oriented plaza framed by the Basilica Ulpia and the adjacent East and West colonnades and separated from the rest of the city by high fire walls.

Much has been written in this century on the origins of this plan. It has been derived from the large-scale temples of Egypt and Mesopotamia, from the markets or shrines of the Hellenistic East, from the early imperial legionary camps of the northern frontier, or from the urban architecture of provincial northern Italy of the first century after Christ. All these earlier protypes influenced the design of Trajan's prestigious forum, which was itself later widely imitated in the provinces.

The imperial fora had not only Hellenistic and provincial antecedents, however, but also local prototypes: the Theater and Portico of Pompey and the portico erected by Q. Caecilius Metellus Macedonicus in 146 and rebuilt by Augustus as the Porticus Octaviae, and the Forum of Augustus himself, which supplied many of the elements of the plan and the cool classicizing style of the architectural elements. Consequently, Apollodorus of Damascus, Trajan's architect-in-chief and the designer of his Forum, must have known all these sources well. As a highly trained successful professional, he worked in the dominant architectural idiom of his day and was limited only by the requirements of his site, the constraints of his materials, and the expressed wishes of his imperial patron. Thus, stated in the contemporary imperial international mode, his plan for the Forum of Trajan was an intelligent blend of oriental, Greek, Italic, and Roman elements that visually expressed Rome's unique position as the capital of the Mediterranean World.

The Origins of the Plan

Trajan and Apollodorus apparently consciously conceived of the Forum of Trajan as the triumphant climax in the series of imperial fora. Their plan would complete and unify the total design of all the fora, which, taken together, had evolved into an uncoordinated assemblage of temples, public squares, and colonnades (Figs. 3-6). The new unity derived from two principal features. First, the axes which determined the general layout continued those of the existing fora. The north-south axis extended that of the Forum of Peace (Fig. 3); while the position of the columns of the Temple of Venus Genetrix in the Forum of Caesar set the line of the front wall of the new Forum. Yet, of these two axes, the first was the most important—the organizing element that united all the fora into a grandiose whole.

As the axis of the Templum Pacis determined the center of the new Forum so the Flavian complex became the conceptual point of departure for the Trajanic plan (Figs. 3, 149A, 149B). Laid out as a mirror-reverse image of the Temple of Peace, the new plan reiterated the architectural elements of the its Flavian model while varying and magnifying them (Fig.

The Proportions of the Plan

3). Thus the Temple of the Deified Trajan, surely a part of the original plan, occupied a position analogous to that of the Temple of Peace; the Basilica Ulpia represented the colonnade in front of that shrine; and the enormous rectangular Trajanic forum square unmistakably echoed the formal garden laid out in front of the Temple of Peace.

Finally, as the ultimate act of homage to the unknown architect of the Temple of Peace, Apollodorus took the internal length of the court in front of the Temple, 400 Roman feet, as the grand measurement which determined the proportions of his various buildings (Figs. 149A, 149B). Multiplied by 1 ¹/₂, it gave the lengths of the Basilica Ulpia (176.28 meters, 600 Roman feet) and of the Forum (including the Basilica). Complete, it provided the length and width (including the Colonnades) of the forum square; three-quarters of this measurement gave the width of the forum square (without the Colonnades). Halved, the same module provided the width of the Basilica Ulpia (58.76 meters, 200 Roman feet). Divided into eighths, it set the proportions of the other buildings. One twelfth the length of the Basilica Ulpia (50 Roman feet) fixed the combined width of the two side aisles in the Basilica and that of the Libraries. One-half the length of the Basilica (300 Roman feet) yielded the length of the nave; and its width (measured from the faces of the plinths of the flanking columns) resulted from dividing the length by 3.52. And finally, the Column of Trajan (with its pedestal and original statue) had a height of 150 Roman feet (44.07 meters), one-quarter the length of the Basilica (or one-half the length of its nave) and one-and-a-half times its height.

The East Colonnade and Hemicycle

In the East Colonnade, Apollodorus based his plan on two modules (Figs. 149A, 149B). With the larger (3.53 meters, 12 Roman feet), he divided the interior length into thirty-one equal parts which located the centers of the thirty columns and terminal piers. In terms of this module, the length thus consists of three unequal parts. Including a terminal pier, the section at each end is ten modules long; that in the center eleven, an inequality which allows for the width of the central recess.

Imaginary lines at intervals of fifteen degrees locate the centers of the pilasters which divide each half of the Hemicycle into five equal bays. The recess takes up one bay of each half; and the center of the Hemicycle lies on a line situated east of the rectangular piers at its entrance by the width of one-half pilaster (Figs. 149A, 149B). Positioned at the north and south sides of the Hemicycle, half-pilasters indicate this line.

In the East Colonnade (Fig. 62), the pattern of the marble pavement is a rectangular grid anchored by the positions of the columns and the corresponding pilasters. The column-centers fixed the centers of the giallo antico borders; and the second, smaller measurement of 3 Roman feet (0.881 meter) served to lay out the pattern of the pavement and determined the widths of the column plinths and the intercolumniations. The sides of the inscribed squares inside the giallo antico borders are three units long and are made up of two rectangular pavonazzetto slabs that measure 1 ¹/₂ X 3 units. The pavonazzetto squares at the crossings of the giallo antico borders have sides of one unit.

In the Hemicycle, the inscribed giallo antico squares framed smaller alternating pavonazzetto squares and circles whose dimensions were derived from those of the small unit in the Colonnade (Fig. 149B). The circles were the dominant motif. Seen from above, they marked the center of the pavement and its main axis and formed a series of triangles set one within the other. Two are complete, and the curve of the walls cuts off the apices of the third. Finally, the height of the interior (Figs. 149A, 149B, 150) was the same as the radius of the plan.

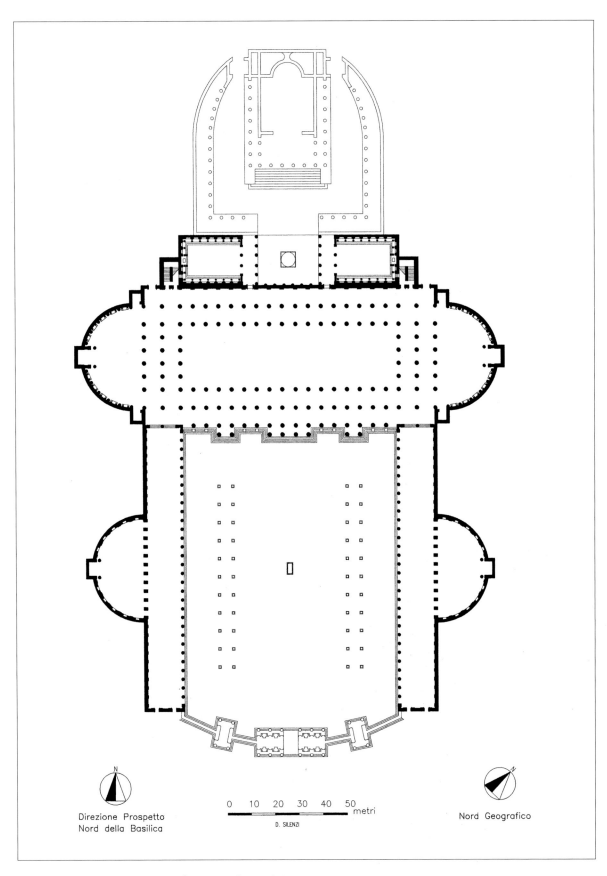

Direzione Prospetto
Nord della Basilica

0 10 20 30 40 50
 metri
D. SILENZI

Nord Geografico

FIGURE 149A. *Restored schematic plan of the Forum of Trajan. D.S.*

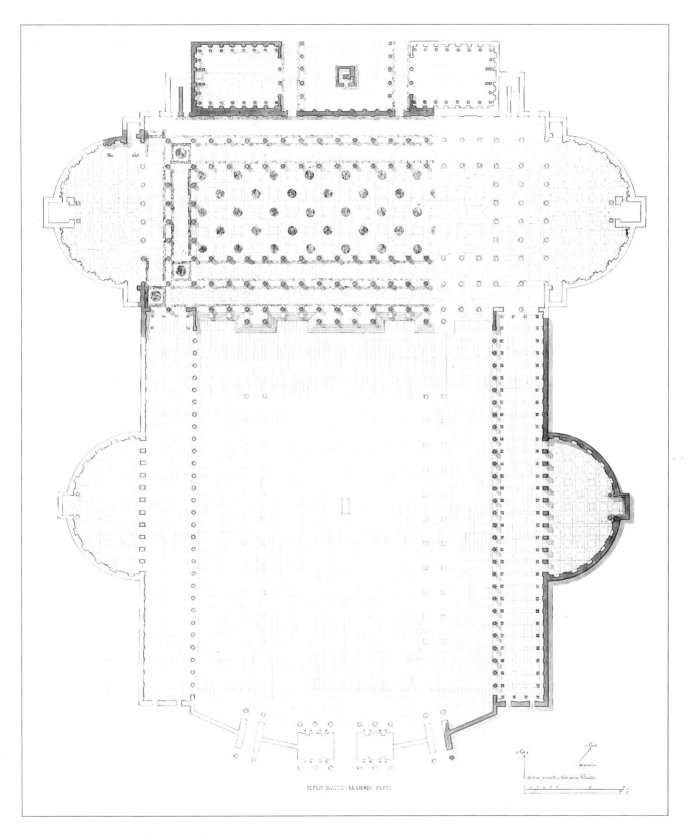

FORVM TRAIANI · RESTORED · PLAN

Figure 149B. *Restored plan of the Forum of Trajan. S.G.*

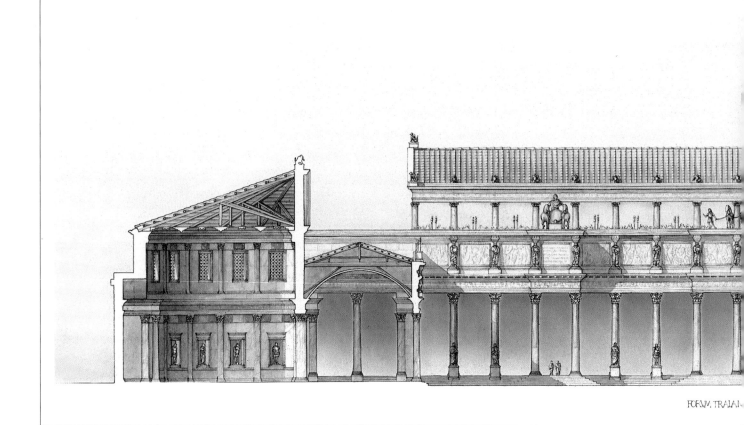

FIGURE 150. *The Forum of Trajan: restored east-west section and elevation with the East and West Colonnades and Hemicycles, looking north to the facade of the Basilica Ulpia. S.G.*

The dimensions of the West Library derived from the "grand square" of the Basilica Ulpia (infra p. 179), which established the outer length of the building. After deducting the space for the thickness of the walls, Apollodorus obtained the inner width, calculating by the square root of two from the interior length, and then divided the length into 90 parts (an esoteric reference to the width of the nave of the Basilica, 90 Roman feet on column centers), each approximately ⅞ of Roman feet (0.257 meters). This was the figure with which he laid out the floor plan, and all his measurements for the various architectural features are expressed in even multiples of this measurement. He again divided the length of the plinth of the columns of the lower order by the square root of two to obtain the diameter of the shafts.

The West Library

The plan of the facade of the Basilica (Figs. 149A, 149B), a copy of that of the rear garden facade of the scaenae frons of the Theater of Pompey, determined the arrangement of the interior. Altogether, the three porches totaled eight columns (four on the central porch, two on the lateral por-

The Basilica Ulpia

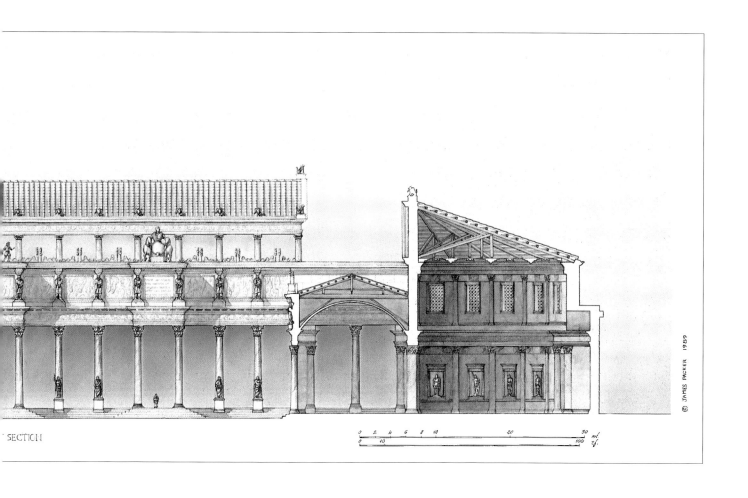

SECTION

ⓒ JAMES PACKER 1989

ches). The central porch had three intercolumniations; the lateral porches, one; the four recesses separating the porches, three. Thus the facade had sixteen columns separated by seventeen intercolumniations two-and-a-half plinths (12 ¾ Roman feet, 3.745 meters) wide. To establish the positions of the columns, Apollodorus divided its length of 300 Roman feet into 117 parts, each 0.753 meter (about 2 ½ Roman feet) wide. Approximately two parts (5 ¼ Roman feet, 1.542 meters) were allotted to each of the sixteen plinths (omitting the two corner ones); five to each intercolumniation. Then, as in the Libraries, by dividing the length of the side of a plinth by the square root of two, Apollodorus derived the lower diameters of the columns from the lengths of the plinths.

The forty-four columns which bordered the nave determined the pattern of its pavement. Borders as wide as the plinths divided the floor into a grid of eighty-five large squares; and five of these squares formed a "grand square" with sides six columns and five intercolumniations wide (95 Roman feet). Three of these "grand squares," divided by two "intervals," each one intercolumniation wide, made up the complete pattern. The "intervals" were aligned with the doors which led to the colonnades around the Column of Trajan and marked the minor lateral axes of the building.

The large squares inscribed alternating circles and smaller squares. The circles were visually and conceptually more important. Their diameter (2.50

meters; 8 1/2 Roman feet) equalled an intercolumniation (12 3/4 Roman feet) divided by one and one-half. Within each "grand square" a circle indicated the corners, the center, and the middles of the sides. A circle also marked the center of the floor of the nave; others emphasized the ends of the principal axes of the building at the sides of the nave. The sides of the squares between the circles (2.35 meters per side; eight Roman feet), which were smaller than the circles, equalled the width of the nave (measured on column-centers) divided by eleven and one-fourth. The diameters of the large circles, that extended the pattern of the nave into the side aisles and marked the corners of the building, equalled an intercolumniation.

A square also determined the height of the ceiling of the nave, 85 Roman feet; and the combined width of the two side aisles (50 Roman feet) equalled the height of the tops of the barrel vaults above them (Figs. 54, 149A, 149B, 151). In other words, in a north-south section, the nave and aisles consisted of a large square as high as the nave was wide flanked by two smaller ones; and the east-west section was a rectangle which measured 100 x 300 Roman feet. Finally, the width of the aisles (14.69 meters or 50 Roman feet) was two-thirds the radius of the apse (22.03 meters or 75 Roman feet). Thus, measuring to its facade, the apse had a diameter equal to one-half the length of the nave (44.07 meters or 150 Roman feet.

Sophisticated as Apollodorus' geometrical architecture was, none but the most visually perceptive visitor would have completely understood it—and then, only after considerable study of the various monuments and their most significant characteristics. One of the most important was the principle of "climactic theme and variations." A single large-scale unit—a half- or segmental circle broken by a central rectangular element—occurs several times throughout the Forum, becoming larger and more complex with each successive appearance (Figs. 149A, 149B). First seen in the curving Murus Marmoreus, this pattern resembles the arrangement of the large hemicycles behind the East and West Colonnades. There, however, a rectangular void, a recess flanked by two columns, replaces the three-dimensional solid of the Central Arch of the Murus Marmoreus. With tribunals as the central elements, the apses of the Basilica Ulpia repeat the same pattern which, in a rectangular variant, appears again in the interiors of the Libraries (Figs. 75-77, 151). Set off by the curving porticoes of its termenos, the Temple of the Deified Trajan is the last and most grandiose expression of this theme (Figs. 3, 5-6, 81).

The Characteristics of the Architecture

Theme and Variations

Marble Polychromy

Colored marbles had varied uses in the Forum. Although their rich effect was important, their casual and frequent use emphasized the imperial power necessary to organize the vast human resources which had supplied Rome with an abundance of these expensive foreign materials. Their repetition unified the buildings that enclosed the forum square, and they served also to highlight important elements (Frontispiece, Figs. 54, 61, 62, 75-78, 149A, 149B-54). Thus the shafts of all the columns on the buildings around the forum square and the bodies of the colossal Dacians on the attic of the Basilica (Fig. 143) were of white, purple-veined pavonazzetto.

The golden, purple-veined giallo antico steps which led to the various structures around the Forum constituted an elegant frame which gave the forum square (Frontispiece, Figs. 149A, 149B), paved with rectangular blocks of visually neutral white marble, the sunken intaglio effect which emphasized its artificial character. Additionally, the giallo antico columns of the three porches of the Basilica Ulpia (and perhaps those of the triumphal arches at the entrance to the Forum) stood out from the pavonazzetto colonnades or solid facades behind.

Apollodorus also distinguished variations and similarities in the plans of the several buildings with africano and granite, giallo antico and pavonazzetto (Fig. 149B). In the opus sectile interior pavement of the East Colonnade, the narrow frames are of giallo antico; the squares at the crossings of the frames and the inscribed rectangles are of pavonazzetto; and, on the sides of the pavement, africano replaces giallo antico in the squares at the crossings of the borders. In the East Hemicycle, these materials are reversed: the inscribed circles and squares are of pavonazzetto; the small crossing squares and the square backgrounds of the inscribed circles and squares are of giallo antico. In the Colonnade, the pavonazzetto columns and responding pilasters echoed one of the colors in the pavements (Fig. 62); while in the Hemicycle, the two superimposed orders of pilasters—pavonazzetto below, giallo antico above—repeated both (Pls. 66, 150).

The constant alternation of giallo antico, pavonazzetto, and africano in the Basilica Ulpia both reiterated the colors of the Colonnades, the Hemicycles, and the forum square, and provided visual meaning and unity. The giallo antico and pavonazzetto rectangles of the brick-like pattern in the side aisles showed that these were less important areas of passage and the africano borders next to the plinths of the columns recalled the squares of the same material along the edges of the pavements in the Colonnades (Fig. 149B). Both giallo antico and pavonazzetto reappeared in the shafts of the columns along the south facade of the building. The pavonazzetto shafts repeated one of the materials of the aisle floors, of the facades of the East and West Colonnades, and of the Dacians on the attic of the Basilica itself (Figs. 54, 61, 150, 152). The giallo antico shafts of the shafts of the porches duplicated another floor color and contrasted sharply with the more muted pavonazzetto shafts of the portico on the facade. In the nave and apses, the pattern and colors of the pavement restated those of the floors in the Hemicycles, although in both wings, the patterns were on a larger scale (Fig. 149B). Bordering the nave, the gray granite slabs between the columns reflected the material of the column shafts; and in the apses, the engaged giallo antico columns echoed one of the major materials in the pavement (Figs. 151, 154).

Showing again that the visitor was in another area of passage, the pavonazzetto and giallo antico brick pattern of the colonnades around the Column of Trajan directly quoted the pavements of the aisles in the Basilica (Fig. 149B); the pavonazzetto shafts of the columns both recalled the Colonnades around the forum square and reflected the materials of the interior pavement (Fig. 54). The pavonazzetto column shafts, pilasters, and wall veneers of the West Library echoed the colors of the East and West Colonnades around the forum square and the Column of Trajan (Figs. 75-78). While reminding the viewer immediately of the entry porches of the Basilica picked out against the pavonazzetto shafts behind, the giallo antico shafts of the aedicula at the end of the room provided contrasting notes of brighter color (Figs. 77, 78, 151-52). Selected from from the visual palette of the Basilica, the narrow giallo antico borders of the gray granite rectangles in the pavement accented an otherwise somber pattern and tied in with the colors of the columns of the two-story aedicula at the end of the room (Figs. 78, 149B, 154). And finally, while we have only a few fragments of the Temple of the Deified Trajan, they are enough to show that the same materials reappeared there (Figs. 3, 5-6, 81). The Egyptian gray granite shafts of the porch were of the same proportions and material as those of the lower interior order of the Basilica; and the pavonazzetto and giallo antico columns of the interior of the cella recalled those of the superimposed orders in the Hemicycles in the Forum and perhaps of the apses in the Basilica. And, of course, the same marbles were presumably again employed in the pavement of the cella.

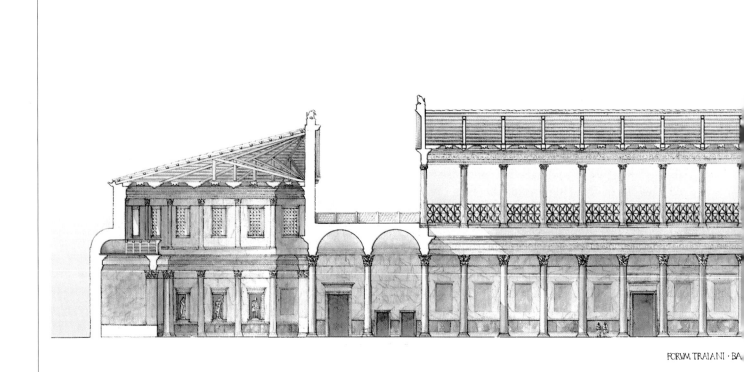

FORVM TRAIANI · BA

FIGURE 151. *The Basilica Ulpia: restored east-west section looking north. S.G.*

The entire Forum was conceived in the manner of a contemporary literary essay. That is, although an original monument in its own right, it was assembled from familiar parts that echoed those of its other famous neighbors. Repeating their achievements, it surpassed them on their own terms. As we have seen, the plan and its large-scale measurement came directly from the Temple of Peace, but lesser elements also constituted major visual references (Frontispiece, Figs. 3, 54, 149A, 149B, 150). The marble pavements in the Hemicycles varied the pavement in the lateral colonnades of the Forum of Augustus, and, with their long lines of Dacian captives bearing elaborate cornices, the attics of the East and West Colonnades and the Basilica (Frontispiece, Figs. 54, 61, 150, 152) unmistakably quoted the attics of the same colonnades and recalled the facade of the Basilica Aemila and perhaps even statues on attics above the garden colonnades in back of the Theater of Pompey.

The imagines clipeatae on the facades of the Central Arch and the attics of the East and West Colonnades again referred to the attics of the colonnades in the Forum of Augustus and to that on the facade of the Basilica Aemilia (Frontispiece, Figs. 54, 61). The Hemicycles clearly duplicated those in the Forum of Augustus. The general plan of the Basilica Ulpia was probably based on that of the Basilica Aemilia and other similar earlier

Achitectural Quotations

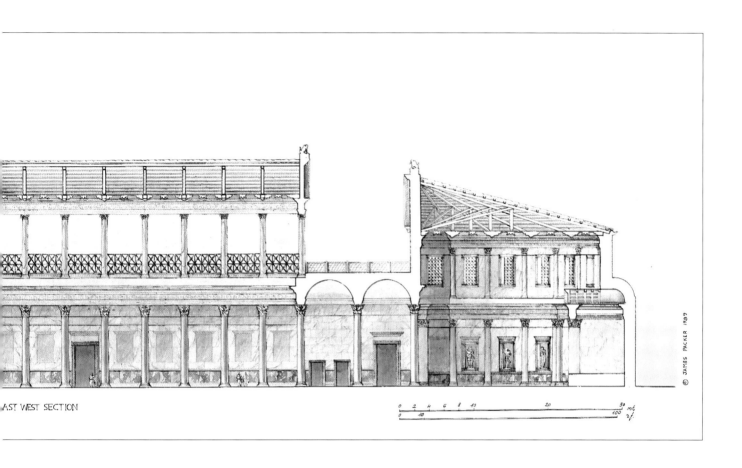

AST WEST SECTION

structures; turned ninety degrees, this plan was repeated in the forum square (Figs. 149A, 149B). There, the two avenues of trees, aligned with the lateral porches of the Basilica and intercolumniations of the columns along the facades of the East and West Colonnades, replaced the interior columns of the Basilica Ulpia, and the Hemicycles behind the Colonnades anticipated the apses of the Basilica (Frontispiece, Fig. 149A, 149B). The equestrian statue of Trajan in the center of the forum square (Frontispiece, Figs. 149A, 149B) quoted the equestrian statue of Caesar in the Forum of Caesar and the recently supressed equestrian monument of Domitian on the northwest side of the Roman Forum. In size and detailing, even the Temple of the Deified Trajan was probably a close copy of the neighboring Temple of Mars Ultor (Figs. 3-6).

Although these frequent architectural citations intimately connected the Forum of Trajan with its neighbors and set Apollodorus squarely within the local architectural tradition, their more important purpose was to assure the viewer that the stability of the Roman world yet endured. Their presence emphasized that, however powerful the Empire had now become, the new grandeur merely continued on a larger and more splendid scale the traditions both of the recent imperial past and of the ancient Republic. Consequently, the magnificent monuments of Trajan's Forum—and the great events they commemorated—were to be understood not as a revolutionary break with the revered past but only as the newly achieved perfection of preexisting artistic—and, by implication, political—forms.

Although composed of simple of simple geometric elements, the plan of the Forum must have seemed enormously complex to the ancient visitor. Looking into one of the lateral colonnades from the brightly lit forum square (Frontispiece, Fig. 62), he would have dimly perceived the regular file of pilasters which divided the back wall into bays; and in the center, the more brightly lighted, taller volumes of the Hemicycle (Frontispiece, Figs. 62, 149A, 149B, 150). These Hemicycles and the orderly rows of columns within the Basilica produced remote, mysterious vistas which receded into darkened interiors accented by daylight introduced from artfully concealed sources (Fig. 154). Reminiscent of Campanian wall paintings in the Second Style, these great colonnades repeated the insistent vertical rhythms of the porticoes of the forum square and both framed and divided the interiors to produce vivid alternations of light and shade. Thus the dazzling daylight of the forum square would have filtered into the nave of the Basilica Ulpia through three rows of columns, and, gazing from the nave towards either end of the building, visitors would have seen, through the continuations of the same colonnades, the more brightly lit, curving sweep of the richly articulated wall of the apse with its tribunal and statues framed within niches.

Once surrounded by porticoes inside the forum square, the visitor was, therefore, constantly surprised (Frontispiece, Figs. 4, 6, 149A, 149B). From the open pavement in front of the Basilica Ulpia, the East and West Colonnades hid the Hemicycles and the apses of the Basilica. The Basilica blocked off a view of much of the Column of Trajan, the two Libraries, and the Temple; and even from inside the Colonnades or the nave of the Basilica, columnar screens effectively concealed the Hemicycles and apses. Enclosed within its portico, the Column of Trajan was fully visible only from the north terrace of the Basilica Ulpia or the steps of the Temple. Even though the Temple of Trajan equalled the size of the Temple of Mars Ultor, the visitor only first glimpsed it after entering the peristyle around the Column of Trajan. Consequently, these architectural "secrets" transformed a casual walk through the Forum into a series of progressive visual revelations, an effect fundamental to the second of the two great themes around which the Forum was planned.

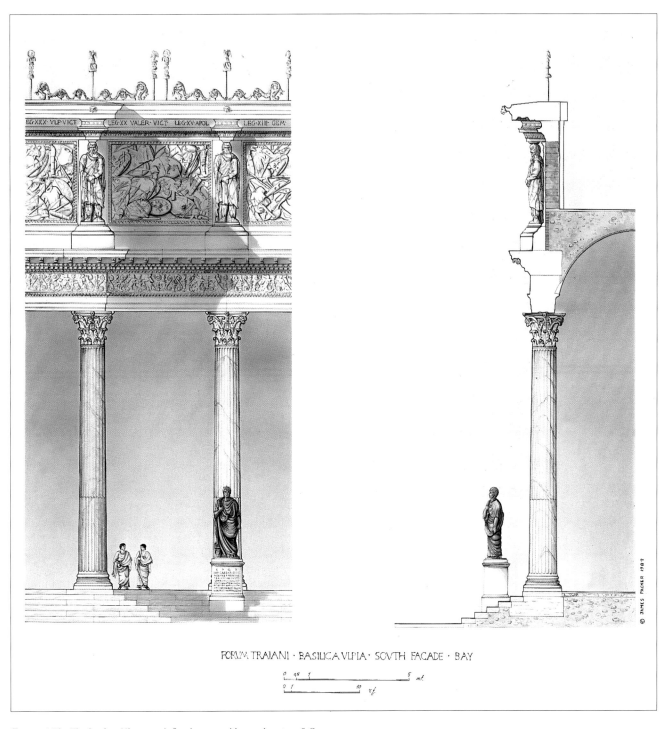

The labels visible on the entablature frieze read:

`LEG·XXX·VLP·VICT` `LEG·XX·VALER·VICT` `LEG·XV·APOL` `LEG·XIII·GEM·`

FORVM·TRAIANI · BASILICA·VLPIA · SOVTH·FACADE · BAY

© JAMES PACKER 1989

FIGURE 152. *The Basilica Ulpia, south façade: restored bay and section. S.G.*

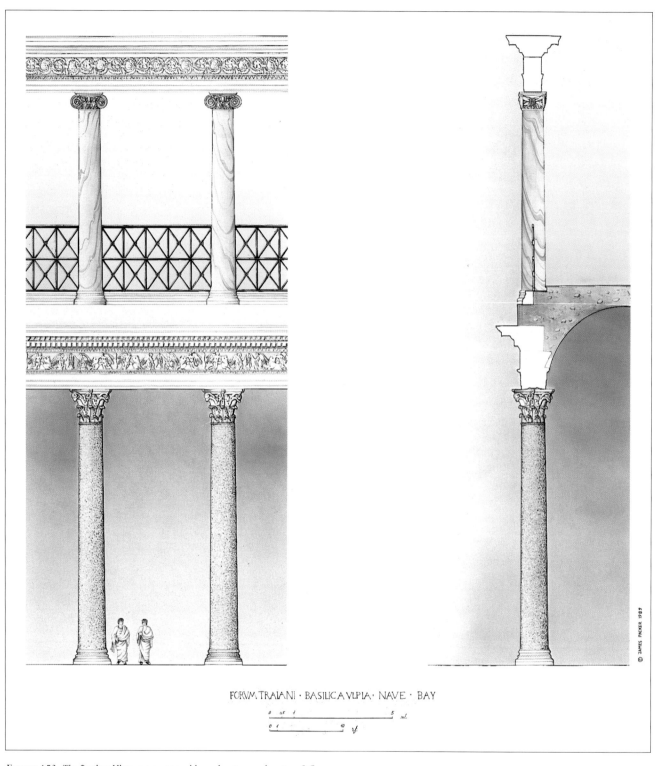

FORVM TRAIANI · BASILICA VLPIA · NAVE · BAY

FIGURE 153. *The Basilica Ulpia, nave: restored bay, elevation, and section. S.G.*

Architecture as Propaganda

In the Forum proper, the height of the facades of the Colonnades and that of the Basilica Ulpia indicated the relative importance of the three buildings (Frontispiece, Figs. 54, 150); and the simple proportions of the open space and the rhythmic repetition of the columnar facades evoked a sense of human order and scale, of well being, of a tranquility conditioned and sustained by latent power. The richness of the architectural materials also ensured the same effect. The expensive imported marbles and the standards and statues of gilded bronze that crowned the surrounding buildings were the unmistakable signs of an overwhelming imperial prosperity and achievement (Frontispiece, Figs. 54, 61, 150, 152). At first glance, the architectural ornament must have seemed only another expression of this same minor theme. Yet, when compared with the complexity of Flavian architectural ornament, its simplicity inevitably recalled the chaste, classicizing forms that characterized Augustus' Forum. On architraves, the elaborate decorations of Flavian cymatia were omitted in favor of normal leaf-and-dart, and half-rounds embellished with bead-and-reel emphasized the divisions between the fasciae. Although the profiles of many of the cornices were almost identical with some Flavian examples, the ornamentation was considerably more austere. The upper cymatium and corona of a typical cornice are plain; the fillets between the dentils are undecorated without the Flavian "spectacles;" the penultimate molding is usually a cymatium with normal leaf and dart; the lowest, a half-round enriched with bead-and-reel. And some orders, while displaying accurately finished profiles, are undecorated.

Indeed, the only elaborate cornices, those cantilevered above the Dacians on the facades of the colonnades and the Basilica (Figs 54, 61, 150, 152), should be taken primarily as contrasting accents to the generally simple character of the surrounding decoration and only secondarily as discreet references to the imperial power embodied in the grandeurs of the imperial residence on the Palatine. Consequently, although the high quality of the execution of all these decorations may have been the partial result of a reorganization of the marble carvers and a closer supervision of their work, the constant repetition of such cleanly elegant architectural ornamentation constituted a powerful visual link between the solid virtues celebrated in Trajan's Forum and those commemorated in that of the Empire's founder.

Friezes likewise echoed the propagandistic content of neo-Augustan classicism. Around the forum square, the martial character of the bronze and marble sculpture and the numerous inscriptions conveyed their ideology so clearly that the friezes on the several buildings needed only to decorate, not inform. Hence, on the East and West Colonnades (Fig. 54, 61), the alternating acanthus, lotus, and palmette simply reflected the sober character of Augustan architectural ornament. On the facade of the Basilica Basilica Ulpia (Frontispiece, Figs. 150, 152), however, while the greater part of the frieze consisted of acanthus vines arranged in heraldically opposed modillions flanked by small vases with acanthus plants, each "scene" concluded at either end with a winged cupid whose torso ended in an acanthus spray—a demigod of Hellenistic origins connected with nemesis and victory (Figs. 140, 152). Hence, on the Basilica, the frieze clearly referred—in restrained fashion—to the subject of the inscriptions and bronze and marble statuary both on the attic above and on the other neighboring buildings: the subjugation of a once proud enemy.

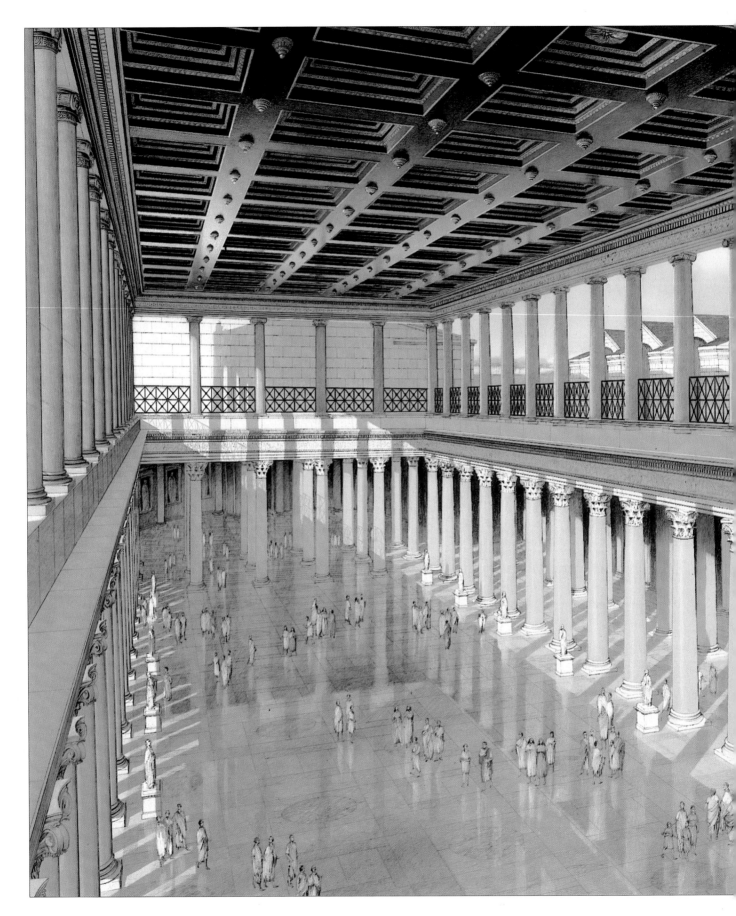

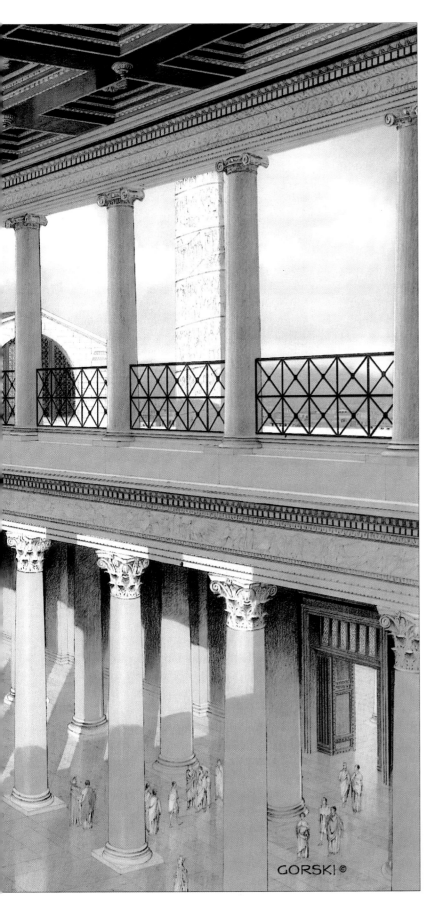

FIGURE 154. *The Basilica Ulpia: restored view of the interior, looking northwest. G.G.*

189

Within the Basilica, the frieze of the lower order, a single scene repeated sixty-five times, dominated the nave. The motifs in each scene (four winged victories, the middle two decorating candelabra, the two at the ends sacrificing bulls) continued the sculptural program of the forum square (Figs. 145-46, 151, 153, 154). As ancient Greek personifications of the defeat of the enemy, the goddesses referred specifically to the political victory of the emperor over foreigners; they also perhaps commemorated the victories of the founder of the Empire to whose iconography Trajan constantly looked back. As sacrificial assistants and cult votaries, these goddesses also recalled the sacrifices made to the genius of the emperor. Yet, while they evoked imperial loyalty and patriotism, they also symbolized victory over death—a clear anticipation of the nearby heroum in the base of the Column of Trajan and of the future grandiose Temple of the Deified Trajan. The lotus-and-palmette frieze of the first interior order of the West Library and the horizontal anthemia of the second were political only in their neo-Augustan simplicity (Figs. 75-78), but the preserved friezes of the porticoes around the the Column of Trajan (Figs. 67, 69-70), of the temenos of the Temple of the Deified Trajan and of the pediment of the Temple itself also played a major role in the sculptural program of the Forum (Figs. 79-80, 81). In each of the serially repeated scenes on the facade of the portico around the Column of Trajan, the two griffins called to mind Trajan's interests in the East. More importantly, as the attendants of Nemesis, whose sharp eagle's eyes and pointed ears saw and heard everything, they stood for divine vengeance. In the virtually identical scenes on the interior of the colonnade, sphinxes took the place of the griffins. Likewise messengers of divine justice, they too were connected with great Hellenic gods— Apollo, Dionysus, and Aphrodite—but they were also apotropaic. Reminding the viewer that he was in the precinct of a hero's tomb, the sphinxes stressed again Trajan's connections with Augustus for whom the sphinx had been a favorite symbol. Thus they obliquely referred to Augustus' deification; by implication, they subtly anticipated the deification of Trajan.

At the ends of each of the identical scenes of the large-scale frieze of the temenos of the Temple of Trajan, at the ends, a cupid terminating in acanthus sprays watered a winged lion-griffin (Figs. 79-80). The cupids faced away from one another; and a ceremonial amphora with Bacchic decorations occupied the center of the composition. These beings recalled the similar creatures on the facades of the Basilica Ulpia and the portico around the Column of Trajan and, like them, were the daemonic servants of Nemesis, referring here (as the Bacchic scenes on the Apulian amphora show) to the Roman subjugation of the East.

Finally, the frieze of the pediment of the Temple, known only from the coins which depict the facade and surely installed only after the emperor's death, showed Trajan as a *divus* flanked by two reclining deities who were perhaps the Danube and the Euphrates (Fig. 81). This relief—and the grandiose seated statue of the *divus* inside the Temple—completed the sculptural and decorative program. Its primary underlying theme was immediately clear: the architectural celebration of the Empire's victorious war over the barbarous forces of disorder—an impressive response to the decorative program of the majestic Forum of Peace at the other end of the same central axis (Fig. 3). Face to face, the two fora together symbolized imperial war and peace. The three triumphal arches which pierced the Murus Marmoreus to the south were the first statements of this grand theme. Atop the central arch (Figs. 47-48), the colossal gilt statue of Trajan, crowned by victory and conveyed into the city in a seiugis led by attendants, marked the central axis of the forum and first attracted visitors' eyes. This group stood on the reassuringly stable, rectangular mass of an attic divided by six vertical piers centered over the columns below. In front of the piers, statues of dejected Dacian prisoners identified the enemy and announced his subjugation; and the full sized representations of the generals (?) in the tabernacles in the five bays of the s—and the busts of other officers (?) in the clipei above—picked out and honored the emperor's most important aides.

All the visible artistic symbols around the forum square commemorated this military prowess. Gilded bronze triumphal chariots crowned the three entry arches and the three matching porches of the Basilica Ulpia opposite (Frontispiece. Figs 54, 150). Standards in the same material stood on both the attics of the Basilica Ulpia and the Colonnades (Figs. 54, 61, 150, 152). On the attics of the Colonnades, inscriptions reading "EX MANVBIIS" ("from spoils") revealed that the conquered enemy had unwillingly financed the Forum; and on the attic of the Basilica and the pedestals above it, additional inscriptions commemorated the military divisions that had fought in the Dacian wars. On the attics of the buildings on all four sides of the Forum, the ubiquitous statues of Dacians visibly demonstrated that even the powerful physiques of the enemy soldiers had not prevented their complete discomfiture. The heavy ornamental cornices supported on their heads showed that, after their conquest, these hardy barbarians had been forced into the service of the Empire (Frontispiece, 54, 61, 150). In the

monument at the center of the Forum (Frontispiece, Figs. 149A, 149B), the figure of Trajan, mounted on an impressive charger, held aloft the symbols of war and victory. On the central axis of the Forum, this statue, aligned with the *triumphator* in the chariot on the Central Arch (Figs. 47-48), with the statue in the chariot on the middle porch of the Basilica, and with the colossus of the deified hero on the Column of Trajan (clearly visible from the forum square above the gilded roof of the Basilica Ulpia), introduced the second grand theme of the Forum: the exaltation of the victorious commander-in-chief.

Trajan's multiple images everywhere confronted the visitor: in the six chariot groups on the three triumphal arches and on the three corresponding porches of the Basilica Basilica Ulpia, in the equestrian statue of Trajan, on the eight pedestals along the entry stair to the Basilica, in the recesses in the East and West Hemicycles, in the tribunals in the apses of the Basilica Ulpia, in the reliefs which wound around the Column and on its top, on the pediment of the Temple and in its interior. His guise constantly changed. In the Forum he was the omnipotent victor; in the Hemicycles and tribunals of the Basilica, the wise administrator and pontifex maximus; on the spirals of the Column, the sagacious general; at its top, the deceased hero; and in the Temple, the sanctified *divus*. Thus, having made the pilgrimage through the Forum to the stair to the Temple (Figs. 3, 5-6, 81), flanked by statues of Victory and Peace, perceptive visitors would have understood the implications of this second grand theme: the entire Forum was a biography in stone which successively revealed the various stages in the life of its hero as he progressed from mortality to deification.

Consequently, when they had finally penetrated to the cella of the Temple and seen the colossal seated statue of Trajan arrayed as Olympian Zeus, visitors would personally have observed the discomfiture of Rome's enemies in the West and East; and, by witnessing the emperor's conquest of death and ascent to heaven, they would have participated in the moving conclusion of that three dimensional mystery play which was the Forum. Their loyalty to the Empire was strengthened, and, as the audience for whom this splendid spectacle had been mounted, they could only marvel, applaud, and depart, rejoicing in their new-found understanding of the central principles and power on which the Imperium Romanum had been established—and now triumphantly celebrated.

Afterword

The University of California at Los Angeles (U.C.L.A.)/ Getty Museum Computer Model

The architectural reconstructions presented herein could not take into account *all* the previously excavated (but uncatalogued) fragments of Trajan's Forum (above, p. XVIII), and much additional material has resulted from the new excavations now (1999) taking place on the site. Consequently, revisions to these reconstructions will almost certainly be necessary. Even before the completion of the in-progress catalogue of all the known remains of the Forum and the end of the new excavations, however, modern computer science has offered a new means of extending and correcting our reconstructions.

For a display on the Forum of Trajan, part of the inaugural show at the new Getty Museum (1997-99) in Los Angeles, the Museum created a three-dimensional computer model of the Forum of Trajan. Seen at the Museum in a video, this model, framed by some of the major architectural fragments from the Forum, indicated to visitors the original positions of the exhibited fragments. Under the direction of Professors Bill Jepson and Diane Favro, Dean Abernathy and Lisa Snyder of the University of California at Los Angeles Department of Art and Architecture realized this model; architect Kevin Sarring and the author served as consultants. Partially finished by late 1997, the model provided new views of all parts of our reconstructed site.

A New Computer Model

Although the Museum never fully completed its model, manipulation of its images in real time helped us to begin correcting the "rough spots" in the two-dimensional drawings reproduced above. These were further revised in a new computer model of the Forum executed in 1998-99 by New York architect John Burge in consultation with architect Kevin Sarring and the author. Our corrections involved areas not shown in our original illustrations, places where either one structural system was not satisfactorily integrated with neighboring structures or where the architectural detailing was ambiguous or not fully realized. The following pages briefly discuss and illustrate the revisions of these "problem areas."

The East Hemicycle

For the East Hemicycle, we indicate above (p. 63, Fig. 150) that the entablature of the lower order pilasters could not have continued across the front of the central recess as Gismondi suggests (Fig. 155) because the opening was too wide for the span of a single marble block. In consequence, we proposed that the entablature of the lower order, profiling over the gray granite columns that flanked the recess, continued into and through its interior. The on-center distance between the columns (6.65 m = 22 $\frac{1}{2}$ Roman feet) is, however, only about three Roman feet greater than the intercolumniations of the Basilica Ulpia. Thus, as Gismondi suggests, it was probably not

too wide for a central tabernacle with an unbroken entablature and pediment (Fig 156). However, since there is no real evidence for Gismondi"s two-story tabernacle, we omit the upper story here, assuming that a pediment would have intersected the pilasters of the upper order (Fig. 156). While moderns may find such juxtapositions disturbing, the Romans apparently did not, as clearly seen in Panini's famous view of the interior of the Pantheon (Fig. 157) where the barrel-vaulted entrance vestibule intersects the lower sections of the pilasters in the upper zone of the rotunda.

In the interior of the Colonnade, the juncture between the internal pilasters and the lower order of the Basilica Ulpia constitutes another major problem (Fig. 158). The Forma Urbis (Fig. 130) unambiguously indicates that these two orders "collide" at the north end of the colonnade, leaving visible from the Colonnade a single column of the Basilica. A low stair would have connected the interiors of the Colonnade and the Basilica (Figs. 149A, 149B, 158), and returns of the colonnade walls must have masked the difference in elevation (some 1 and 3/4 Roman feet) between the floors of the Basilica and the Colonnade. The Colonnade order would have terminated against pilasters that, responding to the lower interior order of the Basilica Ulpia, framed the entrance to the Basilica.

In order to insure that the lunate pediment on the colonnade side was centered above this entrance, the returns of the colonnade walls would have been the same width. Continuing the colonnade between the east aisles of the Basilica Ulpia, the column inside the entrance was aligned with it. Thus the east intercolumniation was slightly wider than that to the west. However, as Fig. 158 shows, this difference was not very noticeable.

In the plaza again (Fig.159), the junctions between the facades of the East and West Colonnades and that of the Basilica Ulpia represent another major problem. Following Gismondi, we omitted a last pilaster at the north end of each Colonnade, ending its order and attic with a blank space that intersected the facade of the Basilica (Frontispiece, Fig. 54). That scheme is very unlikely. To complete the elevation of the facade more satisfactorily, we added a final north pilaster in the computer models (Fig. 159), . The Basilica stair would have partially intersected the base of this pilaster; the entablature of the colonnade order and the attic cornice above would have profiled over it; and the pilaster and the ornamental shield or *imago clipeata* in the attic above would have reduced our originally empty bay at the north end of the Colonnade facade (Frontispiece, Fig. 54) to a narrow—and visually unimportant—space.

The Basilica Ulpia

The Junctions between the Colonnades and the Basilica

The Facade

In the revised restoration (Fig. 159), we omit the upper attic cornice that, in our original reconstruction appeared above the cornices over the Dacian atlantes (Frontispiece, Figs. 54, 150, 152). In fact, we had no fragments of that cornice, but we restored it by analogy with an identically placed attic cornice from East Colonnade of which numerous fragments survive (Figs. 60, 61). Since the facades of the colonnades were slightly reduced versions of the Basilica's forum facade, we reasoned that, if the colonnades' attics had had a final cornice, so must the Basilica. Two considerations prompted our revision. (1) Unlike the colonnade cornices, those from the Basilica include a final frieze. Above the atlantes, this frieze is decorated with rosettes; above the returns, with inscriptions that commemorate Trajan's Dacian legions. Conceptually this frieze was analogous to the parapets with inscriptions above the colonnade attics and, like those parapets, was, in the Basilica, the final element of the attic. Moreover (2), an upper cornice would have perpetually shaded the inscriptions, rendering virtually invisible important subject matter that had to be legible. Thus omission of an upper attic cornice and the consequent exposure of the inscriptions to the full sun accords better with the character of the original design than did our initial reconstruction.

The Apses

In the apses, we also changed our earlier restoration significantly (Fig. 160). The best evidence for these essentially unexcavated wings is still the Forma Urbis (Fig. 130) which records an east apse with a central dystyle tribunal. On either side, engaged columns frame five bays. Materials recovered from the west apse during the excavations of the 1930s supplied additional evidence: a one-quarter engaged giallo antico shaft from the lower order, a cornice from one of the first-story niches (?), and some of the bedding mortar and fragmentary marble slabs from the pavement. Visible in the bedding mortar, the smaller squares in the marble pavement corresponded (as in the Colonnades and nave) to the dimensions of the plinths of the columns in the lower order. The size of these squares (and, therefore, of the missing plinths) and the diameter of the corresponding engaged shaft showed that the lower order in the west apse was the same height as both the colonnades around the plaza and the lower order in the East Hemicycle. Thus the first-floor order in the apse had been considerably lower than the one in the nave

In order both to align the engaged columns of the lower order with the gray granite columns at the entrance to the apse (Figs. 161, 163) and to allow for a second-story window directly above the tribunal, we assume that, in a plan similar to that of hemicycle D of the Baths of Trajan, the centers of the engaged giallo antico columns would have been sixteen degrees apart. Consequently, the bays delimited by these twelve columns (including the two of the central tribunal) will have taken up 176 of the 180 degrees of the circular plan. To compensate for the missing four degrees, the base plinths of the two columns at the north and south ends of the apse would each have extended two degrees beyond column center (a dimension equal

to half the width of the base). The outer side of the plinth would, therefore, have been tangent to the diameter of the apse. Thus the plan of the apse apparently differed somewhat from that of the Hemicycle (Figs. 149A, 149B).

We originally supposed, however, that the tribunals in the apses (fig. 151) closely resembled the recesses in the hemicyles (fig. 150). Like the recesses, the facades of the tribunals had, according to the Forma Urbis (Fig. 130), been framed by two projecting columns, probably with shafts of the same gray Egyptian granite that characterizes both the shafts of the recess in the East Hemicycle (Figs. 53, 156) and those of the colonnade around the nave (Figs. 154, 161, 163-64). In each apse, as in the East Hemicycle, these columns would have been the same size as the flanking order. Since, with the same entablature as the flanking colonnades, the columns of the tribunal could not have stood on a porch, we supposed that the interior of the tribunal, raised above the level of the pavement, would have been reached by a lateral stair. Although we illustrated this arrangement in our east-west section through the Basilica (Fig. 151), we prudently never published a final version of the facade of this rather unorthodox tribunal.

The model suggested, however, that, in appearance, this reconstruction was unnecessarily complicated. Consequently, although we still surmise that the order of the tribunal equaled the size of that of the flanking colonnades (Fig. 160, 163), we set its two columns directly on the pavement. In assuming that the tribunal was simply an open rectangular recess preceded by free-standing columns and flanked by pilasters, we follow the plan of the Hemicycle (Figs. 149A, 149B, 156) and differ from that of the Forma Urbis (Fig. 130). The pilasters would have replaced the engaged columns of the other bays, and the entablature will have supported a conventional pediment below a second-story window (above p. 163). The giallo antico shafts of the lower order (of which only the back quarter was engaged) suggest that the entablature may have profiled over these columns as ressauts. To display the bases of the engaged upper order shafts (of cipollino like the second-story columns in the nave) these ressauts would have carried pedestals; and the upper order columns will also have had ressauts. Several small Corinthian capitals, unfinished on one side, and matching fragmentary shafts of porphyry, giallo antico, and gray granite– the first two marbles also used for the shafts of the tabernacles in the Pantheon– may indicate that there were tabernacles in the lower bays. These would have had podia lower in proportion to the height of their order than did the similar tabernacles in the Pantheon, but, as in the Pantheon (and on the Hemicycle facade of the Markets of Trajan), these tabernacles probably alternated lunate and triangular pediments.

Lighting the Apses

The computer model also allowed us to rethink the elevation of the wall above the entrance to the apse from the outer colonnades (Fig. 161). Partially for reasons of economy, partially owing to the difficult design problems associated with this part of the building, we had omitted an elevation of this wall, showing it only in section (Fig. 151). Yet, since the order of the outer colonnade was higher than that of the apse, we needed to harmonize the "collision" between these two differently sized orders. A second problem involved lighting the tribunal. Since the barrel vaults above the aisles between the nave and the apses were higher than the sills of the upper story windows in the apse, our drawings (Figs. 151, 154) omit windows from the walls above the entrances to the apses. Unfortunately, without windows in these walls, the facades of the two tribunals would have been left in perpetual shadow, an impossible supposition in view of their architectural importance.

To solve these two problems, we assumed in the model: (1) that the apse's second-story engaged columns continued as pilasters across the wall above the entrance to the outer aisle (Fig. 161); (2) that the cornice of the nave order would have been just slightly lower than the high attic above the lower order in the apse; and (3) that, at the entrance to the apse, this cornice visually (and actually) supported both the return of the upper order sub-bases and the pilasters. We also hypothesized that, in the bays between the pilasters, there had been windows sized like those in the apse's other second-story bays (Fig. 163), and light from these windows would have illuminated the facade of the tribunal. In the west apse, these windows faced east; in the east apse, west. Thus the rising sun would have bathed the facade of the west tribunal in a mellow raking light; while the setting sun would have similarly burnished the facade of the east tribunal.

Roofing the Apses

The model also showed how the roof trusses of each apse must have been configured (Figs. 162, 163). With shafts whose diameters were half-a-Roman foot wider than those of the columns that framed the nave, the columns between the outer aisles and the apse must have supported a pediment that carried trusses aligned with the columns (Fig. 163). These trusses sustained both a gabled roof over the intermediate block and its extension: a low conical roof over the apse. The successively lower flat upper sections of the trusses would have corresponded to the raking profiles of the pediment. A section taken through this roof (Fig. 163) suggests that, in order to conform to its curved upper surface, each truss had three almost equal sections. With a flat top, the central section would have been about six Roman inches lower than the gradually curved profile of the theoretical cone that the roof surface approximated. Since, however, the roof of the apse would have been virtually invisible to observers in either the court of the Libraries or in the main piazza this irregularity would have passed unobserved.

Although the model produced no alterations in our original conception of the nave of the Basilica Ulpia, it does give a remarkable impression of the open, airy character of a space which was, conceptually, a roofed version of the exterior plaza (Figs. 154, 164). While the north wall of the Basilica sealed off direct views into the court of the Libraries, tantalizing glimpses of the shaft of the Column of Trajan appeared through the columnar clerestory around the nave, irresistibly drawing visitors from the Basilica into the peristyle around the Column of Trajan.

The Nave

Our original reconstruction supposed that, in north-south section, the Basilica Ulpia had been designed as a giant square (the nave) flanked by two smaller ones (the side aisles) (above p. 180, Fig. 54). While this surmise resulted in an elegant north-south section, our restoration was criticized, after publication, for producing an insufficiently supported roof liable to destruction by wind shear. Consequently, in an attempt to support our roof better, we present here a revised upper story (Figs. 163-64). Above the gray granite columns around the nave, there would have been a Corinthian order (a number of Corinthian capitals suitably sized for this order survive). The Ionic columns shown on Trajanic coins (above Figs. 131-32, p. 149) would thus have been located above the colonnade between inner and outer aisles. The lower height of the exterior Ionic colonnade would have permitted the use of shafts of the same height in both upper orders. Four L-shaped walls, each section the width of one of the intercolumniations below, would also have helped anchor the roof and ceiling securely. Since the width of the roof determined its height, our new wider roof would also have been slightly higher than our original one (thus partially concealing the statue of Trajan on his column). But, it is also possible that the ratio between the length and height of the roof may have been slightly greater than we had originally supposed (thus allowing for a lower roof and a correspondingly better view of Trajan).

The Second Story and Roof of the Nave

This peristyle was probably the original position of the "Great Frieze of Trajan" (Fig. 165). Its main fragments are now incorporated into the Arch of Constantine (Fig. 166), but the complete frieze probably originally decorated the attic above the entablature of the engaged half-columns along the north facade of the Basilica Ulpia. In that position, the frieze would have varied and enlarged upon the events of the Dacian Wars shown on the shaft of the Column, spotlighting key episodes for visitors to the Forum.

The Great Frieze of Trajan

The West Library

In the West Library, our reconstruction (Figs. 75-78) glossed over several significant problems. The most important was the precise location of the stair that led to the upper story. Since the room was completely excavated in the 1930s (Fig. 44) and no trace of the stair was found at that time, we supposed that, in the absence of any apparent connection between the stair in the Basilica and the upper floor in the Library, a second smaller stair, possibly in the unexcavated zone at the northwest corner of the Library, would have given access to its upper niches (above p. 79). The model, however, showed that this hypothesis is probably incorrect.

The excavators of the 1930s found that the south and west walls of the Library had been completely removed (Fig. 44), although the podium in front of the west wall had survived. Consequently, the present west wall, constructed in the 1930s, is a featureless modern partition. Since, however, the ancient podium in front of this wall includes bases for a branch of the colonnade that runs around the north and south sides of the room, our original reconstruction (Figs. 75, 77, 78) assumed that these columns (as along the other walls) framed book storage niches (*armaria*), a scheme that leaves no space for a door between the interior of the Library and the corridor behind the west wall of the Library that leads into the Basilica Ulpia.

A door from this corridor to the stair was mistakenly omitted from our original reconstructed plan of the Forum, although its north side clearly appears on the Getty archaeological map (Pl. 0). Yet this door (Figs. 149A, 167) is actually our most important clue for understanding how the upper story of the Library was reached. If the stair had been intended *only* to access the upper story of the Basilica, it would not have had an entrance into the corridor behind the Library, and that hall would then have led only to the area under the basilica stair (as in a typical Roman apartment house) and to the backs of the Basilica and the Library. The door, however, indicates that the corridor was also a means of reaching the second story of the Library. Nearly half as wide as the aisles in the Basilica, this hall was thus actually an important public space. The south opening in the west wall of the library probably led, therefore, not to a book niche, but rather to a low stair (three steps bracketed by the width of the wall) (Figs. 167, 168). Although all evidence for this stair would have perished either when post-antique construction destroyed the Library's original west wall or when the excavators of the 1930s replaced it, that small stair originally led down into the corridor behind the Library, from the corridor into the Basilica stair, and thence into the second story of the Library (Figs. 167-68). When closed, the wooden doors to the upper and lower corridors in the Library would have appeared like only slightly longer versions of the doors to the other *armaria*. (Concealed stairs were, incidentally, also features of Rome's later great Baroque Libraries, the Valicello, the Angelica, and the Casa Natense.)

The final major problem in the Library has to do with the elevation of the east wall. In order to relate the order of the columnar screen at the entrance to the superimposed colonnades on the other three sides of the interior, we originally proposed an order assembled from the *in situ* base at the entrance to the East Library, one of several existing Corinthian capitals, and a shaft much shorter than elsewhere in the Forum (approximately six diameters high, rather than the usual eight). The resulting squat columns (Fig. 76) looked manifestly incorrect to Dean Abernathy when he programmed this section of the Getty/U.C.L.A. model, and he modified our original design by giving the screen columns the same proportions as others throughout the Forum (Fig. 169). The result is an extremely handsome elevation—something that Apollodorus of Damascus—or whoever the architect of the building actually was—should have designed. Unfortunately, he did not. Neither Dean's reconstruction (Fig. 169) nor our original one (Fig. 76) is correct.

Close inspection of the travertine foundations for the columns at the entrance to the libraries and those of the peristyle around the Column of Trajan (Figs. 44, 149A, Folio O) shows that both sets of columns were identically sized. These orders were much higher than the lower interior order in the Library *and* the podium on which they stood, and, in consequence, we have to assume with Italo Gismondi (Fig. 170) that, on the east side of the building, this order brusquely interrupted the interior colonnades which ended, therefore, at the east wall. This reconstruction (Fig. 171) accords exactly with the archaeological data and is also compatible with the brusque juxtaposition of differently sized orders elsewhere in the Forum.

To sum up, both computer models, that made for the Getty Museum by the U.C.L.A. Department of Art and Architecture and the new one by John Burge, have allowed us—Kevin Sarring, Dean Abernathy, Lisa Snyder, John Burge, and me—to work freely in three dimensions. With them, we have peered around corners to revisit some of the odder nooks in our earlier reconstructions. In the light of these "fuller disclosures" of the underlying archaeological and architectural problems, we have revised and rethought our earlier two-dimensional representations. Whether or not the resulting models are any truer to the original Trajanic architecture may be a subject for further debate– and the excavations of 1999 may shed further light on these problems. Yet meanwhile, our new three-dimensional reconstruction, as realized by John Burge, is at least far more internally consistent than were our earlier drawings. Consequently, we have traveled further than ever before in the direction of recreating the original designs of Trajan's architect(s), and we have thereby been able to conceive of Trajan's famous forum in a more unified, global fashion than has been possible at any time since its buildings collapsed in an disastrous earthquake at the beginning of the ninth century after Christ (above, p. 7). Moreover, the assembly of these models has created arresting three-dimensional artifacts, constructs that allow us to view freely, in a lively and immediate fashion, the brilliantly ordered spaces and elegant fittings of Trajan's sophisticated structures. Thus we can understand, for the first time in nearly 1,200 years, why Trajan's "gigantic complex" so impressed Ammianus Marcellinus and taxed his descriptive powers.

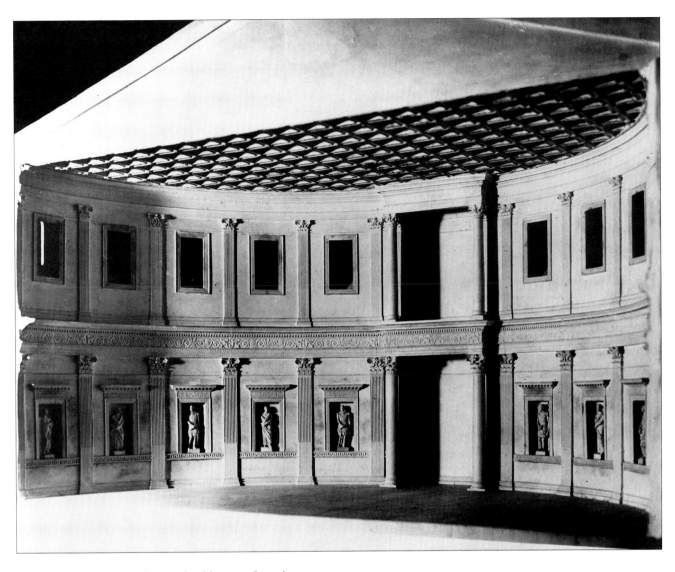

FIGURE 155. *The East Hemicycle: restored model, interior. Gismondi.*

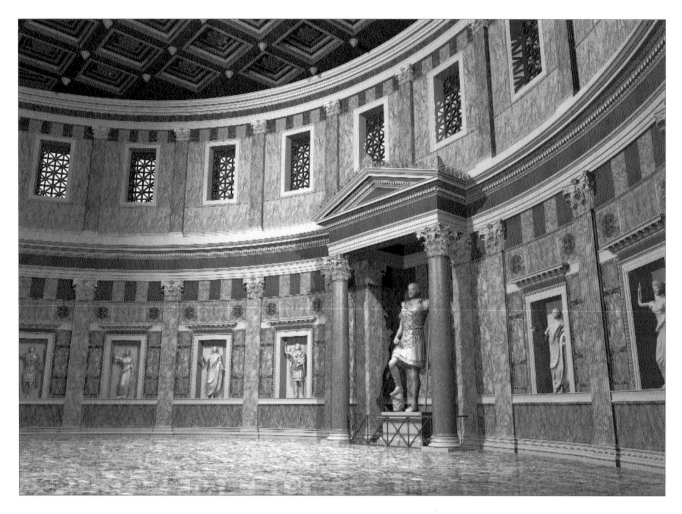

Figure 156. *The East Hemicycle: reconstruction looking northeast. B./P.*

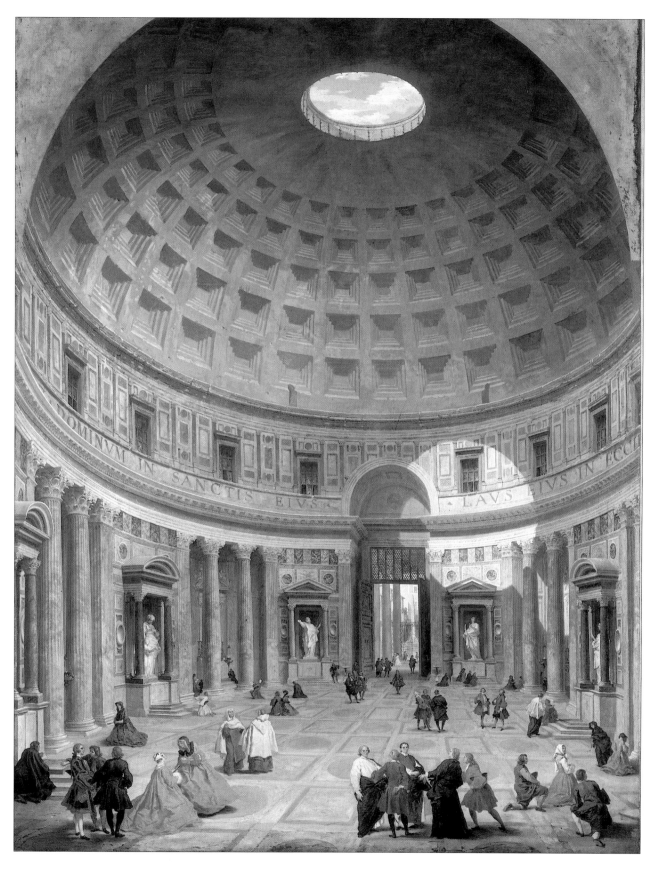

FIGURE 157. *The Pantheon: the interior in the mid-eighteenth century. Panini. N.G.*

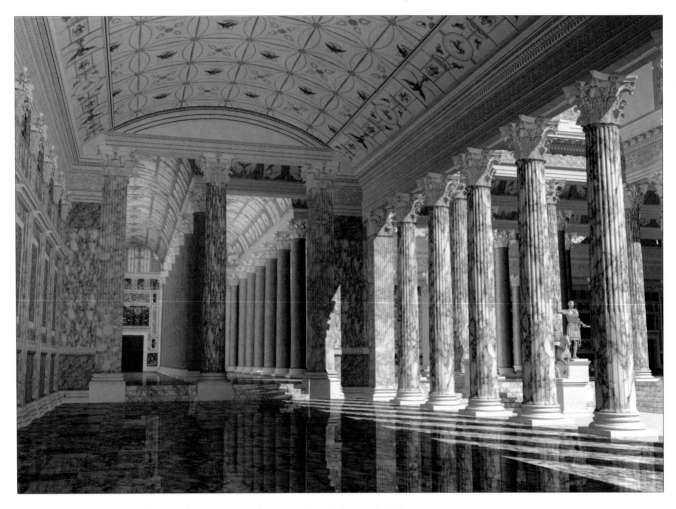

FIGURE 158. *The West Colonnade, restored: the entrance to the Basilica Ulpia, looking north. B /P.*

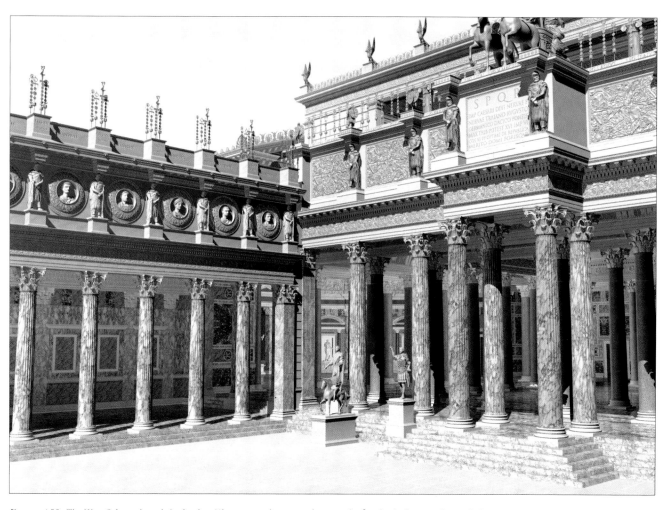

FIGURE 159. *The West Colonnade and the Basilica Ulpia, restored: junction between the facades, looking northwest. B./P.*

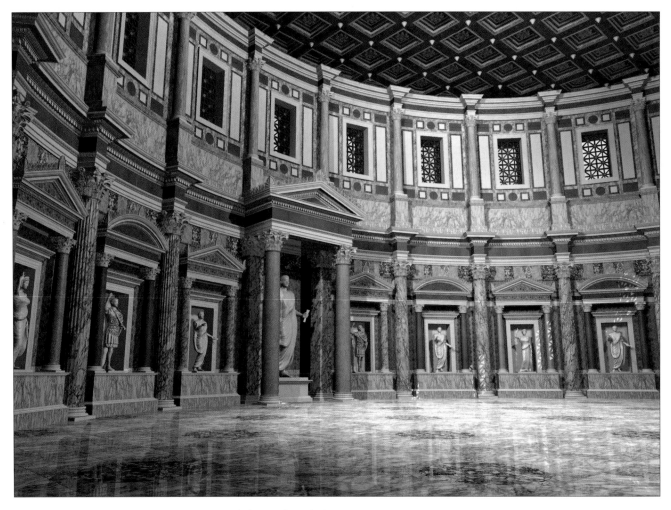

FIGURE 160. *The Basilica Ulpia restored: the west apse, looking northwest. B./P.*

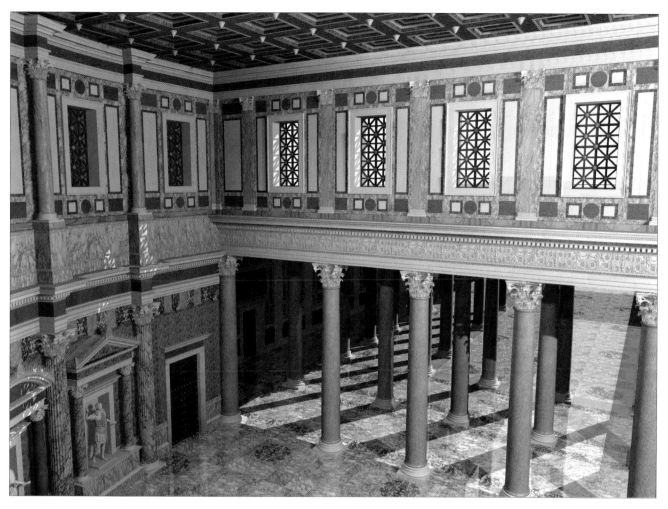

FIGURE 161. *The Basilica Ulpia, restored: wall above entrance to the west apse, looking toward the west outer colonnade. B./P.*

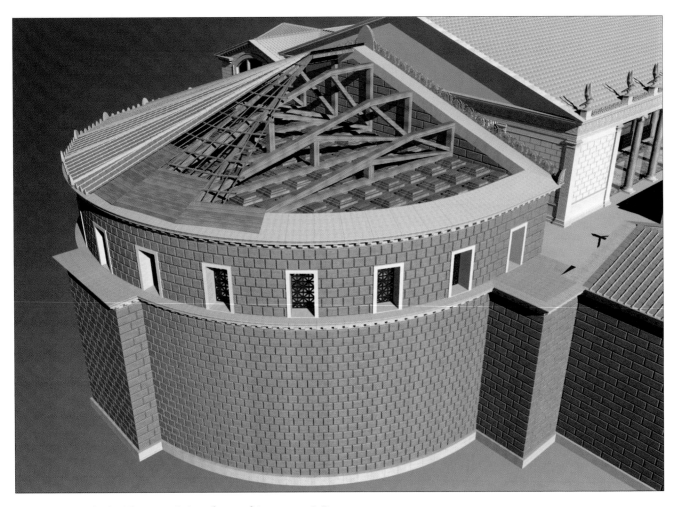

FIGURE 162. *The Basilica Ulpia restored: the roof trusses of the west apse. B./P.*

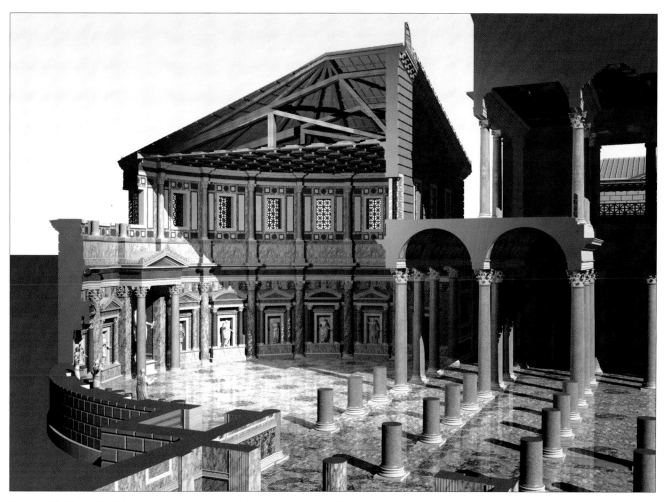

FIGURE 163. *The Basilica Ulpia: restored cutaway view of the west aisles and apse. B./P.*

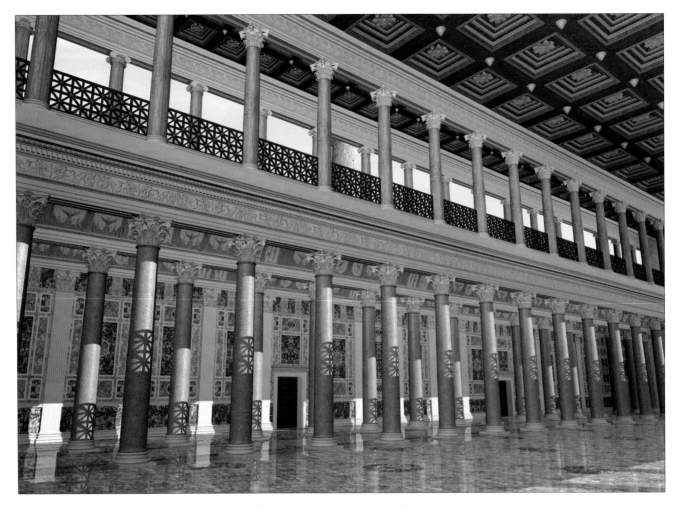

FIGURE 164. *The Basilica Ulpia, restored: view of the nave, looking north toward the Column of Trajan. B./P.*

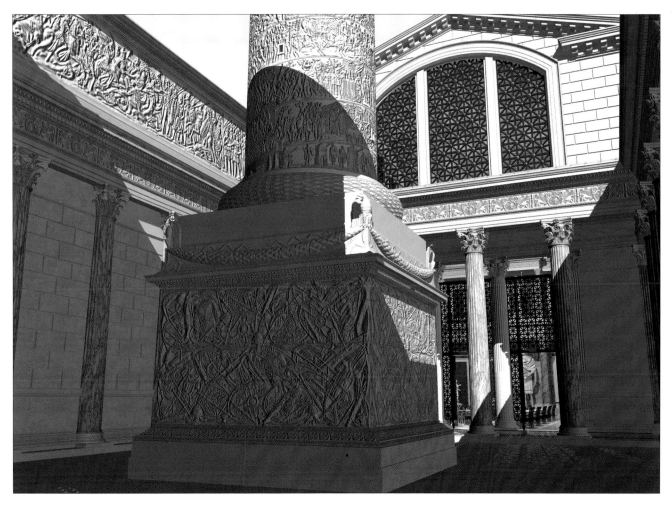

FIGURE 165. *The peristyle around the Column of Trajan, restored: view looking southwest toward "Great Frieze of Trajan" on the attic of the north facade of the Basilica Ulpia. B./P.*

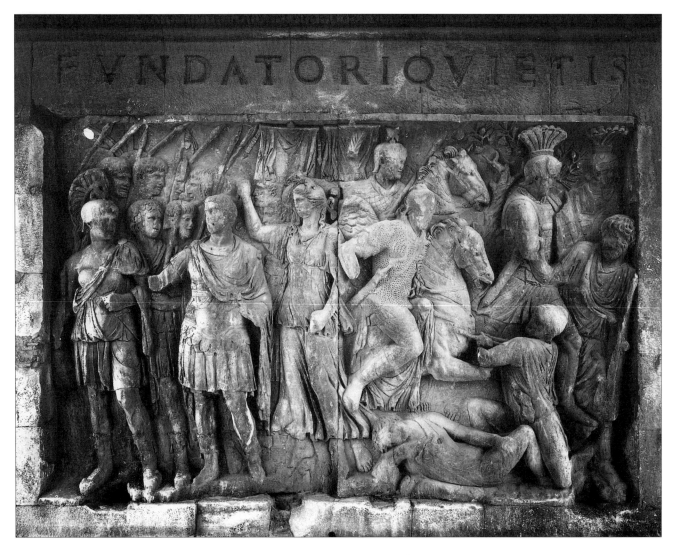

FIGURE 166. *The Great Frieze of Trajan: panel on the east side of the central passage in the Arch of Constantine. D.A.I.R.*

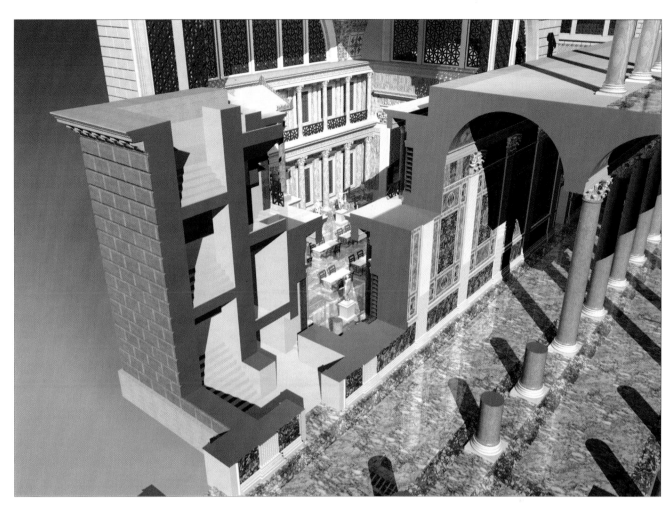

FIGURE 167. *Restored cutaway view, looking northeast through the north aisles of the Basilica Ulpia and the southwest corner of the West Library, showing the corridor behind the Library and the Basilica stair. B./P.*

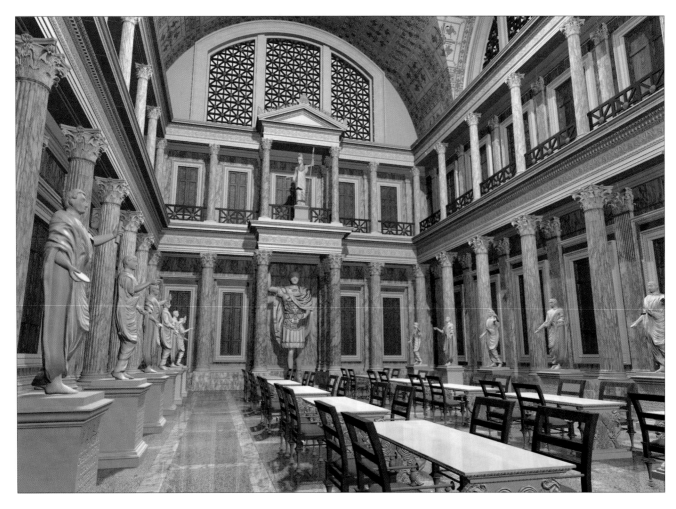

FIGURE 168. *The West Library, restored: the interior, looking west. B./P.*

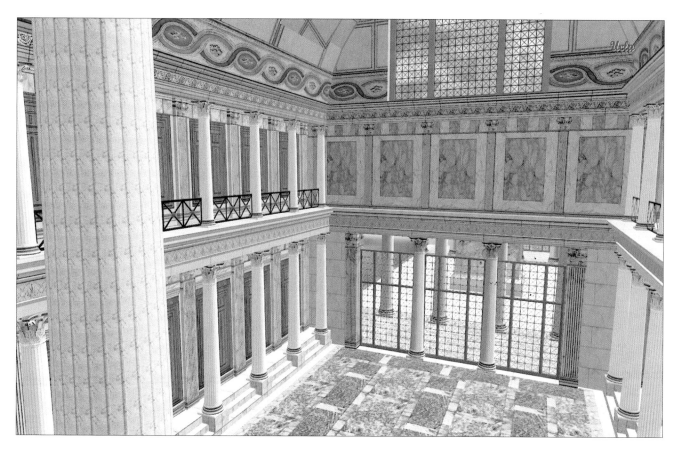

FIGURE 169. *The West Library: restored interior looking northeast. G.M./ U.C.L.A.*

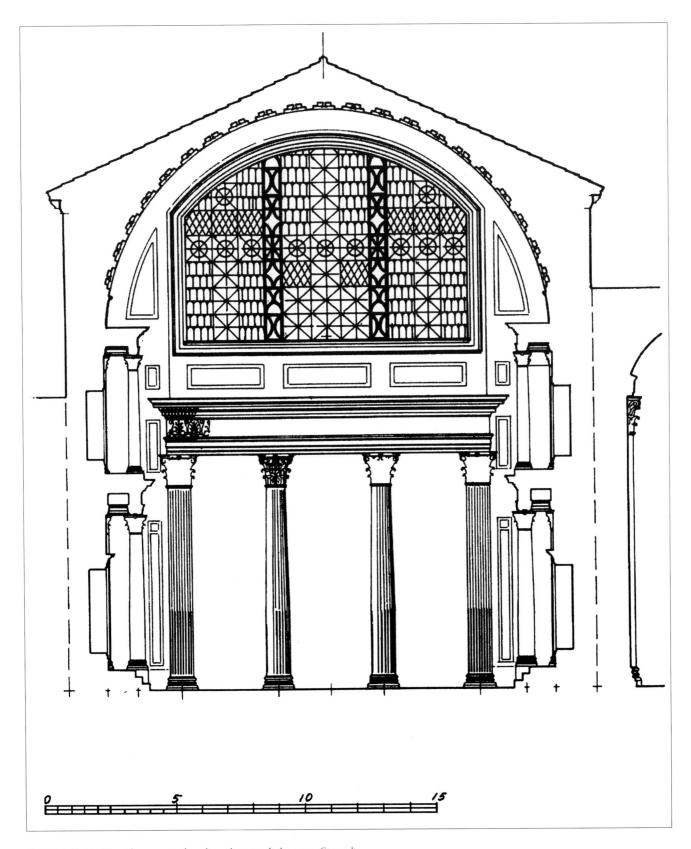

FIGURE 170. *The West Library: restored north-south section, looking east. Gismondi.*

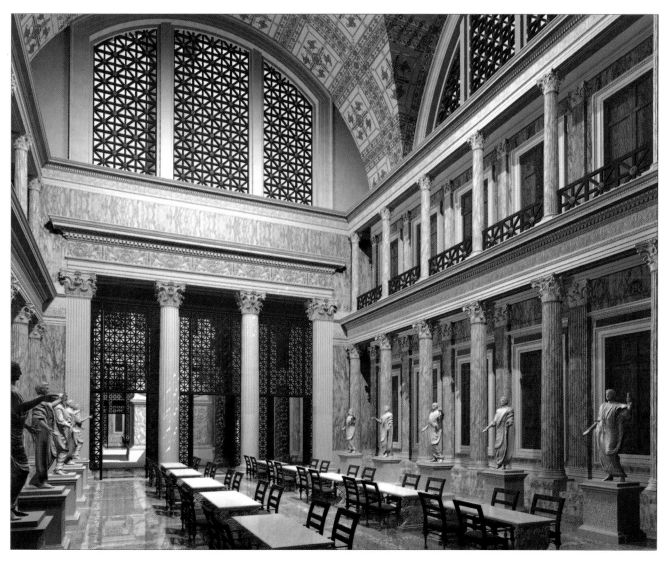

FIGURE 171. *The West Library, restored: interior, looking southeast. B./P.*

Selected Bibliography
with Abbreviations

This list defines the bibliographic abbreviations used in the original work and provides full bibliographical information for works cited by the author's name, by a short title, by the author's name and short title, or by the author's name and publication date.

AA = Archäologischer Anzeiger.

Adam = Adam, J.- P., *La construction romaine*. Paris: Picard, 1984.

AdI = Annali dell'Istituto di corrispondenza archeologica. 1829-.

AJA = American Journal of Archaeology. The Journal of the Archaeological Institute of America. 1897-.

Albertolli = Albertolli, F., *Fregi trovati negli scavi del Foro Trajano con altri esistenti in Roma ed in diverse altre città.* Milan: G.B. Bianchi, 1838.

Amici = Amici, C. *Foro di Traiano: Basilica Ulpia e Biblioteche.* X Ripartizione antichità e belle Arti e problemi di Cultura. Studi e materiali dei Musei e Monumenti Comunali di Roma, 10. Rome: Panetto and Petrelli, 1982.

AnalRom = Analecta romana Instituti Danici.

Anderson = Anderson, J.C., Jr. *The Historical Topography of the Imperial Fora.* Collection Latomus, 182. Brussels: Universa, 1984.

Antiquity = Antiquity. A Quarterly Review of Archaeology.

A:P.B. Archivio Fotografico Comunale, Palazzo Braschi, Rome.

Armellini = Armellini, M. *Le chiese di Roma del secolo IV al XIX.* 3rd ed., Vol. I. Rome: Edizioni R.O.R.E. di Niccola Ruffolo, 1942.

Ashby, "AC," = Ashby, T. "Sixteenth Century Drawings Attributed to Andreas Coner," *BSR* 2 1904: 1-96, Pls. 1-165.

AttiCSDIR = Atti. Centro studi e documentazione sull'Italia romana.

AttiPontAcc = Atti della Pontifica Accademia romana di archeologia.

Barroero. See *VFI.*

Bartoli, *MA* = Bartoli, A. *Monumenti antichi di Roma nei disegni degli Uffizi*, 5 vols. Rome: Bontempelli, 1914-1922.

Bartoli, "Recinzione," = Bartoli, A. "La recinzione meridionale del Foro Traiano." *AttiPontAcc, Memorie* Ser. 3.1, pt. 2 1924: 177-191, Pl. 37.

BdA = Bollettino d'Arte.

BdI = Bullettino dell'Instituto di Corrispondenza archeologica.

Becatti = Becatti, G. *La colonna coclide istoriata.* Rome: "L'Erma di Bretschneider," 1960.

Belloni = Belloni, G., *Le monete di Trajano, Catalogo del Civico Gabinetto Numismatico, Museo Archeologico di Milano.* Milan: Comune di Milano, 1973.

Benndorf-Schöne = Benndorf, O., Schöne, R. *Die antike Bildwerke des Lateranensischen Museums.* Leipzig: Breitkopf und Härtel, 1867.

Bertoldi = Bertoldi, M.E. "Richerche sulla decorazione architettonica del Foro Traiano," *StMisc* 3 (1962): 3-34, Pls. 1-27.

Blake-Bishop = Blake, M.E., Bishop, D. *Roman Construction in Italy From Nerva Through the Antonines.* Philadelphia: The American Philosophical Society, 1973.

Blanckenhagen. *See* von Blanckenhagen.

Bloch = Bloch, H., *I bolli laterizi e la storia edilizia romana.* Rome: Carlo Colombo, 1938.

BMCRE = Mattingly, H., *Coins of the Roman Empire in the British Museum.* Vol. 3. London: Trustees of the British Museum, 1936.

Boatwright = Boatwright, M.T., *Hadrian and the City of Rome.* Princeton: Princeton University Press, 1987.

Boni = Boni, G. "Esplorazione del Forum Ulpium." *NSc* 1907: 362-427.

Borbein = Borbein, A.H. "Campanareliefs, typologische und stilkritische Untersuchungen." *RM* supp. vol. 14. Heidelberg: F.H. Kerle, 1968.

Boyd = Boyd, C. E. *Public Libraries and Literary Culture in ancient Rome.* Chicago: University of Chicago Press, 1915.

BSA = Annual of the Bristish School at Athens. 1895-.

BSR = Papers of the British School at Rome, 1902-.

BullCom = Bullettino della Commissione archeologica comunale di Roma. 1872-.

Callmer = Callmer, C. "Antike Bibliotheken," *SkrRom 10/OpArch* 3 (1944): 145-193.

Canina, *AR* = Canina, L. *Architettura romana.* Section 3 of *L'architettura antica.* 2 vols. Rome: Canina, 1830-1840.

Canina, *Edifizj* = Canina, L., *Gli edifizj di Roma antica, cogniti per alcune reliquie descritti e dimostrati nell'intera loro architettura.* 2 vols. Rome: Canina, 1848.

Canina, *Indicazione* = Canina, L. *L'indicazione topografica di Roma antica.* 3d ed. Rome: Canina, 1841.

Canina, "RSc," = Canina, L. "Sulle recenti scoperte del Foro Traiano e della Basilica Ulpia." *AdI* 23 (1851): 131-35.

Canina, "ScFTr," = Canina, L. "Scavi del Foro Traiano," *BdI* 12 (1849): 177-179.

Carettoni. See *PM.*

Castagnoli, "Doc," = Castagnoli, F. "Documenti di scavi eseguiti in Roma negli anni 1860-1870," *BullComm* 73, nos. 1-3 (1949-1950): 123-187.

CIL = Corpus inscriptionum latinarum. 1863-.

Clarac = De Clarac, Ch. *Musée de Sculpture...du Louvre.* Vol. 2.1 (text), vol. 2 (plates). Paris: Imprimerie Royale, 1841.

Coarelli (1974) = Coarelli, F. *Guida archeologica di Roma.* Verona: Mondadori, 1974.

Coarelli (1981) = Coarelli, F. *Roma.* Guide archeologiche Latzerza, no. 6. Bari: Laterza, 1981.

Cohen = Cohen, H. *Description historique des monnaies frappées sous l'empire romain.* Vol. 2. Paris and London: Rollin and Feuardent, 1882.

Colini. *See* "Notizario."

CR = Classical Review. 1887-.

Crema, *ArchRom* = Crema, L. *L'architettura romana.* Section 3, vol. 12 of *Enciclopedia Classica.* Turin: Società Editrice Internazionale, 1959.

CT = Settis, S., La Regina, A., Farinella, V. *La colonna Traiana.* Turin: Einaudi, 1988.

De Clarac. *See* Clarac.

Dédalo = Dédalo, Revista de arte e arqueolgia.

De Gregori = Degregori, C. "Biblioteche dell'antichità." *Accademie e Biblioteche d'Italia* 11 (1937): 9-24.

De Romanis = De Romanis, A. "Drawings." Books 07025, 07026, 07029, 07030. Rome: Accademia di San Luca, Biblioteca Sarti, 1811-1823.

D'Espouy, *Fragments* = D'Espouy, H. *Fragments d'architecture antique.* 2 vols. Paris: C. Schmid, vol. I, n. d.; vol. 2, 1905.

DeTournon = DeTournon, C. *Études statistiques sur Rome.* 3 vols. Paris: Treuttel et Würtz, 1831.

DissPontAcc = Atti della Pontificia Accademia romana di Archeologia. Dissertazioni.

Donaldson = Donaldson, T.L. *Architectura Numismatica.* London: Day & Son, 1859. Reprint. Chicago: Argonaut Publishers, 1966.

Durm, = Durm, J. *Die Baustile.* Part 2, vol. 2 of *Handbuch der Architektur: Die Baukunst der Etrusker. Die Baukunst der Römer.* 2d ed. Stuttgart: Alfred Kröner Verlag, 1905.

EAA = Enciclopedia dell'arte antica, classica e orientale.

Fea, *Appendice* = Fea, C. *Appendice alla ristampa della Colonna Traiana disegnata et intagliata da P.S. Bartoli.* Rome: n.d., but ca. 1825.

Fea, *Notizie* = Fea, C. *Notizie degli scavi nell'Anfiteatro Flavio e nel Foro Traiano.* Rome: Lino Contedini, 1813.

Fea, *Reclami* = Fea, C. *I reclami del Foro Trajano.* Rome: Stamperia della R.C.A., 1832.

Fine Licht = Fine Licht, K. de. *The Rotunda in Rome.* Copenhagen: Nordlundes Bogtrykkeri, 1968.

Fittschen-Zanker = Fittschen, K., and P. Zanker. *Katalog der römischen Porträts in den Capitolinischen Museen und den anderen kommunalen Sammlungen der Stadt Rom.* Mainz: Philipp von Zabern, 1985-.

Florescu = Florescu, F.B. *Die Trajanssäule.* Bucharest and Bonn: Akademie Verlage and Rudolph Habelt Verlag, 1969.

FT = Pensabene, P. et al.,"Foro Traiano. Contributi per una ricostruzione storica e architettonica," *Archeologica Classica*, 41 (1989): 27-292.

Garrucci = Garrucci, R. *Monumenti Museo Lateranense.* Rome: Tipografia della S.C.de Propaganda Fide, 1861.

Gatteschi = Gatteschi, G., *Restavri della Roma imperiale.* Genova: Tipi della S.A.I.G.A. Barabino and Grave, 1924.

Gilbert, *Rom* = Gilbert, O. *Geschicte und Topographie der Stadt Rom im Altertum.* Vol. 3. Leipzig: Teubner, 1890.

Gismondi, I. "Restorations of the Forum of Trajan." Rome: X Rip., 1939-1940. Now published in *FT*, pp. 198-214, Figs. 98-102, 105-110 (herein Fig. 124).

Gjerstad = Gjerstad, E. "Die Ursprungsgeschicte der römischen Kasierfora." *SkrRom* 10/*OpArch* 3 (1944): 40-72.

Gnomon = Gnomon. *Kritische Zeitschrift für di·gesamte klassische Alterumwissenschaft. 1925-.*

Goethert = Goethert, F.W. "Traianische Friese," *JdI* 51 (1936): 72-81.

Götze = Götze, B. "Antike Bibliotheken," *JdI* 52 (1937): 225-247.

Guadet = Guadet, J. "Memoire de la Restauration du Forum de Trajan." Manuscript nos. 207 (text), 2748 (drawings). Paris: École des Beaux-Arts, 1867.

Gusman = Gusman, P. *L'art décoratif de Rome.* 3 vols. Paris: Librarie centrale d'art et d'architecture, 1908-1914.

Heilmeyer = Heilmeyer, W.D. "Korinthische Normalkapitelle." *RM* supp. vol. 16. Heidelberg: F.H. Kerle, 1970.

Helbig[4] = Helbig, W., *Führer durch die öffentlichen Sammlungen klassischer Altertümer in Rom.* 4th ed. Vol. I. Tübingen: Wasmuth, 1963.

Hill = P. Hill, *The Monuments of Ancient Rome as Coin Types.* London: Seaby, 1989.

Hodge = Hodge, A. T. *The Woodwork of Greek Roofs.* Cambridge: Cambridge University Press, 1960.

Horn = Horn, R. "Die neuesten Grabungen zur Freilegung der Kaiserfora..." *Gnomon* 8 (1932): 283-285.

Huelsen = Huelsen, C. *Il libro di Giuliano da Sangallo.* Leipzig: Harassowitz, 1910.

Huelson, *Chiese* = Huelson, C. *Le chiese di Roma nel medio evo.* Florence: Leo Olschki, 1927.

ILS = *Inscriptiones latinae selectae.* H. Dessau, ed. 1892-1916.

INLan = Collezione Lanciani. In the Istituto Nazionale d'Archeologia e storia dell'Arte (National Institute of Archaeology and the History of Art) Palazzo Venezia, Rome.

Jameson = Feuardent Frères (Jameson Coll. ii). *Monnaies grecques antiques et impériales romaines.* Revised reprint Chicago: Obol International, 1980.

JdI = *Jahrbuch des Deutschen Archäologischen Instituts. 1886-.*

Jonsson = Jonsson, M. *La cura dei monumenti alle origini.* SkrRom. Ser. 8, no. 14 1986.

Jordon, *Top*, I = Jordan, H. *Topographie der Stadt Rom im Alterthum.* 3d ed. Vol. I, pt. 2. C. Huelsen, ed. Berlin: Weidmannsche Buchandlung, 1885. Pp. 453-67.

JRA = *Journal of Roman Archaeology.* 1988-.

JRS = *The Journal of Roman Studies.* 1911-.

JSAH = *Journal of the Society of Architectural Historians.*

Kaschnitz-Weinberg = Kaschnitz-Weinberg, G., "Archäologische Funden in den Jahren 1925-1926," *Jdl. Archäologischer Anzeiger* 62 (1927): 103.

KAVR = *Kaiser Augustus und die verlorene Republik.* M. Hofter et al., eds. Exhibition catalogue, Berlin, June 7-August 14, 1988. Mainz-am-Rhein: Philipp von Zabern, 1988.

Kleiner = Kleiner, D. *Roman Sculpture.* New Haven and London: Yale University Press, 1992.

Kraus, *Weltreich* = Kraus, M. *Das römische Weltreich.* Berlin: Propylaean Verlag, 1967.

Lanciani. *See* INLan.

Lanciani, *Ruins* = Lanciani, R. *The Ruins and Excavations of Ancient Rome.* Boston and New York: Houghton, Mifflin and Company, 1897.

Lanciani, "Schede," = Lanciani, R. "Schede sulla topografia di Roma: Regione VIII, Parte II, sec. XIX-XX." Latin Codex No. 13038. Vatican Library, Vatican City. N. d.

Lanciani, *Storia* = Lanciani, R. *Storia degli scavi di Roma.* 4 vols. Rome: Ermanno Loescher, 1902-1912.

Lange = Lange, K. von. *Haus und Halle.* Leipzig: Veit, 1885.

La Padula = La Padula, A. *Roma 1809-1814. Contributo alla storia dell'urbanistica.* Rome: Fratelli Palombi, 1958.

Latomus = *Latomus. Revue d'études latines.* 1937-.

Leon = Leon, C. *Die Bauornamentik des Trajansforums.* Vienna, Cologne, Graz: Böhlaus, 1971.

Lesueur = Lesueur, J.-B. *La basilique Ulpienne Rome, Restauration exécutée en 1823.* Paris: Firmin-Didot, 1877. Cited in the text by the earlier date.

Lugli, *Centro* = Lugli, G. *Roma antica, il centro monumentale.* Rome: G. Bardi, 1946.

Lugli, *Fontes* = Lugli, G. *Fontes ad topographiam veteris urbis Romae pertinentes.* Vol. 6.pt. I. Rome: Unione Arti Grafiche, 1965.

Lugli, *Itinerario* = Lugli, G. *Itinerario di Roma antica.* Milan: Periodici Scientifici, 1970.

MAAR = *Memoirs of the American Academy in Rome.* 1915-.

MacDonald (1982) = MacDonald, W. *The Architecture of the Roman Empire.* 2d. ed. Vol. 1. New Haven and London: Yale University Press, 1982.

MacDonald (1986) = MacDonald, W. *The Architecture of the Roman Empire.* Vol. 2, *An Urban Appraisal.* New Haven and London: Yale University Press, 1986.

Marrou = Marrou, H.I. "Les dernières fouilles de Rome." *REL* 10 (1932): 469-475.

Matz = Matz, F. *Ein römisches Meisterwerk der Jahreszeitensarkophag Badminton-New York.* Supp. 19 of *Jdl.* 19 Ergänzungsheft. Berlin: De Gruyter, 1958.

Mazzini = Mazzini, G., *Monete imperiali romane.* Vol. 2, *Da Nerva a Crispina.* Milan: Ratto, 1957.

MdI = *Mitteilungen des Deutschen Archäologischen Instituts.*

MEFR = *Mélanges de archéologie et d'histoire de l'École française de Rome.*

MEFRA = *Mélanges de l'École française de Rome. Antiquité.*

MI = *Monumenti inediti pubblicati dall'Istituto di Corrispondenza Archeologica.* Vol. 5. Rome: Istituto di Corrispondenza Archeologica, 1849-1853.

MM = *Madrider Mitteilungen.* 1960-.

Morey = Morey, P. M. "Mémoire explicatif de la restauration du Forum de Trajan." Manuscript Nos. 202 (text), 2198 (plates). Paris: École des Beaux-Arts, 1835.

Nardini-Nibby = Nardini, F. *Roma antica di Famiano Nardini riscontrata ed accresciuta delle ultime scoperte, con note ed osservazioni critico - antiquarie di Antonio Nibby*. 4 vols. 4th Ed. Rome: De Romanis, 1818-1820.

Nash = Nash, E., *Pictorial Dictionary of Ancient Rome. 2 vols. 2d ed. New York: Praeger, 1968.*

Nibby, *RomAnt* = Nibby, A. *Roma nell'anno 1838*, Part 2, *Antica*. Rome: Tipografia delle Belle Arti, 1839.

"Notizario" = Colini, A. M. "Notizario di scavi, scoperte e studi intorno alle antichità di Roma e del Lazio 1931-1932-1933." *BullComm* 61 (1933): 265-266, Pl. A (herein Fig. 3), facing p. 256.

NSc = Notizie degli scavi di antichità. 1876-.

OpArch = Opuscula archeologica.

Packer, "Amici" = Packer, J. "Review of C. Amici," *AJA* 87 (1983): 569-572.

Packer (1997) = Packer, J. *The Forum of Trajan in Rome: A Study of the Monuments.* 3 vols. Berkeley and Los Angeles: University of California Press, 1997.

Packer, "New Excavation" = Packer, J., K. Sarring e R. Sheldon. " A New Excavation in Trajan's Forum." *AJA* 87 (1983): 165-72.

Packer, "NumEv" = Packer, J. "Numismatic Evidence for the Southeast (Forum) Facade of the Basilica Ulpia." In *Coins, Culture, and History in the Ancient World.* L. Casson and M. Price, eds. Detroit: Wayne State University Press, 1981. Pp. 57-67.

Packer, J. "The Basilica Ulpia in Rome: An Ancient Architectural Experiment." *AJA* 77 (1973): 223.

—. "Biblioteca Ulpia: A New Restoration of the West Library in the Forum of Trajan." *AJA* 94 (1990): 313.

—. "Forum Traiani Restitvtvm: A New Reconstruction of the Forum of Trajan." *AJA* 95 (1991): 320-21.

—. "A New Restoration of the Basilica Ulpia in Trajan's Forum." In *American Philological Association 1983 Annual Meeting, Abstracts.* Chico, California: Scholars Press, 1984. P. 142.

—. "Restoring Trajan's Forum." *Inland Architect* (1990): 57-65.

—. "The Southeast Facade of the Basilica Ulpia in Trajan's Forum: The Evidence from the Northeast Colonnade." *AJA* 90 (1986): 189-90.

—. "Trajan's Basilica Ulpia: Some Reconsiderations." *AJA* 86 (1982): 280.

—. "Trajan's Forum in 1989." *AJA* 96 (1992): 151-62. Review of *FT*.

—. "The West Library in the Forum of Trajan: The Problems and Some Solutions." R. and A. Scott, eds. *Eius Virtutis Studiosi: Classical and Post-Classical Studies in Memory of Frank Edward Brown 1908-1988.* Hanover and London: National Gallery of Art, Washington, D. C., 1993: 421-446.

Packer, J., and K. Sarring. "Dossier: Il Foro di Traiano, " *Archeo* 93 (novembre 1992): 62-89, 92-93.

Paribeni, "Inscrizioni," = Paribeni, R. "Inscrizioni dei Fori Imperiali." *NSc* 11 (1933): 484-523.

Paribeni, *OP* = Paribeni, R. *Optimus Princeps.* 2 vols. Messina: Principato, 1926-1927.

Pensa = Pensa, M. "L'architettura traianea attraverso le emissioni monetali coeve," *AttiCSDIR* 2 (1969-70): 236-297.

Pensabene, P. See *FT.*

Percier. C., *Colonne Trajane (Rome), restauration executée en 1788.* Restaurations des Monuments Antiques. Paris: Firmin-Didot et Cie, 1877.

Picard = Picard, G. "Bulletin archaéologique. III. le Forum de Trajan." *REL* 51 (1973): 351-357.

Platner-Ashby = Platner, S.B., and T. Ashby. *A Topographical Dictionary of Ancient Rome.* London: Oxford University Press, 1929.

Plommer = Plommer, H. "Trajan's Forum: A Plea." *Proceedings of the Cambridge Philological Society* 186 n.s. 6 (1959): 54-62.

Plommer, "TrFo," = Plommer, H. "Trajan's Forum." *Antiquity* 48 (1974): 126-130, Pl. XVIb.

PM = Carettoni, G., A. Colini, L. Cozza, G. Gatti, *La pianta marmorea di Roma antica.* 2 vols. Rome: Danesi, 1960.

ProcBritAc = *Proceedings of the British Academy.* 1903-.

RA = *Roma antiqua, "Envois" degli architetti francesi (1788 -1929), l'area archeologica centrale.* Rome and Paris: École Française de Rome, École Nationale Supérieure des Beaux-Arts, Soprintendenza Archeologica di Roma, 1985.

RE = Pauly-Wissowa, *Pauly's Real-Encyclopädie der Klassichen Altertumswissenchaft.* G. Wissowa, ed. Stuttgart: Metzlerscher, 1894-.

Reber, *Ruinen* = Reber, F. *Die Ruinen Roms.* 2d. ed. Leipzig: T.O. Wegel, 1879.

REL = *Revue des études latines.* 1923-.

RendLinc = *Atti dell'Accademia nazionale dei Lincei. Rendiconti.*

RIA = Ward-Perkins, J.B. *Roman Imperial Architecture.* Harmondsworth, Eng.: Penguin Books, 1981.

RIC = Mattingly, H., E. Sydenham. *Vespasian to Hadrian.* Vol. 2 of *The Roman Imperial Coinage.* London: Spink and Sons, 1926.

Ricci. See *VdI.*

Ricci, "Esplorazione," = Ricci, C. "Esplorazione archeologica delle cantine a Macel de' Corvi." *BullComm* 59 (1931): 117-122.

Richardson = Richardson, L., Jr. *A New Topographical Dictionary of Ancient Rome.* Baltimore and London: The Johns Hopkins University Press, 1992.

Richter-Grifi = Richter, F., and A. Grifi. *Il restauro del Foro Traiano con le dichiarazioni di Antonio Grifi.* Rome: Monaldi, 1839.

RIN = *Rivista italiana di numismatica e scienze affini. 1888-.*

RM = *Mitteilungen des Deutschen Archäologischen Instituts. Römische Abteilung.* 1886-.

RM-EH = *Mitteilungen des Deutschen Archäologischen Instituts. Römische Abteilung. Ergänzungsheft.*

Robertson = Robertson, A. S. *Roman Imperial Coins in the Hunter Coin Cabinet*, Vol. 2. London, Glasgow, New York: Oxford University Press, 1971.

Rossi = Rossi, L. *Trajan's Column and the Dacian Wars.* Rev. and trans. by J. M. C. Toynbee. Ithaca, N.Y.: Cornell University Press, 1971.

Rossini, L. "Scavi del Foro di Traiano e del teatro di Pompeo. Rome: unpublished manuscript in the library of the German Archaeological Institute, Rome, 1837.

Sackur = Sackur, W. *Vitruv und die poliorketiker.* Berlin: Ernst und Sohn, 1925.

Sbordone = Sbordone, S. "La biblioteca 'Ulpia Traiana'", *Atti della Accademia Pontaniana* n.s. 23 (1984): 119-125.

Scheiper = Sheiper, R. *Bildpropaganda der römischen Kaiserzeit unter besonderer Berücksichtigung der Trajansäule in Rom und Korrespondierender Münzen.* Bonn: Habelt, 1982.

Settis. See *CT.*

Simon = Simon, E. "Zur Bedeutung des Greifen in der Kunst der Kaiserzeit." *Latomus* 21 (1962): 749-780.

Skr Rom = *Skrifter utgivna av Svenska Institutet i Rom.*

St Misc = *Studi Miscellanei. Seminario di archeologia e storia dell'arte greca e romana dell'Università di Roma.*

Strack = Strack, P. *Die Reichsprägung zur Zeit des Traian.* Vol. 1 of *Untersuchungen zur römische Reichsprägung des zweiten Jahrunderts.* Stuttgart: Kohlhammer, 1931.

Strocka = Strocka, V.M. "Römische Bibliotheken." *Gymnasium* 88 (1981): 298-329.

Stuart Jones, *Cons.* = Stuart Jones, H. *A Catalogue of the Ancient Sculptures Preserved in the Municipal Collections of Rome: The Sculptures of the Palazzo dei Conservatori.* Oxford: Clarendon Press, 1912.

Technau = Technau, W. "Archäologische Funden in Italien," *AA* 47 (1932): 484-486.

Thédenat, FR = Thédenat, H. *Le Forum romain et les forums impériaux.* Paris: Hachette, 1904.

Toebelman = Toebelman, F. *Römische Gebälke.* Vol.I, pt. I, text; pt. 2, atlas. Heidelberg: Carl Winter, 1923.

Toynbee = Toynbee, J.M.C. *The Hadrianic School.* Cambridge: Cambridge University Press, 1934.

Uggeri = Uggeri, A. *Della Basilica Ulpia nel Foro Traiano Istoria e Restavrazione.* Rome, n. d., ca. 1832-1835.

Uggeri, *JP* = Uggeri, A. *Edifices de Rome Antiques Deblayés et Reparés par S. S. Le Pape Pie VII depuis l'an 1804 jusqu'au 1816.* Vol. 23 of *Journées pittoresques.* Rome: Francesco Bourlie, 1817.

Vacca = Vacca, F. *Memorie.* Rome, 1594. Republished in Nibby-Nardini. Vol. 4, Pp. 5-52.

VdI = Ricci, C., A. Colini, V. Mariani. *Via dell'Impero.* German trans. by E. Hohenemser. Rome: Libreria dello Stato, 1939.

Venuti = Venuti, R. *Accurata e succinta descrizione topografica delle antichità di Roma.* 3d. ed. vol. I. Rome: Piale and De Romanis, 1824.

VFI = Barroero, L., A. Racheli, A. Conti, M. Serio. *Via dei Fori Imperiali.* Venice: Marsilio Editore, 1983.

Viola = Viola. S."Memorie istorico-critiche sulla origine, progressi e decadenza del Foro Trajano in Roma." *Giornale Arcadico di Scienze, Lettere ed Arti* 12 (1821): 207-230; 13 (1822): 260-273; 15 (1822): 201-215; 16 (1822): 76-68.

von Blanckenhagen = von Blanckenhagen, P.H. "The Imperial Fora," *JSAH* 13, no. 4 (1954): 21-26.

Wace = Wace, A.J.B. "Studies in Roman Historical Reliefs." *BSR* 4 (1907): 229-257.

Waelkens = Waelkens, M. "From a Phrygian Quarry: the Provenance of the Statues of the Dacian Prisoners in Trajan's Forum in Rome." *AJA* 89 (1985): 641-653.

Ward-Perkins. See *RIA.*

Ward-Perkins, "Columna" = Ward-Perkins, J. "Columna divi Antonini." In *Mélanges d'histoire ancienne et d'archéologie offerts à Paul Collart.* Lausanne: De Boccard, 1976. Pp. 345-352.

Ward-Perkins, RA = Ward-Perkins, J. *Roman Architecture.* New York: Abrams, 1977.

Wiegand = Wiegand, T. *Baalbek.* Vol. 2. Berlin and Leipzig: De Gruyter, 1923.

Winckelmann = Wincklemann, G. *Storia dell'arte presso gli antichi. Opere di G. Winckelmann.* 1st Italian ed. Vol. 1. Prato: Fratelli Giachetti, 1830. Translation of *Anmerkungen über die Geschichte der Kunst des Altertums.* Dresden: Waterischen Hof - Buchhandlung, 1764-1767.

X Rip. = Comune di Roma. X Ripartizione. Antichità e Belle Arti. Archivio, Portico d'Ottavia, Roma. (City of Rome. Department 10. Antiquities and Fine Arts. Archive, Portico of Octavia, Rome.)

Zanker = Zanker, P. "Das Trajansforum in Rom." *AA* 85 (1970): 499-544.

Index

INDUSTRIA PER LA STAMPA IN OFFSETT
Via Dorando Petri, 20 - 00011 Bagni di Tivoli (RM)

Finito di stampare nel mese di luglio 2001